California SEXY

Horny?
LOS ANGELES

A Sexy, Steamy,
Downright Sleazy
Handbook to the City

Except as permitted under the United States Copyright Act of 1976,
no part of this publication may be reproduced or distributed in
any form or by any means, or stored in a database or retrieval system,
without the prior written permission of the publisher.

Printed in Illinois, USA

First Printing: November, 2001
Horny? Los Angeles: A Sexy, Steamy, Downright Sleazy Handbook to the City Edited
by Jessica Hundley and Jon Alain Guzik
ISBN 1-893329-16-X
Library of Congress Control Number: 2001119361

Cover, design, and illustrations by Ingrid Olson, Tülbox Creative Group

Visit our web site at www.ReallyGreatBooks.com

To update the editors on other horny scenes, e-mail Horny@ReallyGreatBooks.com

To order *Horny?* or for information on using copies as corporate gifts, e-mail us at
Sales@ReallyGreatBooks.com or write to:

Really Great Books
P.O. Box 861302
Los Angeles, CA 90086 USA

Really Great Books wishes to thank the following for their permission
to reprint versions of materials included in this book:

Jessica Hundley: Version of "Hollywood's Wild Adolescence"
originally published as "Age of Innocence" in *Hotdog*. Copyright © 2001
by Jessica Hundley. Reprinted by permission of the author.

Kashy Khaledi and Paul Cullum: Version of "Interview with Hugh"
originally published in *Mean Magazine*. Copyright © 2000 by Kashy Khaledi
and Paul Cullum. Reprinted by permission of the authors.

Matt Maranian and Anthony R. Lovett: Versions of "Naked City,"
"Mustang Books & Video," "Nude Beaches," and "HardArt"
originally printed in *L.A. Bizarro: The Insider's Guide to the Obscure,
the Absurd, and the Perverse in Los Angeles* by St. Martin's Press.
Copyright © 1997 by Anthony R. Lovett and Matt Maranian.
Reprinted by permission of the authors.

A Sexy, Steamy, Downright Sleazy Handbook to the City

Edited by
Jessica Hundley & Jon Alain Guzik

Los Angeles

Erotigo brings *Horny? Los Angeles* to your handheld or wireless device!

sex in the palm of your hand℠
www.erotigo.com

Contents

Please Read

- The only sure thing in life is change. We've tried to be as up-to-date as possible, but places change owners, hours, and services as often as they open up a new location or go out of business. Just call ahead if there's any question.

- Every place in *Horny?* is recommended . . . for something. Each reviewer has tried to be honest about his/her experience of the place, and some–times a jab or two makes its way into the mix. And remember, under the Fair Use Doctrine, some statements about the establishments in this book are intended to be humorous as parodies. Whew! Got the legal stuff out of the way.

- Most major credit cards are accepted at the establishments herein, so charge it up. Places that are *cash only* have been noted as such to the best of our knowledge. When in doubt, bring some cash.

- We shouldn't even have to tell you this, but we have to tell you. Drink responsibly. Don't drive after you've been drinking alcohol. If a desig-nated driver is hard to come by and you don't live spittin' distance from your favorite bar, call a cab to take you home. Split the cost with some friends and it's not even that expensive. Once you call for a taxi, wait for it. Drivers are working on their own time and stiffing a cabbie's just plain rude!

 Here's a handy list of taxi companies in the area.

 Bell Cab Co.: (888) 235-5222

 Checkered Cab: (800) 300-5007

 Independent Cab Company: (800) 521-TAXI (8294)

 LA Taxi Co-op: (800) 200-1085

 Metro City Cab: (800) 338-3898

 United Independent Taxi: (800) 411-0303

 Yellow Cab Co.: (877) 733-3305

- And finally, should you get lucky thanks to this book, please, please, please practice safe sex! See our guide to free clinics on p. 180 if you don't know how!

Key to the Book

For your viewing pleasure

You can be sure that a *Horny?* stamp of identification means these spots do whatever it is we say they do. This key should help you figure it all out.

Strip Club!
Fully nude, topless, or bikini, off with those clothes . . .

Porn Galore!
Magazines, books, and videos—smut sold with pride . . .

Adult Toys!
Sexy toys and novelties = fun for big girls and boys . . .

Lingerie!
Lace and leather, maybe even some feathers . . .

Sexy Street Wear!
Not quite nighties, but definitely naughty . . .

Outdoor Fun!
Find your natural side while eliminating pesky tan lines . . .

Hotel, Motel, Holiday Inn!
For when the back seat just don't cut it . . .

Spa and Massage!
Clean and dirty at the same time . . .

SM/BD/Fetish!
If you like it rough and tumble . . .

Curious?
Gay, but straight-friendly, come see how the other side lives . . .

Alcohol Served!
So you know it's 21-and-over . . .

Open Late!
It's late (past midnight), you're horny, fill in the rest . . .

Contributors

Steve Allison

Charlie Amter

Kristine Ayson

John Baldrica

Melissa Bellovin

Alexandria Blythe

Chuck Bronco

Coner Brook

H.C. Brown

Chad E. Brown

Chris Contreras

Timothy Catz

Barb Choit

Justin Clark

Bruce Craven

Paul Cullum

Dancer X

Jen Diamond

Evangeline Heath

Erin Holmes

Marty "Gemini" Jimenez

Steve Kandell

Sally Kleinbart

Nick LeBon

Josh Levitan

Little Margie

Rebecca Lorimer

Jen Liu

Matt Maranian

Heather Marcroft

Jonathan Miertschin

Molly Mormon

Phuong-Cac Nguyen

Joseph Nicchitta

Noel

Nancy Pearce

Robert D. Petersen

Todd Philips

Gary Phillips

Aaron Reardon

Andrea Richards

Robhonky

Jonathan Sanford

Aurisha Smolarski

Travis T. Stevens

Z Bone

Acknowledgements

Jessica Thanks . . .

Nancy Pierce for helping to incite the PMS, FUTUREflapper, and SnuggleWarrior revolutions; Chad E. Brown, Sean Daly, and Jonathan Miertschin for the dungeon tour accompaniment; Tom "Texas" Holmes for spreading the gospel of sexual democracy; all my good pals for keeping me sane in the chaos (I love you!); and all the folks who make me horny: past, present, and future.

Jon Says . . .

First of all, I'd like to thank all of the fine people of Los Angeles without whom there would be no book. I'd like to thank all of my friends who lent a helping hand and read parts of this guide while it was still in its nascent form. I'd like to thank Steve Salardino, whose constant prodding of games of cribbage and trips to the horse track kept me sane; Andrew Vontz's performance art; Emily's bubba-ness; Steve K. for his constant, um, support; and Molly for being Molly. I'd also like to the thank Rodney Klein for DJing at all of those places where I can meet girls; my sister for the kind words and gossip; and finally, I'd like to thank my mom and dad, because without their support, I wouldn't be here in the first place.

Jessica & Jon Say . . .

Jessica and Jon would first of all like to thank the best damn interns ever to get college credit, Fanny Vanessa Chavarria, Susan Jonaitis, Rebecca Lorimer, and Nikki Derdzinske. We also owe a great heaping of gratitude to all our fantastic writers, who went way above and beyond the call of duty to help us get this book in; to Dancer X and Lady Elizabeth for their sage advice; to Z Bone for his incredibly informational site, www.zbone.com; to Ingrid Olson for her swell design work; to Frank Culbertson for his eagle eye; and to Mari Florence for making it all happen. But most of all, we'd like to thank, Miss Nina Wiener, without whom this book you are reading would still just be blank pages.

Introduction

Dearest readers and fellow sleaze journeymen (and women),

To write a thorough, all-encompassing travel guide to "erotic" LA is no easy feat. The city, whose essence is intrinsically linked to the entertainment business (which in turn, is constructed on a solid foundation of the populous' desires), offers an overwhelming amount of sexual diversions. Strip clubs, drag shows, leather and latex shops, S&M dungeons, porn stores, and swingers' clubs, not to mention the abundance of meat-market bars—Los Angeles County provides a multitude of diversions for a wide variety of tastes. Its seeming endless expanse, a sweep of urban sprawl tamed only by the mountains and the sea, encompasses a welcome overload of sensual pleasures.

From the very beginning Los Angeles was built on a history of scandal and intrigue, feats of sexual perversion, prowess, and seduction that would make your mama blush. The last stop on the Wild West wagon train, the final promise Manifest Destiny, LA evolved from rough-and-tumble outlaw outpost to bustling metropolis in just a few short decades, its ranches and family farms quickly replaced with trolley lines and looming skyscrapers. The world had discovered movies and the movie moguls had discovered Los Angeles. Its near perfect weather, its diversity of landscape, and its cheap land provided the perfect locale for the burgeoning film studio boom. There is no business, as they say, like show business and with the influx of actors, musicians, and artists came a freedom of spirit and a liberal embrace of sensual decadence that immediately established LA as either a moralless Sodom or a sexual utopia, depending upon whom you asked.

Those with a desire for fame (or infamy) arrived by the droves. Mae West, already imprisoned for obscenity in New York City (for her play *Sex*, which she had written, produced, and directed), sought refuge in LA and quickly became one of the biggest film femme fatales of all time, bedding the likes of Cary Grant and George Raft on-screen and reputedly seducing legions in real life. Clara Bow, another bawdy East Coast transplant, was the very first media-proclaimed "It Girl," a dancer and model whose sexual conquests were legendary. The notorious gossip, author, and experimental filmmaker Kenneth Anger was so awed by her appetite for men that he claimed (in *Hollywood Babylon* his collected tales of Tinseltown amorality) that she had slept with the entire USC football team. Since proven to be a gross exaggeration, the rumor nevertheless remains a good indication of Bow's notorious reputation.

LA also attracted boatloads of overseas immigrants who brought with them the notoriously liberal European outlook on sexual propriety. Rudolph Valentino transformed himself from a young Italian naif into the ultimate Latin Lover; Marlene Dietrich made the trip from Germany to overturn our conceptions of female sexuality, cross-dressing her merry way to fame; and Charlie Chaplin crossed the Atlantic to make the masses laugh and the young girls swoon.

Chaplin became one of the first of many Hollywood royals to be immersed in scandal (for supposedly impregnating an underage actress), and was joined, over the years, by everyone from Fatty Arbuckle (accused of rape) to Elizabeth Taylor (for her notorious affair with Rock Hudson) to Hugh Grant and Eddie Murphy (whose alleged involvement with Sunset Boulevard streetwalkers got them both in hot water). But, for the bulk of LA's celebrities, sexual scandal has only served to boost their careers. We like our icons to live a life as dramatic and passionate as the ones they play out for us on the screen or stage and if that means a touch of perversion, a smattering of adultery, or a remarkably prodigious sexual appetite, all the better.

As a result of this saturation of sensuality, the city has cultivated a healthy disdain for prudishness and a wide-armed embrace of cheerful impropriety. As well as being the home of mainstream pop culture, LA is also the headquarters for much of the world's porn industry. Centered predominately in the steamy San Fernando Valley, the adult film business was, is, and will be booming. Although a few of the city's more uptight residents tend to get persnickety at the goings-on on the "other" side of the Hollywood Hills, it's highly unlikely the tittie-flick folk are going anywhere anytime soon.

And why should they? Although former mayor Richard Riordian called the industry "a black eye on the city," the truth is that porn fits right in. This is, after all, a town where sleaze is omnipresent. If you've got a hankerin' to experience LA smut you need only to drive a few blocks in any direction. Topless and fully-nude clubs abound and, due to the eternally perfect weather, even our everyday denizens are frequently clad in the most sparing of garments.

The presence of thousands of young hopefuls, pouring off the buses from the Midwest and beyond, searching hard for the big dream has the added benefit of populating the city with young, attractive, and pleasantly naive citizens, a quality which makes the people-watching (try the beaches, cafés, and hiking trails) a uniquely titillating pleasure. As the great man once said, "wish they all could be California girls" (and boys too, of course).

For someone visiting from more reserved climes, this liberation can be both stimulating and utterly overwhelming. LA County's many neighborhoods and suburbs combine to form one of the largest cities in the world. The freeways spread a tangle of asphalt and exhaust across its expanse, and the lack of decent public transportation makes Los Angeles an extremely difficult place to navigate. Of all American cities, it is the one perhaps most confusing to visitors—a fascinating but labyrinthine maze where even the most sophisticated and savvy of travelers may need a knowledgeable guide.

For those who possess a particular taste for the sexier, steamier side in their journeys, *Horny?* was created to serve as a combination den mother, camp counselor, and group leader, a kind of welcome beacon in the dark night, thankfully pointing the way toward smut.

We (with the valued assistance of our talented contributors), have perused countless aisles lined with lace negligees, girlie mags, and sex toys of every ilk; gazed upon hundreds of bobbing breasts and bare asses; and even submitted to a whippin' or two—all so that dirty guys and gals around the world can better navigate the choppy seas of LA sleaze.

So cast off your inhibitions, throw on your crotchless undies, grab your spankin' paddle, and let *Horny?* be your guide! Happy sailing!

Hugs, kisses, and some serious groping,

—Jessica & Jon

P.S. While we've attempted to create a complete compilation of LA's racier attractions, it's doubtful we've succeeded fully. You'll note for instance, the lack of extensive gay content in this book. Our apologies! This omission was not due to any accidental oversight on our part. Several other books encompassing queer life in Los Angles already exist and to include both gay and straight sexual hot spots in this edition of *Horny?* would have resulted in a travel guide the size of the *Gutenberg Bible.*

For those of you who would like a more thorough investigation of LA's queer offerings, keep a look out for a gay *Horny?* guide from Really Great Books in the near future, and in the meantime, please forgive the exclusion!

Get Horny!

Contents

THE BIG TEASE
Performance|Strip

Ah, LA! The city where everyone wants to be a star!

The waiter serving you your calamari appetizer, the gal behind the counter at the local book store, or the elderly man changing your oil—nearly all of them have not so hidden aspirations to make it into the biz, to star on the silver screen, to belt out a tune to the roar of an adoring crowd, to make it to the big time. As the legend goes, each and every day, fresh-faced beauty queens and strapping quarterbacks step off the bus at Hollywood and Vine, wide-eyed, bushy-tailed, and looking for that lucky break.

As a result, Los Angeles County is host to a bevy of performance-based sleaze, where strip clubs, decadent drag shows, and go-go dancers lurk at every turn. This overload of raw talent and blind ambition means (lucky for you!) that the quality of LA's professional performer is just a mite higher than what folks might find in Kansas City. In the heart of smoggy Tinseltown, Miss Corn-fed Indiana is willing to take off her shirt instead of smugly waving to the crowd in that hometown parade! Here, one person's broken dream is another person's hard on.

That's not to say that true skill and real enjoyment don't exist in LA's adult industry specialists. At the right venues, you'll find sexuality embraced without inhibition, exploitation, or psychological hang-ups. Expect to pay anything from nil to around $20 bucks to gain entry (avoid cover fees by checking the back of the weeklies or club web sites for coupons) and anywhere from $10 to $50 for a lap dance. Tipping well will most likely endear you to the dancers, so if you want some extra attention, spend some extra cash.

So take a deep breath, get those dollar bills ready to stuff down some G-strings and let *Horny?* be your guide!

Performance | Strip

The Beverly Club

A touch of class.

424 N. Beverly Dr. (south of Santa Monica Blvd.), Beverly Hills; (310) 275-8511. Open Mon–Sat: 8:30 p.m.–2 a.m., closed Sun.

Just a hop, skip, and a jump from the swank shops of Rodeo Drive (get your Gucci and your groove on, all in one fell swoop!), this is the only strip club directly in the heart of the 90210 area code. Although it once had high aspirations, The Beverly Club is now a bit worn around the edges. Despite this, you can still order up some decent food ($10 for four courses if you get there by 10 p.m.); and its private areas include the Executive Lounge (which is used for chair dances) and a very dark VIP room (for those who like to feel very important). These extra features, along with the quiet atmosphere and veteran dancers, help the Beverly remain a cut above the rest.

—JH

California Girls

You'll wish they all could be California girls!

1109 N. Harbor Blvd. (one block south of Westminster Ave.), Santa Ana; (714) 554-0491. Open Daily: 11 a.m.–1:45 a.m.

No cover charge and a friendly atmosphere make this a relaxed place to sip a cold one or bring an adventurous date. The girls are bikini-clad, allowing customers to get up close and personal, so ready yourself for the go-go dance of a lifetime. The ladies here know how to move, and the hiring policy seems to be "cream of the crop" only. There are a few pool tables if you need a breather, but be sure to pay attention when the house song plays (you guessed it) and all the ladies in the house jump on-stage to shake their booties in unison.

—JH

> "Is it not strange that **desire** should so
> many years outlive **performance?**"
> — SHAKESPEARE

What's THE Difference?
Strip Club 101 for the T&A Novice

Alas, pasties clubs are a thing of the past, and Los Angeles strip clubs fall into merely three basic categories: nude, topless, and bikini.

Nude Clubs: No alcohol allowed by law, but they can stay open as late as they want and the ladies are buck nekkid! Enjoy your eight-dollar lemonade!

Topless Clubs: With the proper permits and liquor license, topless clubs (boobies but no bare bottoms) are allowed to booze you up. If they've got food too, then 18-year-olds are in like Flynn; no grub, it's 21-and-over. Unfortunately, the overpriced well drinks and cheap beer make for a 2 a.m. closing time just like any other LA County ale house.

Bikini Clubs: This is strip-club soft-core—a nice bet if you're planning on taking a lady friend. Girls strip down to a bikini, but stop there. As a result you can not only suck back the legally licensed liquor, but you also can get much closer to the dancers than the other (naughtier) clubs allow.

Most of all remember to clap like a maniac, behave like a gentleman and tip like a Maharajah! —Z Bone

Hollywood A Go Go

In-your-face dancers.

10542 Victory Blvd. (one block east of Cahuenga), North Hollywood; (818) 763-3090. Open Daily: 11 a.m.–2 a.m.

While not hard-core strippers, the girls at Hollywood A Go Go are in some ways kinkier, wearing bikinis over G-strings over nude pantyhose: A panty-and-stocking lover's dream! Besides the great costumes, the dance style at the club is extra-intimate. As you sit at the bar, a girl will dance on a pole a foot away from you, swinging her hair in your drink and kicking her platforms right past your nose. And the girls are multi-talented as well. Not only do they go upside down, flip back up and swing what seems to be 720 degrees around, but they also work as the barmaids, serving drinks between sets. So, if you're a pantyhose freak, a pole aficionado, or someone who gets a little squeamish at the site of bare breasts bouncing around, Hollywood A Go Go is ideal for you.

—Jonathan Miertschin

Performance | Strip

Hollywood Tropicana

Mud-wrestling mania!

1250 N. Western Ave. (between Sunset Blvd. and Santa Monica Blvd.), Hollywood; (323) 464-1653. Open Tue–Sat: 8 p.m.–2 a.m., closed Sun and Mon.

This club had its glory days in the mid '80s and has since lost some of its magic. It does, however, still offer its infamous mud- and oil-wrestling specialties, bizarre events where customers can bid on a gal, change into shorts (courtesy of the Tropicana), then wrassle their chosen lady to the floor. While this may be your only chance to get up close and personal with a stripper, touching naughty parts is not allowed. Showers are provided for washing off the subsequent grime, but you may want to bring your own bleach. The lack of a liquor license may mean watching paunchy men roll around with bikini-clad babes sans the flattering haze of alcohol, but the novelty is worth it, at least once.

—JH

Bombshells Away!

Exotic World Burlesque Hall of Fame & Museum

If you're looking for a little striptease history, just drive two hours or so out past the desert town of Victorville where former burlesque queen Dixie Evans houses her **Exotic World Burlesque Hall of Fame & Museum**. Follow the hand-painted signs memorializing burlesque greats to Evans' desert ranch, where a back house is filled to the brim with costumes, photos, newspaper clippings, and a stunning display of vintage pasties (worn by all the greats!). Exotic World is not only an intriguing and educational spot, but a nice slice of unique Americana. Dixie, still gorgeous and possessing a very wry wit, will take you on a tour of the museum herself, dishing out chorus-girl gossip and astounding facts at every turn. Each year, the ranch also hosts the Miss Exotic World competition in which strippers of all ages strut their stuff on the poolside stage as a bevy of happy onlookers sweat in the desert heat. To view a 65-year-old raven-haired showgirl sashaying alongside a 19-year-old beauty clad only in her panties is an experience not to be missed. —JH

29053 Wild Rd., Helendale (off I-15, on the way to Vegas); (760) 243-5261; www.exoticworld.com; open daily 10 a.m.–4 p.m.

The Library

Orange County bikini action at its finest.

24356 Swartz Dr. (off El Toro Rd.), Lake Forest; (949) 951-7665; www.thelibrarygc.com. Open Sun–Sat: 5 p.m.–2 a.m.

Conveniently located just off the 5 freeway and across from the Laguna Hills Mall (get some new towels at Bed Bath & Beyond, some scented candles at Pier 1 and some hot chicks at The Library all in one trip!), this new addition to the Orange County sprawl is a fairly upscale club, clean and tidy, with some very attractive ladies. They may not be topless, but the advantage of the bikinis on these naughty librarians is that it allows for much closer proximity, especially during their special so-called "study sessions." Any strip club with a theme deserves a seal of approval, and The Library certainly gets kudos for originality. Every Tuesday is the amateur contest ($1,000 prize), and the competition can get pretty fierce. Look at those stacks!

—JH

Candy Cat 1

Melons and Manson, aw yeah!

21625 Devonshire St. (east of Owensmouth Ave.), Chatsworth; (818) 341-0134. Open Daily: 12:30 p.m.–1:30 a.m.

When out in the deep Valley, why not explore the Manson caves where the whole brood hung out, right there off of Topanga Canyon Blvd., and then go visit the Candy Cat 1, a passable topless joint. Talk about all the crazy characters in the Manson family—that kooky Squeaky!—while delighting in the joys of beer and boobies.

Also at 6816 Winnetka Ave., Winnetka; (818) 993-3187.

—JAG

"Remember, if you smoke after sex, you're doing it too fast." – A N O N Y M O U S

Performance | Strip

Performance | Strip

Cheetahs

The girls here are no harmless kittens.

4600 Hollywood Blvd. (between Vermont Ave. and Hillhurst Ave.),
Los Feliz; (323) 660-6733; www.cheetahsofhollywood.com.
Open Mon–Sat: 3 p.m.–2 a.m., Sun: 6 p.m.–2 a.m.

Not really a strip club, but not really not one either, Cheetahs is a safe place to take anyone—a mixed group of friends, even a first date. Filled with beautiful girls dancing in sexy costumes to good music, it's always a golden time. A wide selection of booze makes the night go smooth as you watch hot hipster chicks take their tops off to the dulcet tones of the Steve Miller Band. So, bring lots of dollars for the girls and quarters for the pool table and grab a seat by the front pole—Cheetahs is a great place to meet your future ex-wife!

—JAG

Crazy Girls

Famed topless rocker bar.

1433 N. La Brea Ave. (south of W. Sunset Blvd.), Hollywood;
(323) 969-0055. Open Daily: 7 p.m.–2 a.m.

Just think of *Cheers*, but with a smoke machine and a string of hot girls showing you their tiny thongs after slapping their asses and smiling at you upside down on the edge of a brightly lit stage to the tune of Rob Zombie's "Superbeast." The dancers are attractive, committed to their craft, and not desperate to hassle you for sad forays into the VIP lounge, though they do hustle here a bit. The place got shut down a couple times in the late '90s for various improprieties, and the quality of the lap dancing has since suffered, but Crazy Girls is still a good place to take a date after a nice dinner. And if looking at the dancers wasn't enough entertainment, you can always stargaze—almost every celeb who's gone through his bad-boy phase has slapped down a few Benjamins here, when he wasn't flying dancers to Aspen for private shows.

—Bruce Craven

Vavavavoom
The Not-So-Lost Art of Burlesque

If you like the line of a lady's leg and the curve of a voluptuous backside, but don't want the accompanying sleaze which permeates most strip club establishments, the lost art of burlesque may be for you. Since the 1800s, ladies the world over have been lifting up their petticoats and showing off their bloomers with a mixture of coyness, seduction, and a healthy sense of humor. Cancan girls at the Moulin Rouge teased the crowds with high kicks and energetic acrobatics, English damsels showed stocking on the London stage, and right here in America, vaudeville bloomed, showcasing lovely ladies and raunchy comedians. There was Weimar-era Berlin with its smoky cabarets; the Minsky extravaganza, one of America's first burlesque reviews; Ziegfeld's girls bringing bawdiness to Broadway; and the bosomy burlesque strippers of the 1940s and '50s.

The burlesque tease slowly metamorphosed into the bump and grind sleaze of today's professional dancers, who specialize in pole maneuvers, hip thrusts and ass shaking, and who rarely err on the side of subtlety. There are, however, a few LA-based acts which have made a name for themselves reviving the old-school style.

The **Velvet Hammer** (who claim artist Ann Magnuson as a member) and the **Pussy Cat Dolls** (who have been accompanied by everyone from Carmen Electra to Gwen Stefani) are two of the city's most prominent troupes, and all offer cabaret-style stage shows which showcase beautiful ladies in a setting born of verve and imagination. Their acts can range from '20s bathing-beauty bounce to '30s Berlin sin to the sequined-pasty shake of '50s showgirls, all depending on the whims of the dancers themselves. Taking on a wide variety of personas, these revamped burlesque acts are not only sexy, but funny, playful, and remarkably innocent as well. Check their web sites at www.velvethammerburlesque.com and www.pussycatdolls.com for upcoming shows.

In a city where less is usually more, the coy flirtation of burlesque is a breath of fresh air. It is not about showing, it's about suggesting, about the thrill of the unknown, about glorifying the female form (all shapes and sizes) rather than exploiting it. Burlesque relies on the refined art of the tease, and it's the sly self-possession of the dancer which will keep you coming back for more. You may not see straight-up T&A at the city's burlesque performances, but you will see beautiful, talented ladies proudly flaunting their sexuality with wit, dash, and whole lot of pizzazz. —JH

Performance | Strip

Viagra FOR Women!
The Hollywood Men

Since the murder/suicide of Chippendales founders Steve Banerjee and Nick Denola in 1987, the fine art of male stripping has been steadily going to the dogs. Where once horny bachelorettes and randy housewives stuffed crumpled dollars down the bulging G-strings of sweaty men at clubs the country over, there are now few reminders of that strange and beautiful side effect of late-twentieth-century feminism.

Los Angeles, home to an overabundance of traditional tittie bars, boasts one (and only one!) strip club catering solely to a straight female clientele. **Hollywood Men**, founded by Chippendales protégé (and *Playgirl*'s 1998 Man of the Year) Scott Layne, has gathered up the hunkiest of hunks for an extended Friday- and Saturday-night residency at Club 7969 in Hollywood. There are a few other bars which host male strip nights on occasion, and you can always hire a professional bodybuilder to arrive at the bachelorette party in a cop uniform, but if it's good old-fashioned Chippendales action you want, Hollywood Men is the place—three of the original Chippendales dancers are even in the Hollywood lineup.

Choosing his crew of burly exhibitionists by looks, personality, stage presence, and dance training, Layne prefers his performers to be of the Harlequin Romance cover-boy type; so expect lots of defined muscle, oiled flesh, and long, flowing locks. Be forewarned: If skinny mod boys in corduroys are more up your alley or you don't like hair whipped in your drink, Layne's show may not be your cup of tea. But everyone is sure to have a good old time amidst the fury of catcalls and rabid objectification. It's not often women get to sexually harass men in front of a paying audience and the feeling of smug satisfaction is well worth the $20 entry/two drink minimum asking price. You go, boy! —JH

Hollywood Men information: (818) 845-6636; www.nicepackage.com. Twice-weekly performances at Club 7969: 7969 Santa Monica Blvd. (between Crescent Heights Blvd. and Fairfax Ave.), Hollywood; show times: Fri at 8:30 p.m. and Sat at 8 p.m. (doors open one hour before show); 18 and over. $15 general admission, preferred seating $20.

Other male strip shows: Mr. J's: 2101 E. Edinger Ave. (off Highway 55), Santa Ana; (714) 667-5000; shows Fri/Sat nights on the second stage. Also check out Nasty Variety at Lil Wonder Bar: 2692 S. La Cienega Blvd. (south of Venice Blvd.), Culver City; (310)837-7443; call for show times.

Other resources: To rent a male stripper, visit www.lahunk.com.

Gotham City

Holy smokes, Batman, tatas dead ahead.

21516 Sherman Way (west of Canoga Ave.), Canoga Park;
(818) 703-0089. Open Daily: noon–2 a.m.

Gotham City is a very low-key and friendly place to have a beer, shoot some pool, and get out of that super-hot SFV sun. If you're out in the Valley and you need a drink and need to see topless girls all at the same time, then by all means check out Gotham City. With good music, a few real pretty girls, and a full bar, what more could anyone really ask for, especially in Canoga Park?

—JAG

Jumbo's Clown Room

LA's premiere clown room.

5153 Hollywood Blvd. (between Western Ave. and Normandie Ave.),
East Hollywood; (323) 666-1187; www.jumbos.com.
Open Daily: 2 p.m.–2 a.m.

Jumbo's is a sad-clown-themed strip club. This may frighten some people. That's understandable. Maybe you don't want porcelain-headed clown dolls staring at you as you stare at the girls. However, Jumbo's is perhaps the friendliest, least-threatening strip club in all of LA. Female-owned and -operated, Jumbo's is sexual democracy in action, employing women of all sizes, colors, ages, and tastes (including, back in the day, a young Courtney Love). Everyone goes to Jumbo's, from down 'n' dirty bikers to shaggy-haired scenesters. There's no screaming DJ pushing lap dances; the girls pick their own music from a juke that has everything from Patsy Cline to Dr. Dre. And the diversity of the acts is astounding, ranging from tantalizing burlesque to whip-cracking S&M—even the occasional fire-eater! All this and there's a full bar with draft beer in frosty cold mugs and no cover. So as long as you can handle the watchful teary eyes of the black-velvet clowns, you'll definitely find someone or something you'll love at Jumbo's.

—Jonathan Miertschin

Performance | Strip

Performance | Strip

Leggs

Leggs, she knows how to use them.

1835 N. Cahuenga Blvd. (north of Hollywood Blvd.), Hollywood;
(323) 461-5344; www.clubleggs.com. Open Daily: noon–2 a.m.

Once a Greek restaurant, this topless club still maintains its "Athenian" theme, so expect lots of white statuary and a few Doric columns tossed here and there to lend that classy touch of antiquity. In between lap dances you can even ponder Plato or theorize on the current state of democracy in an atmosphere reminiscent of a low-rent Parthenon. The former restaurant's kitchen is also still in use, so order up some salmon steak or jalapeño cheese pops and settle back for some real old-world decadence. The girls are sufficiently pretty and the place is spacious and relatively clean. Come on Mondays for Football Night or on the weekend when the place is bustling for the titillatingly titled Klub Klimax. Hail almighty Aphrodite!

—JH

"When I'm good I'm very, **very good**
but when I'm **bad** I'm better."
— MAE WEST

Miss Kitty's

Mildly spiced topless action in the heart of Industry.

13079 E. Valley Blvd. (southeast of the 605 fwy.), City of Industry;
(626) 336-1453; www.misskittystopless.com.
Open Daily: 11 a.m.–2 a.m.

Located in the heart of Industry, the only really good thing about this topless bar is the moniker "Miss Kitty's." It might be better if there were, say, an Old West theme to go along with the name, you know, with sexy cowgirls in fringed buckskin and six-guns a-blastin', a piano player who ducks when a whiskey bottle comes flying his way, cancan lovelies kickin' it up in their petticoats. Instead, you get the standard tittie-bar offerings of half-naked hot gals, which ain't so bad itself.

—JAG

Pleasures

Rock-and-roll and naked ladies!

3570 E. Foothill Blvd. (between N. Rosemead Blvd. and Sierra Madre Villa Ave.), Pasadena, (626) 795-1259. Open Mon–Wed: 4 p.m.–1:45 a.m., Thurs/Fri: 11:30 a.m.–1:45 a.m., Sat/Sun: 7:30 a.m.–1:45 a.m.

As the only strip club in family-values Pasadena, this joint is already in a class of its own. But even if you go there because it's the only place in town, you'll have a good time. There's a main room with a bar where very pretty topless girls strut their stuff, or head for the VIP room if you want the topless action to get a little hotter. Pleasures is one of the only strip clubs to book live bands—and on nights when its rockin' the clientele gets an injection of young twentysomethings showing their love by coming out to support their friends' bands.

—Robhonky

Pussy Cat Club

Strip club 101.

At Club 7969: 7969 Santa Monica Blvd. (west of Fairfax Ave.), West Hollywood; (323) 654-0280. Open Only Tues: 9 p.m.–2 a.m.

A soft-core intro to strip clubs that takes place once a week in West Hollywood's Club 7969, Pussy Cat Club provides a good place to bring your girlfriend or wife or your little bro on his 21st. The crowd is the usual blend of Hollywood hipsters with some minor celebrities thrown in for show. The strippers are on the whole extremely good looking, and if you get tired of watching their bump and grind, you can always stare at the hottie sitting at the next table. Normally a dance club, there's a tiny mobile stage for the girls, and the view is good from all sides. This is the perfect place for popping the strip-club cherry: beautiful girls, a comfortable atmosphere, and low on the sleaze factor.

—JH

"Is sex dirty? Only if it's done right."
— W O O D Y A L L E N

Sam's Hofbrau

Bratwurst and boobies, what more could you want?

1751 E. Olympic Blvd. (west of Alameda Ave.), Downtown
Los Angeles; (213) 623-3989; www.samshofbrau.com. Open Daily:
11 a.m.–2 a.m.

Nestled in the industrial wasteland of the Downtown loft district, Sam's
Hofbrau is a little taste of Munich in the midst of abandoned ware-
houses and defunct railroad tracks.

Inside, its heavy chandeliers and red pleather banquets offer German hos-
pitality and bare breasts in a cozy, old-world atmosphere. Most of Sam's
dancers are sweet and sans silicon, and for those sitting at the lip of the
stage, some spare bills can get you a spectacular view. The more enthusi-
astic the audience, the better the show. If you're the shy type you can play
pool, watch the numerous televisions, or hide in the corner nibbling on
the kitchen's limited selection of German delicacies. Bratwurst anyone?

—JH

"One half of the world cannot understand the pleasures of the other."
— JANE AUSTEN

Star Gardens

Where it's always 1986.

6630 Lankershim Blvd. (north of Victory Blvd.), North Hollywood;
(818) 764-9766. Open Mon–Sat: noon–2 a.m., Sun: 2 p.m.–2 a.m.

Remember that Whitesnake video with the big-haired model gyrating on
the hood of a white Jaguar? With its time machine transmission firmly
stuck in the late '80s Headbangers Ball mode, Star Gardens is a metal-
head/biker paradise. With daytime beer specials like $2 Heinekens from
noon to 4 p.m. and $2 drafts from noon to 7 p.m., it's a cinch to meet
the one drink minimum. And there's never a cover charge. The girls are
surprisingly hot, though mostly of the skinny bleached-blonde white-
girl-in-butt-floss variety. Heavy on the eyeliner and the rock, please.

—Tim Katz

Rules OF THE Lap Dance
Dos & Don'ts from a Private Dancer

Want to get the most out of your lap dance without pissing off your dancer? Follow these simple rules, written by a professional stripper for the discerning customer. Even regulars might learn a thing or two:

• **Tip well before the dance—at least $10 above asking price!** This money will go straight into the dancer's pocket. She won't have to split it with the club. Offer to pay more per dance and you're bound to get a little more.

• **Don't bend her ear unless you plan to buy a dance!** Even if you are going to buy one, please practice economy of speech. Do you hold up the line at the bank by telling the teller all your tales of woe? Save it for your shrink.

• **Sorry, honey, you're not going to rock her world.** Have you ever cum at work? Didn't think so. Always remember, first and foremost, she is at work. For you, going to a strip club may be a social occasion, a way to unwind, whatever, but the dancer is at work, not on a date with you. She may pretend to enjoy it, she may even let herself go a bit, but she will never have an honest-to-God true orgasm. Other thoughts are occupying her mind, such as: *How much longer is this song going to last?*; *Is my tampon string visible?*; or *I hope the bouncer who deals Vicodin is here tonight.*

• **Don't try to kiss her!** C'mon guys. It's selfish and utterly naïve to expect this kind of intimacy. She probably has a husband or a boyfriend (or even a girlfriend) and reserves her kisses for them, not you.

• **Don't try to finger-bang her the second she says it's all right to touch her!** Not all girls allow touching, but those who do for the right price mean EXTERNAL TOUCHING ONLY! If she wanted your finger inside any of her orifices, she would put it there (right after monkeys fly out of her ass).

• **Don't be an idiot and say any of the following, all of which she hears about 30 times an evening . . .** 1) "Not now, maybe later." 2) "Is it all about the money?" 3) "Do you ever get aroused during a dance?" 4) "Do you ever date a customer outside of here?" 5) "I'm making a movie about strip clubs." Her thoughts when you say these things: 1) Wishy-washy asshole, he can't even say "No." 2) Duh, I'm at work. Would you go to work if you didn't get paid? 3) Yeah, I get about as aroused as a gynecologist gets during a pelvic exam. 4) I'll say yes to make him buy a dance. 5) If I only had a nickel for every smarmy auteur who doesn't know jack about what really goes on here but thinks it's cute to exploit my life to lend his stupid film a sense of titillating profundity . . . —Dancer X

Performance | Strip

The Wild Goose

A touch of history in a city that knows no better.

11604 Aviation Blvd. (south of Imperial Hwy.), Inglewood;
(310) 643-9769; www.thewildgoose.com. Open Daily: 11 a.m.–2 a.m.

With lots of dancers, a full bar and food, plus no cover, The Wild Goose is a laid-back spot to grab a quick beer and nachos and catch some tatas by the airport. Open since the 1960s but recently redone, The Goose is a touch of history in a city that knows no better.

—JAG

Time FOR Some One-ON-One
A Handy Glossary of Strip-Club Dances

Lap Dance: The old standby. While you sit enrapt, hands at your sides, a dancer grinds against your groin and caresses your chest while she gives you your own special show. The heat of the dance depends on the girl, the club, and how much of a tipper you are.

Bed Dance: A brand-new invention, this is pretty much the same as above, but the customer is prone, allowing for some serious dry humpin'. In some cases, if you're lucky, the dancer may consent to touching as well. But don't get too fresh!

Couch Dance: The name says it all. This type of dance allows for the most amount of touching of the customer by the dancer, since you're prone and oh so vulnerable.

Private Dance: Immortalized by the great Tina Turner, the private dance is just that. You and a lovely lady all alone in a tight space, usually in a sweaty booth or glorified walk-in closet. Get out the cash boys, cuz these babies are charged on a song-by-song basis.

Shower Dance: First introduced in Los Angeles by Bob's Classy Lady (see p. 20) the shower dance is, that's right, you guessed it, a dance in a shower. In nude clubs things can get real kinky, and if you're at the right dive, you may be able to "point" the water to the spot of choice. And when you reach behind the glass to slap on those dollar-bill tips, just remember, the shower dance is all lookee, no touchee!

—Z Bone

Bare Elegance

Plush burgundy room filled with the most gorgeous young women.

4824 W. Imperial Hwy. (one block east of the 405 fwy.), Inglewood;
(310) 649-1100; www.bareelegance.com. Open Mon–Thurs: 11 a.m.–
2 a.m., Fri/Sat: 11 a.m.–4 a.m., Sun: 6 p.m.–2 a.m.

Deep in the heart of Hawthorne, right near LAX, lies a neon-encrusted
jewel. We call it Bare Elegance, where all-nude beauties dance on tables,
two stages, and luxurious couches for private viewers. The chairs and
carpets are blushed with regal burgundy, the lights are low and colorful-
ly sensuous. Bare Elegance employs some of the most beautiful dancers
in LA, and it's all available for a $10 cover. Parking is valet only, but well
worth it, because at Bare Elegance *you* are the VIP. The girls are flirta-
tious and friendly, and the atmosphere is very comfortable. Table dances
are fun ($20) and private dances are available ($30) when the need for a
bit more intimacy arises. Remember, Monday night is amateur night.
But you can always check the schedule or get free passes on their more
than competent web site.

—Joseph Niccitta & Cris Contreras

Blue Zebra

Where the girl next door takes off her clothes.

6872 Farmdale Ave. (near Vanowen St.), North Hollywood;
(818) 765-7739; www.bluezebracabaret.com. Open Daily: 11 a.m.–
2 a.m.

Difficult to find if you don't know the area, but usually worth the trip. A
mid-level cousin to Spearmint Rhino, the Zebra features semi-plush sur-
roundings and a lighting system which sometimes outperforms the girls.
The dancers go two at a time unless things are slow. Most of the strip-
pers are older than the fare you'll find in Hollywood (late 20s and up),
which means they're well-versed in strutting their stuff. Offering a wide
selection of colors and sizes, silicon or au naturel, the club has something
for virtually any taste. Zebra girls are selected not just for their physical
assets but for their personalities as well. There are some private booths
for lap dances, but don't expect things to get too naughty. If you want a
stripper who looks like a Playmate but acts like the gal next door, this is
the place for you.

—JH

The Magic Kingdom's Naughty Neighbors
Orange County Strip Clubs

When you think of Anaheim, you think of Mickey Mouse, The Haunted Mansion, and good, clean Disney-sponsored family mirth. But wouldn't you know, behind the Mouse mask lies a heart of smut and sex? Of course you did. For a place like Orange County (Southern California's own Republican hotbed of Family Values), Anaheim's got some pretty good strip clubs. After a long day at Disneyland, put the kids to sleep (they're bound to be tuckered out) and then it's boobies galore.

Try these all-nude clubs: **Flamingo Theatre**, **Imperial Theater**, and **Sahara's Theater** (see p. 30). There is no booze, but after a day at the Happiest Place on Earth, some good old-fashioned T&A will perk you right up and get you ready for another round with Mickey and Minnie.

If all-nude is too much for you, try **Fritz That's Too**, a really good top-less club where you can have a drink or three and watch the dancing girls. In nearby Stanton, there are two bikini bars, **Venus** and the aptly named **Fuzzy Bear**.

If strip clubs aren't your idea of adult fun, there are a few squeaky-clean clubs in the just-opened **Downtown Disney**, such as **House of Blues**, **Ralph Brennan's Jazz Kitchen**, the sports-themed **ESPN Zone**, and the Latin-themed dance club, **Y Arriba Y Arriba**. Better yet, what's more fun than just enjoying Disneyland by making out on It's a Small World or sipping a mint julep while watching the fireworks? If you can, try to get into the exclusive **Club 33** (named for the park's 33 original investors)—with memberships starting at $7,500 and annual dues of $2,500, it's the only place in the park you can drink. Good luck and enjoy your trip, you just may get your rocket rods turned on. —JAG

See next page for the Anaheim digits.

"Don't have sex, man.
It leads to kissing and pretty soon you have to start talking to them."
— STEVE MARTIN

The Digits for Anaheim

Club 33 at Disneyland: *33 Royal St., New Orleans Square, Disneyland, Anaheim; just try to get this phone number!*

Downtown Disney hosts ESPN Zone, House of Blues, Ralph Brennan's Jazz Kitchen and Y Arriba Y Arriba: *S. Disneyland Dr. and Magic Way, Anaheim; info line, (714) 300-7800; www.disney.com; no fee to enter.*

Flamingo Theatre: *618 E. Ball Rd. (between Anaheim Blvd. and State College Blvd.), Anaheim; (714) 535-0811.*

Fritz That's Too: *710 E Katella Ave. (just off I-5), Anaheim; (714) 978-1828.*

Fuzzy Bear's: *8595 Katella Ave. (between Magnolia Ave. and Beach Blvd.), Stanton; (714) 826-8595.*

Imperial Theater: *2640 W. Woodland Dr. (just west of Magnolia Ave.), Anaheim; (714) 220-2524.*

Sahara's Theater: *1210 S. State College Blvd., #C (at Ball Rd.), Anaheim; (714) 772-2242.*

Venus: *11572 Beach Blvd. (south of Orangewood Ave.), Stanton; (714) 898-9933.*

The Body Shop

Aromatherapy not available.

8250 W. Sunset Blvd. (west of Crescent Heights Blvd.), Sunset Strip; (323) 656-1401; www.bodyshopclubla.com. Open Mon–Thurs: noon–2 a.m., Fri/Sat: noon–3 a.m., Sun: 5 p.m.–2 a.m.

The parking sucks, but the location, if you like Sunset Strip cruising and celeb ogling, is pretty sublime. You can grab a hot meal and some heavy-metal history down the street at the Rainbow Room, then mosey on over to The Body Shop to get the ol' engine lubed. The girls are fairly attractive, and the amateur night (Mondays) offers enough prize money to seduce some classy ladies into the spotlight. The stage is small so don't expect acrobatics, but the booths are tiny too, which means close-proximity lap dances.

—JH

Performance | Strip

Carolina West Century Lounge

It's that strip club with the great sign near LAX!

5601 W. Century Blvd. (at Aviation Blvd.), right by LAX;
(310) 641-6833. Open Mon–Thurs: 11 a.m.–2 a.m., Fri/Sat: 11 a.m.–
4 a.m., Sun: 6 p.m.–2 a.m.

You've seen the sign a million and a half times on your way to and from LAX. Like a beacon, it guides your lust jet home, baby, home. All big and shiny with that cool 1950s lettering, it's yelling, "Nude, Live Nude, Live NUDES!!!" The Century Lounge is where your crazy uncle would while away the pre- or post-flight hours way back when. Oh, there's also a fully nude dance club with good lap-dance action and an adult toy shop to boot. Once inside, you'll find yourself wishing for a longer flight delay. Let it snow, let it snow, let it snow.

—JAG

> **"Sex on television** can't hurt you
> unless you **fall off."** —ANONYMOUS

Classic Lady of Oz
(formerly known as Bob's Classy Lady)

Dorothy, you ain't in Kansas anymore.

14626 Raymer St. (near Sepulveda Blvd.), Van Nuys; (818) 787-2627;
www.bobsclassylady.com. Open Mon–Thurs: 11 a.m.–2 a.m.,
Fri/Sat: 11 a.m.–4 a.m., Sun: 4 p.m.–2 a.m.

Classic Lady of Oz, formerly known as Bob's Classy Lady: Try to say that name three times fast. A funky title for a funky club. Oz is like a neighborhood bar set in a huge warehouse where they don't serve alcohol and the girls happen to get naked. (For convenience sake, there's a full sports bar right next door, same owner.) The girls are all down-to-earth and vary widely in attractiveness. Drop-dead gorgeous to . . . The private dances are done in very private, curtained booths in the back. It can be mild or wild, depending on whom you pick. There is a remarkable absence of pressure to buy a dance here, and the vibe is very laid-back. Great club to spend a few hours by yourself or with friends.

—Dancer X

Ecstasky

Place Your ✷✷✷✷ in the Upright Position

Performance | Strip

One of the many benefits of being rich and entitled is the happy inclusion of sensual luxury in every experience. Given the right amount of cash, one's life can include fine wines and fine linens, designer clothes and eyewear, and for those with an extreme excess to flaunt, multiple homes, vintage autos and, of course, the prerequisite private plane.

The desire to travel at one's whim sans the company of undesirables has created a strong demand for custom-detailed jets, compact and spiffy little numbers packed with buttery leather, big-screen TVs, and enough room to stretch your legs. While most of us will never experience the luxurious air travel promised to folks like Hef, Elvis, and the President, there is a way to experience flight without the troublesome aspects of uncomfortable seats, packaged peanuts, and that annoying insurance salesman from Iowa City taking up your armrest and waxing poetic on the inherent beauty of fly fishing. Offering charter flights from X to LAX, the appropriately named **Ecstasky Airlines** has come up with a clever alternative for those who might like a little decadence with their in-flight but who can't quite afford the 30 mil for their very own jet.

The company offers a wide selection of tantalizing amenities, including limo service to and from the airport, complimentary champagne, a Sky Spa for in-flight facials, and an "Ecstasky" robe and slippers should you feel like getting into something a little more comfortable. And as if all this weren't enough, Ecstasky places the cherry on top of this already seductive sundae in the form of live, in-flight "exotic entertainment."

Back in the good old days, even ordinary commercial airlines had the good sense to realize that the shorter the stewardesses' skirts the bigger the business, but when those pesky feminists got their fingers in the proverbial pie, the hemlines came down, and the cute hats, the tight tops, and the coy smiles disappeared.

But do not despair. Now, not only can you sip free booze, eat fine food, and arrive to the airport in style, you can also spend those long hours in the air in the pleasant company of large-breasted strippers strutting their stuff for your viewing pleasure. Sure beats *Forrest Gump*! —JH

Information and reservations : (310) 821-4473; www.ecstasky.com.

Club Platinum

High-class nudie bar, deep in the Westside.

11908 Mississippi Ave. (off Bundy Dr.), West Los Angeles;
(310) 479-1500. Open Thurs–Sat: 11 a.m.–4 a.m., Sun: 11 a.m.–
2 a.m., Closed Mon–Wed.

This is one of LA's newest clubs, a "gentlemen's cabaret" which features
a free lunch buffet (daily 11:30 a.m.–3 p.m.) and weekend stage visits
from moonlighting pornstars. Convenient to both the 10 and 405 free-
ways, this is the perfect place to stop over on your lunch break and escape
the corporate day-to-day with a little T&A. At Platinum, you can grab
some chow, gaze at the ladies, indulge yourself in a lap-dance dessert,
then head back over to the daily grind, refreshed and ready to rumble.

—JH

Déjà Vu Showgirls

The McDonald's of strip clubs.

7350 Coldwater Canyon Blvd. (off of Sherman Way),
North Hollywood; (818) 982-1199; www.dejavu.com.
Open Sun–Thu: noon–3 a.m., Fri/Sat: noon–4 a.m.

The Déjà Vu chain of strip clubs is the prime example of the glitzy
Vegas-ification of smut. There's lots of expensive lighting and fog
machines, usually a good overproduced show, and you end up losing a
lot more cash than you'd expect. The girls are usually super-sexy and
have the right moves down to a science. Table, wall, and couch dances
are all available for 20 bucks. Referred to by other dancers as the
"McDonald's of strip clubs," there's a lot to be said for the Déjà Vu ver-
sion of the Big Mac.

—JAG

*Also at 7000 Garden Grove Blvd. (west of Goldenwest St.), Westminster;
(714) 891-1430.*

*5520 Kearny Villa Road (north of Clairemont Mesa Blvd.), San Diego;
(858) 278-5332.*

1331 W. Colton Ave. (west of Tennessee St.), Redlands; (909) 798-6330.

5282 Mission Blvd. (west of Central Ave.), Montclair; (909) 627-9806.

Exotica

A downtrodden tour of the Roman Empire.

15619 E. Valley Blvd. (N. Maypop Ave.), La Puente; (626) 968-4434.
Open Sun–Thurs: 10 a.m.–2 a.m., Fri/Sat: 10 a.m.–3 a.m.

If you're ever lost in the City of Industry and happen to be looking desperately for a fix of fully nude girls getting crazy in a late Roman Empire atmosphere, then Exotica is the right place for you. With a fully stocked bookstore attached to the strip club, Exotica provides the one-stop shop for all your illicit needs. Fairly pretty girls and a hot dog machine (!) only add to the grand excitement. When in Rome . . .

—JAG

> "I went to a **meeting** for
> premature ejaculators. I left **early.**"
> — R E D B U T T O N S

4 Play

4 Play is 4 fun.

2238 Cotner Ave. (just east of the 405 fwy., between Olympic Blvd. and Pico Blvd.), West Los Angeles; (310) 575-0660; www.4playclub.com.
Open Mon–Wed: 11:30 a.m.–2 a.m., Thurs: 11:30 a.m.–3 a.m., Fri: 11:30 a.m.–4 a.m., Sat: 6 p.m.–4 a.m., Sun: 6 p.m.–2 a.m.

A clean, upscale club (there's statuary!) featuring a parade of slender (mostly white) ladies with silicon-enhanced bosoms. The dances are usually one song long and the girls are plentiful—unless you stay awhile, you won't see the same stripper twice. Many of the dancers are making their debut, so this is your place if you like that untainted attitude. Small tables with cloths and candles, waitresses in evening gowns, and free chips and pretzels make for a classy atmosphere. There are two private dance rooms for nude and bikini grinds and an upstairs VIP area with bed dances. The attitude is welcoming and there's little pressure to drink or spend extra money on a private show. All in all a solid offering.

—JH

Frisky Kitty

One cat you won't mind rubbing up against your leg.

18454 Oxnard St. (near Reseda Blvd.), Tarzana; (818) 705-7383.
Open Sun–Thurs: 11 a.m.–2 a.m., Fri–Sat: 11 a.m.–4 a.m.

Deep in the heart of Tarzana lies a kitty with a heart of smut, a Frisky Kitty, where the space is snug and cozy and the lap dances are just right. With easy-on-the-wallet prices and none of that pushy service you find at the bigger clubs, the Kitty is a great addition to the San Fernando Valley's already legendary melting pot of sleaze.

—JAG

Make Out

Scenic Overlooks, Hollywood Hills

What could be more appropriate in auto-centric LA than to drive up into the scenic Hollywood Hills, park at one of the many handy-dandy turnouts and press lips like hormone-addled teenagers! The view is astounding, the air is clear (some nights, at least), and if you've got the right wheels, you may just get lucky! Is that the stick shift I'm sitting on or are you just happy to see me?

—JH

The Gentleman's Club

All the style of a comfortable Swiss train depot, as decorated by Bob Guccione.

5175 San Fernando Rd. (near Broadway), Glendale; (818)-552-3686.
Open Mon–Thurs: noon–2 a.m., Fri/Sat: noon–3 a.m.,
Sun: 7 p.m.–2 a.m.

Nestled at the edge of Glendale, a stone's throw from the railroad tracks and a sling's shot from the Los Angeles Zoo, this place predates the new Getty museum, yet was clearly influenced aesthetically by J. Paul's preference for old Greek and Roman statues. The Club prefers plaster to marble, yet the effect is still very elegant after a tub of margaritas in nearby Burbank or nine shots of whiskey in the neighboring and suddenly hip Atwater Village. It costs you about a ten-spot to get inside, but the view is worth it and you probably won't want to leave, even when you crash from liquor withdrawal. The Gentlemen's Club provides complete

nude adult entertainment, which means you get to look at coochie and drink incredibly expensive water. As for the lap dancing, mixed reports: nothing quite on par with the subtle skills of the Southern states, but still pretty fine by LA standards.

—Bruce Craven

Hollywood Cabaret

Farm girls from Kansas City . . . nude!

6315 Hollywood Blvd. (just west of Vine St.), Hollywood; (323) 465-3208. Open Daily: noon–2 a.m.

Farm girls from Kansas City who hop off the bus at Hollywood and Vine need only walk a few blocks to begin their careers in showbiz at the Hollywood Cabaret. A one-stop shop for all things sleazy, the Cabaret boasts a toy-and-book store, along with a small theater (video porn) and three old-fashioned peep-show booths where you can watch your dancer grind behind glass. The club also has a standard strip show with two stages, runways, and poles. The private VIP lap dances can get nasty, particularly during the day shift. The ladies are young and passably attractive, a lot of them pierced and tattooed, if that's your thang. Perfect for the out-of-work musician looking for a gal to tune his guitar strings!

—JH

Hollywood East

The sixth pit of strip-club Hell.

13217 E. Valley Blvd. (off the 605 fwy.), La Puente; (626) 369-3475. Open Daily: 11 a.m.–2 a.m.

Nasty girls, and I mean nasty in the worst way. The only good thing about Hollywood East is that you get to go and say the words *La Puente* over and over—try and say it just once. It rolls off your tongue. Even if you need some T&A on your way back from Palm Springs or points way east, don't do it. Save your time and spend your hard-earned cash at a more decent club, like say 30 miles west in Downtown Los Angeles, where the streets are paved with gold and girls are always pretty.

—JAG

Road Trip!
Destination: Sin City, Las Vegas

Face it: You like to drink, gamble, and have wild sex and lots of it. Everyone does, and here in Las Vegas, the Sin City cliché rings true. In fact, almost the whole state of Nevada has sin on its mind. Where else but in Nevada, the Silver State, is it legal to drink for free, gamble up a storm, and have cheap tawdry sex with a hooker? Nowhere!

That said, hop on the 15 freeway, or better yet, take a cheap flight (or a pricier but more special flight on Ecstasky, see p. 21), and head on out to Vegas, where all your dreams really can come true. The whole city is designed to help you part with your cash, from the 24-hour gambling with its free drinks to the bling-bling strip clubs, restaurants, and hotels. You'll wanna bring plenty of green. No money, no party.

First off, where to stay. I like the **Paris Resort and Casino**, **The Bellagio**, and, for old-school Rat Pack–style comfort, **Caesars Palace**. All of these hotels are right in the heart of The Strip and offer prime gambling, dining, and people watching. Off The Strip, there's the **Hard Rock Hotel & Casino**, filled with lovely nublies from all over the globe—it's the place to meet hot young things, and the swimming pool rocks! Also, the Hard Rock has a few clubs to choose from, so you'll never be at a loss for things (or people) to do. Other good clubs in this desert paradise are **Club Rio at the Rio**, **Studio 54 at the MGM Grand**, and **RA at the Luxor**. All of the clubs in Vegas have a high cheese-to-fun ratio, and that's a good bet. Call for cover charges and if you gamble at any of these places, ask the pit boss for a comp—it never hurts to ask, but don't be a shlub, you have to play more than the nickel slots to get something for nothing here.

Now, don't go thinking I forgot about the naked dancing girls. Strippers here in Vegas are a sight to behold, and they'll have you yelling sweet Jeebes faster than you can empty your pockets into a slot machine. A few good ones are the **Can Can Room**, **Little Darlings**, **Palomino Club**, and (my favorite strip-club name) **Tally Ho Club**. In the great state of Nevada, as in California, "all nude" means no booze. So head on out to Vegas. Your trip here can be tame or wildly uninhibited, it all depends on who you go with. Remember, in Vegas, as in life, the more the merrier. Good luck and tell 'em I sent you.

—Jon "Big Money" Guzik

See next page for the Vegas digits.

The Digits for Las Vegas

The Bellagio: 3600 Las Vegas Blvd. South (at New York Blvd.), Las Vegas; (702) 693-7111.

Caesars Palace: 3570 Las Vegas Blvd. South, Las Vegas; (800) 634-6661.

Can Can Room: 3155 Industrial Rd., Las Vegas; (702) 737-1161.

Club Rio at the Rio: 3700 W. Flamingo Ave., Las Vegas; (702) 364-9192.

Hard Rock Hotel & Casino: 4455 Paradise Rd., Las Vegas; (800) HRD-ROCK; www.hardrock.com.

Little Darlings: 1514 Western Ave., Las Vegas; (702) 366-1633.

Palomino Club: 1848 N. Las Vegas Blvd. South, Las Vegas; (702) 642-2984.

Paris Resort and Casino: 3655 Las Vegas Blvd. South, Las Vegas; (702) 946-7000

RA at the Luxor: 3900 Las Vegas Blvd. South (at E. Reno Ave.), Las Vegas; (888) 777-0188.

Studio 54 at the MGM Grand: 3799 Las Vegas Blvd. South (north of Tropicana Blvd.), Las Vegas; (702) 891-7777.

Tally Ho Club: 2580 S. Highland Dr. (north of Sutter Ave.), Las Vegas; (702) 792-9330.

The Jet Strip

Nasty, nasty, nasty!

10624 Hawthorne Blvd. (between W. Century Blvd. and Lennox Blvd.), Lennox; (310) 671-1100 (recording), (310) 671-3073 (live person); www.jetstrip.com. Open Mon–Thurs: 11 a.m.–2 a.m., Fri–Sat: 11 a.m.–4 a.m., Sun: 4 p.m.–1 a.m.

Sleazy, nasty, and fairly cheap, what more could you want from an airport strip club? Well, there are sexy girls too. Owned by the Bare Elegance folks, The Jet Strip is a little more, er, um, in your face than its upscale sister club, though the girls are just as purty, if not more so! Long hours, a huge menu, and hands-on fully clothed lap dances only add to the excitement. Check it out: very cozy and very sexy. And don't forget that fried foods and naked girls make an awesome combo plate, aw yeah!

—JAG

Performance | Strip

Paradise Showgirls

The seventh pit of strip-club Hell.

14310 Valley Blvd. (at N. Tonopah Ave.), La Puente; (626) 336-1622; www.sahara2000.com. Open Sun–Wed: 11 a.m.–2 a.m., Thurs–Sat: 11 a.m.–4 a.m.

What is it with La Puente and bad strip clubs? Don't folks in the way-deep 626 need some good smut too? Smut without the hassle of driving to San Berdoo or all way into Downtown Los Angeles? Can't someone give the people what they want? Don't waste your time with Paradise Showgirls, all you'll get is bilked out of a c-note and a bad taste in your mouth. Is that what you really want? Give us more. Sleazeballs of the world, unite!

—JAG

Paris House

Ooh la la!

7527 Santa Monica Blvd. (between Fairfax Ave. and La Brea Ave.), West Hollywood; (323) 876-0033. Open Daily: noon–10 p.m.

Not an actual "strip club" in the traditional "American" sense, but rather a corral of scantily clad women in a red-velvet waiting room where patrons get to hand-pick a lucky lady for a one-on-one dance in one of the many small dark private rooms that line the hallways. The club refers to its ladies as "models," but what exactly they strut down the runway is up to you. This type of club is popular in Germany and France, which makes the Paris House experience a unique one.

—Tim Katz

"I think people should be **free** to engage in any **sexual practices** they choose; they should draw the line at **goats** though." – ELTON JOHN

Playpen

All you can eat . . .

1109 S. Santa Fe Ave. (2 blocks north of the 10 fwy.), Downtown Los Angeles; (213) 489-2000; http://theplaypen.mircronpcweb.com/ Open Mon–Fri: 11 a.m.–2 a.m., Sat/Sun: 11 a.m.–4 a.m.

Not much to write home about, but it is close to the downtown hotels and Staples Center and the girls are fully nude. Yipes! Check out the amateur contest held every second Thursday; with its big prizes (first place $1,000, second place $500)—the talent is usually of a high caliber. Also, the specials here rock: an all-you-can-eat buffet every day from 11:30 a.m. to 2 p.m. except Saturdays, Sunday barbecues from 4 p.m. to 7 p.m., and free pizza on Mondays from 4 p.m. to 7 p.m.—making this Playpen a place to get your grub on too. Also, every Tuesday you get a free T-shirt with a lap dance, and every day has the hourly three-for-one lap dance. Weekdays there's no cover charge and a two-drink minimum, and weekends there's a $10 cover charge with a two drink minimum. Get your grind on!

—JAG

"How **many husbands** have I had—
you mean, apart from **my own?**"

– Z S A Z S A G A B O R

Rio

Low-budget smut close to Downtown.

13124 S. Figueroa St. (south of W. El Segundo Blvd.), South Central Los Angeles; (310) 523-3266. Open Mon–Thurs: 11 a.m.–2 a.m., Fri/Sat: 11 a.m.–4 a.m., Sun: 7 p.m.–2 a.m.

Kind of out of the way, unless you're motoring to Gardena, the Rio is a new kid on the block, opened at the tail end of 2000. A couple of pretty girls and decent prices make it a good, not great, place to hang. Put it this way, if your car breaks down off the 110, you could find a worse place to wait for Triple-A.

—JAG

Performance | Strip

Performance | Strip

Sahara's Theater

Suburban smut.

16025 Gale Ave., #A11 (west of Hacienda Blvd.), Hacienda Heights;
(626) 333-1982. Open Daily: 11 a.m.–2 a.m.

A small chain of strip clubs, the bulk of them housed in suburban strip malls, the Sahara's offer all the usual tittie-bar pleasures in somewhat clean and comfortable surroundings. The girls are average or a lil' bit above and the drinks are moderately priced, although the pressure's on to keep your glass full. If you're living on the cheap, you may want to make sure to sip that Dr Pepper as slow as humanly possible. The clubs offer standard lap dances and relatively steamy couch dances as well. In general, if you're looking for middle-of-the-road adult entertainment with no surprises, Sahara's is the place for you.

—JH

*Also at 1210 S. State College Blvd. (south of E. Ball Rd.), Anaheim;
(714) 772-2242.*

Seventh Veil

Aladdin's naughty sisters were here.

7180 W. Sunset Blvd. (west of La Brea Ave.), Hollywood;
(323) 876-4761. Open Daily: noon–3 a.m.

The cheesy faux-Arabian Nights décor adorning this Sunset Boulevard building is not promising, but The Seventh Veil isn't all that bad inside. You sit at the stage—literally a small ledge in front of you—holding your drinks. Customers plop their dollars on the rail that tops the ledge and knock them off down onto the stage floor a foot or so below. This makes for an amusing practical joke—simply brush or blow your friend's singles onto the stage as a dancer is grinding in his face, ensuring a lengthy and unwanted show of "affection." The girls range from conventionally attractive (long-haired and long-legged) to not so purty, and their specialty seems to be "the propeller," whereby they whip their long tresses around to brush against your crotch. Unfortunately, they have a smidgen of diva attitude; you may get screamed at for, say, not tipping an ugly stripper and then daring to look at her ("If you're not going to pay, look in the mirror!").

—Josh Levitan

I Only Read It FOR THE Articles
A Playboy *Reader Parties at the Mansion*

I'm not afraid to say that I owe whatever sexual prowess I have to my Italian grandfather. Or, more precisely, to my grandfather's stash of *Playboy* magazines. Every family's got its secrets, and in Minnesota, which lacks the drama of missing interns or murdered superstars, we had Grampa's little basement bookcase.

Playboy was my sexual primer, a place to experience things I was truly awful at pursuing in adolescence. My brothers and I used to tie a pillowcase to a rope and haul the contraband issues up a laundry chute, and I'd study each as though it were a missing volume of the *Encyclopedia Femalia*. The jokes. The advice. God help me, even the articles. It wasn't a perfect pedagogical setup, of course. There was the awkwardness of not knowing how to use, in speech, all the kinky words I learned in print (and you thought it was embarrassing when someone mispronounced *facade.*) But it was a jumping-off point into understanding and confidence. About women, somewhat. But more about those new buzzing, whirring, confusing feelings inside of me.

And then, not so long ago, I realized a voyage (for some of us), akin to a pilgrimage to Mecca. I hit a party at the **Playboy Mansion**. It wasn't quite the stuff of Valhalla, but it was definitely in the same congressional district. Man-made waterfalls with mattresses lining the rocks. Rooms with padded floors. Two-story monkey cages. And, most noticeably, packs of slavering guys chasing indifferent women with asses of airbrushed perfection. And I felt, once again, like that squeaky little seventh grader trying to kiss without cutting his tongue on his braces.

Irony is, the lessons of *Playboy* magazine are useless here. The centerfolds don't care if you like puppies or piña coladas, don't care if you can rattle through their published turn-ons like a checklist. They're Playmates, those avatars of the mythical proportions, and as such do not abide by the normal laws of human attraction. What do they want from a man? Well, a big house with monkey cages seems to go over pretty nice. Beyond that, I have no idea. But *Playboy* really isn't about how to snare the Bunny of legend. It's about appreciating the cuddly, furry, adorable creature inside of every woman. And that you'd better learn what it likes, or you're liable to get bit.

—John Baldrica

Want to attend one of Hef's parties yourself? Get a good agent, a good headshot, and find some good luck. Of course, it helps if you wear bunny ears . . .

Performance | Strip

Spearmint Rhino

Feel the horn!

2020 E. Olympic Blvd. (near the 10 fwy.), Downtown Los Angeles;
(213) 629-9213; www.SpearmintRhino.com. Open Mon–Fri: 11 a.m.–
2 a.m., Sat/Sun: 11 a.m.–4 a.m.

This is the mother of all strip bars, an über-chain of upscale gentleman's
clubs which boasts outlets all over the West Coast, the U.K., and even the
former Soviet Union. Californians have the rare pleasure of benefiting
from the LA franchise's close proximity to porn-industry headquarters,
and on any given night you might spot your favorite adult star returning
to her exotic-dancing roots. The décor of each club is kept relatively uni-
form, a sort of bastardized version of an upper-class British men's club,
complete with fireplace, dark wood, ambient lighting, and plush seating.
You may not find Cantabridgians talking Parliament politics and smok-
ing Cuban cigars, but you will find an onslaught of female flesh. Overall,
the girls are high-quality lovelies to match the steep cover charge and the
luxury décor.

—JH

*Also at 15004 Oxnard St. (east of Sepulveda Blvd.), Van Nuys;
(818) 994-6453.*

*15411 Valley Blvd. (west of N. Hacienda Blvd.), City of Industry;
(626) 336-6892.*

573 N. Central Ave. (north of Arrow Hwy.), Upland; (909) 946-5378.

312 S. Riverside Ave. (north of Merrill Ave.), Rialto; (909) 873-2257.

630 Maulhardt Ave. (west of N. Rice Ave.), Oxnard; (805) 988-6518.

"I chased a girl for **two years**
only to discover that her tastes
were exactly **like mine:**
We were both crazy about **girls.**"
— GROUCHO MARX

Star Strip

Infamous upscale strip club with foxy A-list dancers.

365 N. La Cienega Blvd. (at Beverly Blvd.), West Hollywood;
(310) 652-1741. Open Mon–Thurs: noon–3 a.m., Fri/Sat: noon–
4 a.m., Sun: 7 p.m.–3 a.m.

If you visit this La Cienega über-club on a Friday, you're likely to find the
place packed with Hollywood hipsters, mainly couples, with the occa-
sional group of horny bikers thrown in for good measure. There are two
stages and the dancers are the usual mix, skinny girls with obvious boob
jobs who will be doing porno soon (if they're not already), a few cuties
who are probably legit actresses paying the rent, and one blonde that
rivals most supermodels. There's a pool table in the back if you get bored
of the dancing. It's always fun—and somewhat unique in LA anyway—
to break racks with a bikini-clad stripper.

—Josh Levitan

"Sex is like **air**...not important
 until you're not **getting** any."
— D E B B I E R E Y N O L D S

Star Strip Two

Nude girls in the heart of Silver Lake.

2470 Fletcher Dr. (near Riverside Dr.), Silver Lake; (323) 644-1122.
Open Sun–Thurs: 11 a..m.–2 a.m., Fri–Sat: 11 a.m.–3 a.m.

Off the 5 freeway, close to Dodger Stadium, Glendale, and Downtown,
Star Strip Two is right in the middle of everything Eastside. Not to men-
tion the fact that it's the only strip club in all of Silver Lake, which means
that if you're a neighborhood hipster with a jones for a naked girl, relief
is only moments away. Stop off at the am/pm for a corn dog, large Coke,
and some chewing tobacco to get into the white-trash spirit of the club.
Bon appétit!

—JAG

Performance | Strip

Tropical Lei

Better than a trip to the Big Island.

2121 W. Foothill Blvd. (off Monte Vista Ave.), Upland;
(909) 985-1575; www.tropicallei.com. Open Mon–Thurs: 11 a.m.–
2 a.m., Fri/Sat: 11 a.m.–3 a.m., Sun: 3 p.m.–2 a.m.

Deep in the heart of Upland lies the Polynesian Island adventure of the
Tropical Lei strip club. While not really all that island-themed, the
Tropical Lei is still a pretty good all-nude club right across the county
line in San Berdoo. With a variety of dances all at different price
points—bikini ($12), topless ($20), or nude ($40)—this place has all
your bases covered. Also, don't forget to check out the aptly named T&A
bookstore attached to the club. Aloha!

—JAG

"No one will **ever win** the battle
of the sexes; there's too much
fraternizing with the enemy."
— H E N R Y K I S S I N G E R

Valley Ball
(Formerly Oddball Cabaret)

Heshers that rock and the strippers who love them.

8532 Sepulveda Blvd. (near Roscoe Blvd.), North Hills; (818) 893-3392;
www.valleyball.com. Open Mon–Thurs: 11 a.m.–2 a.m.,
Fri/Sat: 11 a.m.–4 a.m., Sun: 6 p.m.–2 a.m.

In the halcyon days of the 1980s, when metal ruled the world, the
Valley Ball was the sight of many a music-video shoot and heavy-metal
Country Club after-parties. Now, all that's left are the faded memories of
those grand times. Well, that and the Valley Ball. Here, the dancers are
still naked, still foxy, and still love those boys who rock. Check it out and
rock on in style!

—JAG

Performance | Strip

Venus Faire Showgirls

Sexy peep show in NoHo! Open 24 hours!

6452 Lankershim Blvd. (at Victory Blvd.), North Hollywood;
(818) 763-0566; www.venusfaire.com. Open 24/7.

If you're a sex-obsessed megalomaniac with a penchant for great stage directions (and really, who isn't?), Venus Faire is just the peep show place for you. A glassed-off wall is the only thing keeping you and these sexy girls apart. A throwback to the olden days of sex, pick up the phone and tell the gals just what to do. Move a little to the left, oh yeah, bend over, and just like that, you are the auteur you always wanted to be. Don't forget to ask for the Double Time special where the shows become 11 fun-filled minutes to live out your fantasy just a little longer.

—JAG

The Blacklite Cocktail Room

Trannies 'n' porn! Pornies 'n' tran!

1159 N. Western Ave. (near Lexington Ave.), Hollywood;
(323) 469-0211. Open Daily: 10 a.m.–2 a.m.

The Blacklite Cocktail Room offers a great mini-paradigm of the transforming future world of ethnic and sexual identity. What was once a "black and white" hipster bar in the '70s has evolved, as LA has evolved, into a Latino-influenced chocolately mix complete with the ultimate party favor—gorgeous drag queens in Lucite high heels. The future isn't about simple binaries and neither is The Blacklite. With a decent jukebox, creative moonscape/garbage-bag decor, stiff drinks, and the allure of what might be going on "upstairs," the Blacklite is the perfect place to unwind as well as the safest bet to hit for liquor as the clock nears 2 a.m. The Blacklite is conveniently located a hop, skip, and a jump from Stan's on Western (see p. xxx) if the exciting mixed-race and -gender future world has got you all riled up.

—Nancy Pearce

"**Ménage à trois** is a French term.
It means **Kodak** moment." – G R E G R A Y

I Was A Dime-a-Dance Dame

Notes From an Erstwhile Taxi Dancer

In the summer of '98, I shelled out $50 for a Chrissy Snow wig, threw on a cocktail dress, fastened my four-inch strappy sandals, and hotfooted it downtown to 12th and Figueroa. A friend had tipped me off to the phenomenon of taxi dancing—good money and sugar daddies galore, she assured me. Debuting in Prohibition-era Chicago, taxi dance halls—where lonely or curious men secreted away to pay by the minute for a dance with a willing woman—gained rapid popularity and set up shop in Downtown LA in the early '40s. So, one June dusk I warily parked my car on one of Downtown's dingier blocks and even more warily climbed the stairs of a sinewy, decades-old warehouse to the second-floor location of **Club Flamingo**, steeped in the local lore with far more rustic charm than it warranted. I was hired.

My first night, the place looked like a prostitution ring on a bad cop show. The girls on the viewing couch behind a brass rail that separates the clients from the hostesses, and *gauchos*, older gringos, and middle-aged brothas around tables, drinking Cokes, laughing, then slowly making their selections. Each girl eyes her client, punches her time card, and takes the arm of her latest dance whom she accompanies to the dark dance floor—or the even darker corner where the grinders guide their men to optimize their tip potential. Between dances girls and their customers sit nearby or watch television and sip sodas, occasionally fielding propositions from customers flashing hundreds. In the end I didn't have what it takes to taxi dance with the best of them. I felt like I fell into Holden Caufield's classification of a phony, so my career as a taxi dancer lasted a whole week-and-a-half. Maybe I should have given a life as a cabbie a shot.

—Molly Mormon

Most taxi-dancing clubs are Downtown, where SRO hotels and strip clubs continue to evade the mini-malling of the city. Here are some to check out next time you feel like dancing on the clock.

Club Fantasy: 307 W. Fourth St. (between S. Hill St. and S. Broadway), Downtown Los Angeles; (213) 620-9572.

Club Flamingo: 624 W. 12th St. (between S. Flower St. and S. Hope St.), Downtown Los Angeles; (213) 748-2512.

Club Paradise: 1124 S. Los Angeles St. (between W. 11th St. and W. 12th St.), Downtown Los Angeles; (213) 746-6093.

Club Starlight: 222 S. Broadway (between W. Second St. and W. Third St.), Downtown Los Angeles; (213) 747-7653.

Club Makeup

All in the grand tradition of glam rock.

At the El Rey Theater, 5515 Wilshire Blvd. (between La Brea Ave. and Fairfax Ave.), Mid-Wilshire; (323) 936-6400; www.clubmakeup.net. Open the first Sat of every month: 9 p.m.–2 a.m.; $20 cover; cash only.

Über-promoters Joseph Brooks and Jason Lavitt present this super-sexy, ultra-glam, gender-bending evening. Homos and heteros, pre- and post-ops, femme fatales and fag hags arrive in droves, filling the El Rey theater with a damn near lethal dose of sexual energy. The evening's climax, a live midnight show featuring drag queens and performance artists, never fails to shock and amaze the most jaded of clubgoers. Someone for everyone—if you don't hook up at Makeup, you're doing something horribly, horribly wrong.

—Todd Philips

Dragstrip 66

Get your kicks at Dragstrip 66.

At Rudolpho's of Silverlake: 2500 Riverside Dr. (at Fletcher Dr.), Silver Lake; (323) 969-2596; www.dragstrip66.com. Open the second Sat of the month: 9 p.m.–4 a.m.; $15 cover; cash only.

A Silver Lake institution since way back in '93, this once-a-month happening is a must-see for anyone with a fondness for punk rock and men in lady's lingerie. Patrons are encouraged to dress to the nines (check web site for this month's theme) and join in the fun. So throw on your wig, strap on your falsies, and go pogo to Sid Vicious in your mama's stilettos. MC Gina Lotriman whoops up the crowd with her comic onstage antics while the rock-and-roll blasts. And if the resulting chaos in the "showroom" makes you swoon, head out to the patio to share a smoke with Drew Barrymore, Marilyn Manson, or Warhol superstar Holly Woodlawn, all of whom have been glimpsed taking in the 66 sights. A pansexual wonderland, Dragstrip opens its arms to anyone willing to ham for the crowd, regardless of gender or orientation. Go right ahead honey, rev those engines!

—JH

Le Bar

Sexy Latino boys in hot hot pants.

2375 Glendale Blvd. (south of Silver Lake Blvd.), Silver Lake;
(323) 660-7595. Open Daily: 6 p.m.–2 a.m.

If Latino boys in hot pants are your fancy but Selena stole your heart, then cross on over to Le Bar, Silver Lake's popular alternative oasis. You'll know you've gone too far if you don't see a huddle of hungry young to middle-aged men outside anxious to get their swerve on (with you . . . or the live entertainment). Once through the double doors you'll be transported to a fantasyland decked out in Christmas lights galore, reflective tinfoil, disco balls, and a stage show featuring drag queens and go-go dancers not to be missed. Be sure to pack your wallet with plenty of singles because the libations are cheap and so are the dancers. So pull up a seat and enjoy the show. At the end of the night you won't know which is tangier: the lime in your drink or the she-male on your lap.

—Coner Brook

Also check out Le Bar's little brother, Le Barcito: 3909 W. Sunset Blvd., Silver Lake; (323) 644-3515.

Plaza

What the world would look like if divas ruled.

739 N. La Brea Ave. (just north of Melrose Ave.), Melrose;
(323) 939-0703. Open Daily: 6 p.m.–2 a.m.; $5 cover; cash only.

With only a $5 cover charge and drag shows at 10:15 p.m. and midnight, seven nights a week, Plaza fills all your sexy-Mexican-trannie needs and then some. Filled with swinging rancheros, drag-queen dolls, and a good mix of straights and gays, Plaza is the south-of-the-border experience of a lifetime. The gals, a mix of Shakira clones, Imelda Marcos look-alikes, and voluptuous Vargas types, shimmy and shake and get the crowd all riled up, lip synching to their favorite Latino tunes. So get your ass on down to Plaza, pop a Corona, and buy that lady a rose. And, as an added bonus, Pink's Hot Dogs is within stumbling distance. What's not to love?

—JAG

Pink Corvette Dreams
LA's Own Angelyne!

LA's premiere public exhibitionist, **Angleyne** offers up her over-developed mammaries and blow-up-doll kisser on billboards. And thank God for that. Even a traffic jam becomes tolerable under the shade of Angelyne's double Ds and when stuck at an interminable red light, we have her to thank for the titillating view.

A model and artist who paints strangely appealing Keane-esque portraits of herself (check local listings for gallery shows), Angleyne is also the typical Los Angeles enigma. While rumor has it she was once a singer, she is now simply "Angelyne," and that, it seems, is enough.

Stretching her Warholian 15 seconds into more like 15 decades, Angelyne has made a career out of being one very special thing: famous. In the process she has managed to prove that to warrant adoration, it is not necessary to do anything other than bombard a hungry public with a provocative image. How Angelyne subsidizes what must be millions of dollars' worth of advertising remains unanswered—perhaps she's the secret heir to a billboard dynasty. In a city rife with mysterious eccentrics, her meticulously constructed persona gives no indication as to who the hell she really is or what the hell she really does—only that she is blonde, amply endowed, and drives a pink Corvette (hang around the Sunset Strip a few times a week and you're bound to see her). But then again, her real name, real age, real tits matter little in a town that makes its bread-and-butter on the manufacture of make-believe.

All that does matter is this: Angelyne is a star savvy enough to transform herself into a public peepshow…and we're just smart enough to love her for it. —JH

Performance | Strip

"**Sex:** The thing that takes up the least **amount of time** and causes the most amount of **trouble.**"

— J O H N B A R R Y M O R E

Queen Mary

The Queen Mother of drag bars.

12449 Ventura Blvd. (three blocks west of Laurel Canyon Blvd.), Studio City; (818) 506-5619. Open Wed–Sun: 5 p.m.–2 a.m., closed Mon/Tues; admission $7/show plus two-drink minimum; cash only.

For almost 40 years, the Queen Mary has been roping them in. Back when camp was just a summertime activity, the Queen Mary embraced the grand tradition of gay cabaret to become a beloved Valley institution. The shows, a bawdy mix of female impersonators, drag comediennes, and male strippers, offer something for everyone. On Wednesday and Thursday nights there's a dance club and karaoke. Stage shows are reserved for Friday through Sunday with two shows on Fridays and Saturdays. Reservations are required for the shows, so call early. The crowd is open and ready to set sail. Ships ahoy!

—JAG

"It's **not true** that I had nothing on.
I had the **radio** on." — MARILYN MONROE

Silverlake Lounge

Mexican trannies in hipster central.

2906 W. Sunset Blvd. (off Silver Lake Blvd.), Silver Lake; (323) 663-9636. Open Fri–Sun: 3 p.m.–2 a.m., closed Mon–Thurs; no cover Sun; cash only.

During the week, the Silverlake Lounge plays host to the outré indie-rock club The Fold, but on the weekends, all bets are off when the Lounge turns into the best gay ranchero bar north of Mexicali Way. With drag shows at 11:30 p.m. on Friday and Saturday nights and two (!) shows on Sundays (at 9 p.m. and 11:30 p.m.), a full bar, and a free-to-almost-free cover charge, this is the place to get your Eastside drag jones on. Get there early for a café con leche and a guava empanada at Café Tropical next door, a doubleheader not to be missed.

—JAG

Tempo

The glitz of Vegas meets working-class Latin LA.

5520 Santa Monica Blvd., #106 (at N. Western Ave.), Hollywood;
(323) 466-1094. Open Mon–Wed: 9 p.m.–2 a.m., Thurs: 9 p.m.–3 a.m.,
Fri/Sat: 7 p.m.–3 a.m., Sun: 2 p.m.–2 a.m.; $6 cover; cash only.

Your favorite Telemundo soap stars, in person! Not really, but the she-
males who take the stage in this East Hollywood mini-mall hovel cer-
tainly have mastered the look: hair, makeup, and skin all with that sig-
nature orange cast. And most of the musical numbers they (question-
ably) lip-synch to are in Spanish, which summon tender emotions in
even the burliest of its gaucho clientele. At Tempo you can enjoy a dense
crowd of mustachioed, Stetson-sporting rancheros molesting one anoth-
er lasciviously, while prima donnas belt out tearjerkers and graciously
receive dollar bills in their Miracle Bras and skirt waists. A commercial
break from the melodrama is a Ricky Martin–esque lip-syncher, shaking
his bonbon to sustain the testosterone factor. The real star of the show is
the Cher impersonator, whose rousing rendition of "Believe" was as
apropos in this Latin quarter as in WeHo, despite her *muy* faux pas '80s
glitter wig. Shows nightly at 10:30 p.m. and midnight.

—Heather Marcroft

Make Out
Griffith Park

The biggest city park in the country (take that Manhattan!), Griffith
Park has miles of trails on which to hike, bike, or swap the spit with your
better half. Gay cruising areas can be found by the telltale lingering males,
secluded picnic spots are perfect for heavy petting, and on any given
evening at the park's famous Observatory (though probably under con-
struction as you read this) you'll find hundreds of hormone-addled ado-
lescents too busy ramming tongues to bother with the spectacular view.
—JH

*Griffith Park: 4730 Crystal Springs Dr. (off the I-5 and the 134 fwy.),
Los Feliz; (213) 485-5501 or (323) 913 4688;
www.cityofla.org/RAP/grifmet/griffith.htm.*

*The Griffith Observatory: 2800 Observatory Rd. (at the top of the park),
Los Feliz; (323) 664-1191; www.GriffithObs.org.*

Contents

CONSPICUOUS CUMSUMPTION
Shopping

Los Angeles, as you may know, is all about appearances:
The car you drive, the person you date, the clothes you wear, and the products you buy are all part of a shorthand that folks here use to decipher and deconstruct a person before even saying a single word to them. So if you shop, make sure you get the best. The best! And one thing Los Angeles loves to do—besides jumping to conclusions about people—is shop, shop, shop. Just go to the Beverly Center (or hell, The Pleasure Chest!) on any weekend and try to find a damn parking spot.

Los Angeles, besides being the world's capital of conspicuous consumption, is also the porn and sex capital of the world, god bless. And these are, to paraphrase, two great tastes that taste great together. There are stores here in Los Angeles to tickle everyone's fancy, from latex bondage gear to custom-made clothing for strippers, from leather sex harnesses to expensive handmade Italian underwear, and much, much more.

So if you can't find that sexually-related paraphernalia you are searching for here, it probably doesn't exist…anywhere.

In the Shopping chapter, we explore the best of sex (and sexy) shops. We want to help you find that dirty movie, those chrome leg spreaders, or even the men's G-string of your dreams. We want you to be happy and satiated, damn it. Good luck and bring plenty of cash—you wouldn't want some of these spots showing up on your credit card bill, now would you?

Shopping

Ecstasy

The all-natural missing kink.

7217 Melrose Ave. (west of La Brea Ave.), Melrose; (323) 857-5300;
www.ecstasymelrose.com. Open Mon–Sat: 11 a.m.–9 p.m.,
Sun: noon–7 p.m.

This shop on Melrose provides a wide variety of "natural" pills and
potions to up the ante on your pleasure and that of your partner.
Looking to sprinkle a little spice on your sex life? Ecstasy provides safe
and legal herbal enhancements to spike those love chakras. Stacks of
origami pill containers and walls of Kama Sutra guides, aromatherapy,
and erotic body oils should have your own explosions framed in fractals
and dripping with natural Gia juice.

—Aaron Reardon

"If it is the **dirty element** that gives
pleasure to the act of **lust,**
then the dirtier it is, the more
pleasurable it is bound to be."
— M A R Q U I S D E S A D E

Hollywood Gift & Discount

Tons o' crap meets kinky treats.

6566 Hollywood Blvd. (between Cahuenga Blvd. and Highland Ave.),
Hollywood; (323) 464-2774. Open Daily: 11 a.m.–6 p.m.

This is one of the many cheesy T-shirt and tchotchke shops which litter
the boulevard of broken dreams. In addition to the usual "I Love LA"
commuter mugs and "My grandma went to Hollywood and all I got was
this lousy T-shirt" offerings, this small store also provides a limited selec-
tion of lingerie, a few dusty dildos, and an overload of low-class gag gifts
like pecker party candles, key-chain porn projectors, anatomically cor-
rect Oscar statuettes, and a fully f***able plastic pig. If you get a kick out
of pasta shaped like titties, then this your kind of party.

—JH

TOY/NOVELTY

Hello, Dolly!
The Realdoll Comes to Life

Nestled in the strawberry fields just north of San Diego in an unassuming brick warehouse, Matt McMullen's **Abyss Creations**, home of the **Realdoll**, plays host to the truly surreal. Disembodied hands lie in a neat line atop a wooden table surrounded by a smattering of multicolored eyeballs. Headless, handless, and footless torsos swing gently from iron meat hooks. A pile of human hair spills over the top of a battered cardboard box. These macabre scraps are waiting to be transformed, through McMullen's capable hands, into the most hauntingly realistic, meticulously detailed, outrageously expensive ($6,000 a pop) sex dolls in the world. A few short years ago the former makeup and special-effects artist decided, Frankenstein-style, to build himself a faux woman as an "art project." Using only the highest grade silicon, McMullen labored over his creation, attempting to make it as close to lifelike as possible. The end result, a strikingly realistic (although not yet anatomically correct) female facsimile, was photographed for McMullen's web site and shown at a few local galleries.

And that was that, until the young artist received an e-mail offering him a pretty penny if he could create yet another doll, this time a woman with working "parts." From this initial request a fully evolved company was born, with most of Matt's family (mom, dad, and sister-in-law) working around the clock to keep up with the ever-growing number of Realdoll customers.

The luxury sex toys now come in a variety of shapes and sizes, and prospective lovers are allowed to choose everything from the doll's ethnicity to its hair color to its weight and height. Dreaming of an Asian gal with large breasts and blue eyes? You've got it! Jonesing for a brunette with a big ass and a blank stare? Just ask, fork over the cash, and ye shall receive! Looking for something more masculine? Take heart, the Male Realdoll is here! While the current Realdolls feature undeniable authenticity and an inexhaustible willingness to pleasure, they remain regrettably unable to fulfill all of the functions of a "real" woman. With this is mind, McMullen admits to experimenting with various motors and electronic inner workings. "I think it would be cool if they could walk and talk," says the sex toy's creator, a far away look in his eyes, "or get up afterwards and make me a sandwich." —JH

Realdoll available from Abyss Creations: 850 Armorlite Dr., San Marcos (near San Diego); (760) 471-8418; www.realdoll.com. Appointment only.

Shopping

Interview With Hugh
Hef Reveals His Roots

LA has the unique honor of being home to not merely one but two of the reigning kings of periodical pornography. Larry Flynt's *Hustler* has its home base in a towering boat-shaped high-rise on Wilshire Boulevard, and long time girlie-mag godfather Hugh Hefner has made our fair city his home since the early 1970s. His infamous Playboy Mansion, snug in the Hollywood Hills, has been the epicenter of LA's hotshot nightlife for more than three decades, providing parties, premieres, and a whole lot of bunny love. Uncle Hef waxes philosophic on sex, stardom, and sunny Cal-i-for-ni-a.

Q: With this kid-in-a-candy-store life that you've carved out for yourself and having always been interested in movies, it must have been a dream of yours to get out here and move to LA in 1971.

A: The fact was that I just liked the life out here. And because it was the place where my dreams came from. I think that to some extent, film people and movie stars are our royalty. They were for me as well. I always imagined that whatever was going on in the Roaring Twenties, which I thought was better than anything that was going on when I was a kid in the Depression, was probably best in Hollywood. That was a major influence on getting the house and starting to entertain here and building the reputation for the Mansion.

Q: And for the magazine as well.

A: Right, what *Playboy* has been trying to do from the very beginning was simply to try to give sex a good name. It's all the context and what message you're sending. Simply running a porn magazine doesn't do anything. And what I tried to do, even with the centerfold in the beginning— I said, "The centerfold is as important, in terms of its editorial message, as 'The *Playboy* Philosophy'." Because what it said was, "These are nice girls, and nice girls are sexual beings, and they like sex too. Sex is okay." And that was a very radical idea in the 1950s. I think a few other people agree with me now.

Q: Do you have any dreams left? To go to the moon, maybe?

A: No, only to do what I'm doing: To love and be loved and to celebrate.
　　　　　　　　　　　　　　　　　　—Kashy Khaledi and Paul Cullum

Reprinted courtesy of Mean Magazine.

Hustler Hollywood

Flynt's own sex paradise—something for everyone, including coffee addicts.

8920 W. Sunset Blvd. (just west of N. San Vicente Blvd.), Sunset Strip; (310) 860-9009; www.shophustler.com. Open Daily: 10 a.m.–2 a.m.

Larry Flynt christened this Sunset Boulevard landmark in 1998, and it remains a hot spot for those in touch with their horny side who need a manual or visual aid to get their rocks off. The store has a wide selection of goods, giving it a mall-like atmosphere. Merchandise includes jewelry, sex videos, magazines (two stands—porn mags are shrink-wrapped), lingerie, feather boas, S&M gear, books, novelty sex-related items, and a large collection of signature *Hustler* stuff like tees and shot glasses. The Flynt take seems to be "sex is fun and everyone should do it." That's even more obviously reflected in the store's café, where menu items are endearingly called (among other things) Pussy Juice and Hot Sweaty Peanut Butter Balls. Tasty! If making the trek to *Hustler*'s haven of sleaze, park in the back and watch the meters. Many a ticket is issued here.

—Phuong-Cac Nguyen

International Love Boutique

Who said English was the international language?

7046 Hollywood Blvd. (just East of La Brea Ave.), Hollywood; (323) 466-7046; loveboutique.com. Open Mon–Sat: 10 a.m.–midnight, Sun: noon–10 p.m.

With royal-blue walls, silver stars hanging from the ceilings, and a come-hither male mannequin beckoning you in, this store is difficult to confuse with the endless array of souvenir shops on the Hollywood Boulevard strip. Rather than the usual star-shaped ashtrays and cheap sunglasses, the Boutique offers essentials for your mating games. Dildos, lubrication, a small but solid selection of bondage gear, kitschy trinkets, and greeting cards, plus close proximity to the Tinseltown sights, make this a more-than-convenient stop for horny tourists.

—Jen Diamond

Le Sex Shoppe

If this place is French, so is my pit bull.

3147 N. San Fernando Rd. (at Andrita St.), Glendale; (323) 258-2867.
Open 24/7 (selected locations have limited hours).

Le Sex Shoppe's vast empire of adult-novelty stores is the fast-food chain
of sex shops. They're open 24/7, they're everywhere, and you end up get-
ting stuffed on cheap but delicious products. They have videos, toys,
books, booths—everything a late-night perv could want! An added pre-
mium is the sleaze factor, as most of the Le Sex franchises are less than
pristine. Shopping there will be sure to make you feel depraved, and we
know you like it dirty. Come for the food, stay for the pie!

—JAG

Also at 5507 Hollywood Blvd. (at Western Ave.), Hollywood;
(323) 462-2460. Open Daily: 9 a.m.–2 a.m.

6315 ¹/2 Hollywood Blvd. (at Vine St.), Hollywood; (323) 464-9435.

6816 Eastern Ave. (between Florence Ave. and Gage Ave.), Bell Gardens;
(323) 560-9473.

45 E. Colorado Blvd. (at Fair Oaks Ave.), Pasadena; (626) 683-9468.

4877 Lankershim Blvd. (north of Camarillo St.), North Hollywood;
(818) 760-9529.

10614 Whittier Blvd. (west of Norwalk Blvd.), Whittier; (562) 695-6301.

4539 Van Nuys Blvd. (south of the 101 fwy.), Sherman Oaks;
(818) 501-9609.

21625 Sherman Way (between Canoga Ave. and Topanga Canyon Blvd.),
Canoga Park; (818) 992-9801. Open Daily: 9 a.m.–10 p.m.

"It is **impossible** to obtain a conviction
for **sodomy** from an English jury.
Half of them don't believe that it can
physically be done, and the other
half are **doing it.**"

— W I N S T O N C H U R C H I L L

Lotions and Lace

Your one-stop Riverside County love shop.

10175 Magnolia Ave. (between Tyler St. and Hole Ave.), Riverside; (909) 352-4405. Open Mon–Sat: 11 a.m.–9 p.m., Sun: noon–6 p.m.

This store has just about everything you could ever want for fun in the bedroom (and beyond). Their smutty goods are showcased in such a friendly and comfortable atmosphere you could even bring along Grandma! Shop for a beaver-shaped clit stimulator or a bondage bed without embarrassment. There's definitely something for everyone here from clothes and shoes to toys and videos. If you're itchin' for some old-school sleaze, L&L carries classic porn like *Debbie Does Dallas* alongside instructionals on how to strip, massage, or give your man the whippin' he deserves. There's also an enormous selection of dildos, pocket pussies, games, and sex dolls, as well as some specialty items, like the tasty Gummi Dong, an edible vibrator made of jelly candy. Yum!

—JH

Also at 22500 Town Circle, #1189 (west of Frederick St.), Moreno Valley Mall; (909) 656-6430.

9197 Central Ave. (between the 10 fwy. and Moreno St.), Montclair; (909) 626-6228.
743 Baker St. (west of Bristol St.), Costa Mesa; (714) 429-1911.

Maya

For the exotic erotic in you.

7452 Melrose Ave. (at N. Gardner Ave.), Melrose; (323) 655-2708; www.mayahollywood.com. Open Mon–Sat: 11 a.m.–10 p.m., Sun: noon–8 p.m.

Sometimes the one thing that your hipster apartment needs to become an interstellar love den is an exotic three-foot statue of an Indian love god mounting his mortal wife among flames and angels. Maybe it just needs some jasmine incense. Either way Maya's got you covered. Maya's carved phallic tree demonstrates its merchandise—apparently innocent art that demands closer inspection. Large green eyes invite you through the fiery neon entrance into a room where masks and carvings hang over cabinets filled with belly chains and other jewelry, waiting to turn you into Shiva for a little erotic dance for your own love slave.

—Aaron Reardon

Shopping

Hollywood's Wild Adolescence
The Pre-Code Years

While no one can deny the fact that Hollywood is enamored with stretching the boundaries of "good" taste and spitting in the face of "decorum," the truth of the matter is that the salaciousness of today's films pales when compared to the classics produced in the sweaty, heady days of the late 1920s and early 1930s.

Just entering its adolescence, Hollywood of the pre-Depression era was busy exploring the limits of its own morality, a curiosity which, when combined with the loosey-goosey liberation of the Jazz Age, made for some of the naughtiest films of all time. Mae West stripteased down to sequins for *I'm No Angel,* Joan Crawford went to prison in *Paid,* Spencer Tracy and Loretta Young got busy in the hayloft for *Man's Castle.* These pre-Code films were rife with plunging necklines, double martinis, double-entendres, and drugs ("junk" and "snow" addictions fueled many a pre-Code plot line).

This steadily increasing onscreen debauchery came to an abrupt end by orders of the Motion Picture Producers and Distributors of America. The organization's head, former Presbyterian elder William H. Hays, authored a regulatory manifesto for the industry in a blatant attempt to appease vocal conservatives (and maintain his cushy $100,000-a-year job). Forbidding "profanity, excessive violence, illegal drugs, suggestive dancing and white slavery" (and enforced from 1934 to 1968), the **Hays Code** provided a strict rulebook for the film studios. The document began with a list of 10 "don'ts:" with childbirth, miscegenation, and ridicule of the clergy all making the list. The result was a cinema transformed from an authentic reflection of societal morality into a sterilized limbo of twin beds and chaste kisses. Mae West was the biggest box-office draw one year, Shirley Temple the next. Thanks to video and DVD, many of the masterpieces of the pre-Code era are available again. For today's viewer, the shock comes not so much from the films' graphic depictions of sex, greed, and power, but in the glimpse we catch of a society disconcertingly similar to our own. Lift up the veil of censorship and what one finds is a world fueled by our very same obsessions: money and power, pleasure and pain, desire and passion, love and good, old-fashioned lust. —JH

Reprinted courtesy of Hotdog *magazine.*

The Pleasure Chest

If size matters, this is your place.

7733 Santa Monica Blvd. (at Schraeder Ave. across from the TomKat Theater), West Hollywood; (323) 650-1022; www.ThePleasureChest.com. Open Sun–Thurs: 10 a.m.–midnight, Fri/Sat: 10 a.m.–1 a.m.

As the nondescript entrance opens into a full-service sex shop, you descend into a pirate's booty of porn. Here, for a few bucks, you can get kitschy items like boob-shaped ice cube trays and smutty wind-up toys or choose from a line of soft-porn greeting cards. Go upstairs to view four aisles of massage oil, body paint, lubrication, edible underwear, and an entire wall of condoms. There are dildos galore, any color, any size— some glow in the dark and some are jokingly gigantic. They also have all the bondage gear you'll ever need: ball gags, wrist restraints, masks, whips, even an anti-gravity device for a couple hundred bucks. The Chest doubles as a head shop and uniform clothing store. Shop here for your sexy cop outfits and cross that thin blue line.

—Jen Diamond

> "I don't see much of **Alfred** since he got
> so interested in **sex.**"
> — M R S . A L F R E D K I N S E Y

Casanova's Adult World

The 7-Eleven of smut!

1626 1/2 Cahuenga Blvd. (south of Hollywood Blvd.), Hollywood; (323) 465-9435. Open Daily: 10 a.m.–2 a.m.

Right in the heart of Hollywood, Casanova's Adult World peddles a pleasant array of smut from early in the morn 'til late at night. Its convenient location in the midst of numerous Cahuenga hot spots (Beauty Bar, The Room, and others) make it a handy stopover if you happen to stumble into someone on the dance floor who's ready and willing. Pop into the clean, nicely organized sleaze shop to pick up the lube, porn, and condoms—or the giant Anal Intruder—all of which are sure to make your night on the town complete.

—JH

Shopping

Circus of Books

 |

Kinkier than a car full of clowns.

4001 W. Sunset Blvd. (at Santa Monica Blvd.) Silver Lake;
(323) 666-1304; www.circusofbooks.com. Open Sun–Thurs: 6 a.m.–
2 a.m., Fri/Sat: 24/7 (including all holidays).

This infamous LA mini-chain (a chain-ette!) is in some ways the anti–Le
Sex Shoppe (see p. xxx). Focusing on the more, um, outré, elements of
sex, Circus of Books carries toys, videos, magazines, and (as the name
might suggest) books, both the sexy and the artsy kind. Catering to both
a gay and straight clientele, they have virtually everything your little
heart could desire, and late at night too! COBs are open late—all night
on the weekends—so put on your miner's hat and start that digging!

—JAG

*Also at 8230 Santa Monica Blvd. (between Crescent Heights Blvd. and
La Cienega Blvd.), West Hollywood; (323) 666-1304.*

Drake's

 |

All the gay porn you can eat!

7566 Melrose Ave. (between Fairfax Ave. and La Brea Ave.), Melrose;
(323) 651-5600. Open 24/7.

Drake's is the place to get porn—gay or otherwise—24/7 in the Melrose
District. Open since the dawn of time, Drake's has yet to change their
décor since the '80s—it's almost like walking into a slick Patrick Nagel
painting, and who doesn't like that? Check out the large assortment of
novelty goods including dildos and French ticklers in the front section
and the hard-core porn in the back. My advice is to have a few drinks on
Fairfax and get some sexy goodies on your way home—Drake's won't let
you down. Now if they'd only change that color scheme . . .

—JAG

"I feel like a **million** tonight—
but one at a **time.**"—M A E W E S T

Ride 'Em Cowboy
Mustang Books & Video

Shopping

There are four really great reasons to patronize **Mustang Books & Video**: 1) The excellent selection of pornographic entertainment. 2) It's not hip, and you will feel somewhat sleazy shopping there. 3) The location is so far away from any place anyone you've ever known would ever be, that the chances of running into someone you've met at, say, your Weight Watchers meeting, are remarkably low. 4) After you've stocked up on gang-bang videos and sex toys, there's a Christian bookstore located right across the street for those wrestling with religious guilt.

Mustang is quite unique in that they offer the one commodity unavailable in most porn shops, the commodity that anyone who has ever entered a dirty bookstore desperately wants and seems to have some difficulty finding: Sex partners! On the wall just next to the hallway leading to a maze of private video booths, there hangs a large bulletin board covered with index cards and lurid Polaroided body parts. Each index card features a handwritten personal ad, some with accompanying photos. To make it a little easier, ads are broken down into the categories Straight, TV & TS, Gay, and Bondage. Even if you're not on the prowl for recreational sex, the bulletin board makes for great reading. The ads run the gamut from titillating to terrifying: an attractive, 30-year-old junior high school teacher itchin' for group sex, a buff fireman willing to "perform" in his fire gear, some poor soul who "Wants Penis Removed," and dozens more. You're welcome to help yourself to a cup of hot coffee as you browse, and though it's an odd place for it, there's a candy machine that dispenses exactly one handful of Boston Baked Beans or SweeTarts just outside the coin-operated video booths, conveniently leaving the other hand free to insert coins.

The best part about Mustang Books & Video is the "Try Me Then Buy Me" vibrator display—a piece that could easily command thousands in a SoHo art gallery. —Matt Maranian

959-961 N. Central Ave. (south of Foothill Blvd.), Upland;
(909) 981-0227.

If you like Mustang check out **The Toy Box** *(comparable to Mustang in size, and the only other store to feature bulletin-board classics!): 1999 W. Arrow Rte. (west of Central Ave.), Upland; (909) 920-1135.*

Shopping

Drawn AND Quartered
A Primer on Erotic Comix

For those seeking a little something more, er, prurient in their comic-book offerings than *The Punisher*, Marvel's *Daredevil*, or even DC's *Nightwing* (though these titles have their share of edgy kicks), check out the adult comix fare at several shops around town. Most notably, **Golden Apple Comics** (with locations on Melrose and in the Valley), **Hi De Ho** (no pun intended) in Santa Monica, and Culver City's **Comics, Ink**, have a wide selection of blood pressure–raising stuff from the adventures of the erotic superhero *Avengelyne* to Frank Miller's tawdry *Sin City* to the rated-X-for-sex-and-violence *Faust* and its spin-offs.

And the Hernandez Brothers, who brought us *Love & Rockets* originally in the early '80s, keep stepping up with the lives and loves of homegirl over-woman Penny Century and friends and acquaintances Maggie, Hopey, Norma, and Negra collected in the *Locas in Love* graphic novels.

The Eros Comix line is for those who want more, ah, action and less story. From *Liz & Beth*, to *Spanish Fly*, *Southern Cumfort*, *Miss Adventure*, and *Karate Girl*, one is bound to find something they like among these self-proclaimed smut and bondage titles.

Though new issues haven't been around in a while, *The Desert Peach* is a German gay revisionist history of events in World War II. The character is the very stylish gay brother of the famed Desert Fox, Erwin Rommel, and, as his creator Donna Barr points out, " . . . no matter the cold, hunger and death [on the Russian Front], he insisted on taking his coffee (real or ersatz) in his tiny porcelain cup."

If you really want kink, check the import section. From Spain, the hot characters in *Young Witches* are both stylish and well-endowed; and the sci-fi *Druna* proffers revenge for a scantily-clad and sexually-tortured detective when the cosmos turns her a-hole boyfriends into slime. But nothing, and I mean *nothing*, in the comic-book world gets as balls-out perverted as Japanese *hentai*. From that girlish duo, the *Bondage Fairies* (who frolic the forest doin' it with giant squirrels, spiders, each other, whatever) to the young, nerdy hero of *Slut Girls* (who finds himself the poor victim of a masseuse, who turns out to be a sexual extrovert, and all of her "liberated" girlfriends), you'll want to take these reads home in a plain brown paper bag. —Gary Phillips

See next page for the Comic-Book Store digits.

The Digits for Comic-Book Stores

Comics, Ink: 4267 Overland Blvd. (south of the Veterans Auditorium), Culver City; (310) 204-3240.

Golden Apple Comics: 7711 Melrose Ave. (east of Fairfax Ave.), Melrose; (323) 658-6047. Also at 8962 Reseda Blvd. (between Parthenia St. and Nordhoff St.), Northridge; (818) 993-7804. www.goldenapplecomics.com

Hi De Ho Comics: 525 Santa Monica Blvd. (at Fifth St.), Santa Monica; (310) 394-2820.

Also good to check out:

Another World Comics & Books: 1615 Colorado Blvd. (east of Eagle Rock Blvd., at Vincent Ave.), Eagle Rock; (323) 257-7757.

Comics Factory: 1298 E. Colorado Blvd. (east of Lake Ave.), Pasadena; (626) 585-0618.

Meltdown Comics & Collectibles: 7522 W. Sunset Blvd. (between Fairfax Ave. and La Brea Ave.), Hollywood; (323) 851-7283.

Ramodi's

Porn aged like fine wine.

6630 Hollywood Blvd., #D (between Whitley Ave. and N. Cherokee Ave.), Hollywood; (323) 467-5660. Open Daily: 10 a.m.–7:30 p.m.

At first glance this store seems to offer only a bizarre potpourri of seashell art, neo-African knickknacks and overpriced thrift-store items, but closer inspection reveals a variety of sex toys behind the main counter and an enormous selection of Ramodi's specialty: vintage porn. Looking for an issue of *Oui* from June 1971? A debut edition of *Playgirl*? A *Hustler* circa '78? Then Ramodi is your man. His collection is vast and his prices fair, considering the mint condition of most of his mags. And where else can you get old-school pornography, beaded curtains, and a six-foot bong all under one roof?

—JH

"We have reason to **believe** that man first walked upright to free his **hands** for masturbation."

– LILY TOMLIN

Spanky's Adult Emporium

"All smut, all the time!"

213 N. Harbor Blvd. (north of S. Figueroa St.), Santa Ana;
(714) 554-4495; www.spankysxxx.com. Open 24/7.

Spanky's (which also has two stores in the heart of the Missouri bread-basket) is a 24-hour video and magazine store that also features what they call hundreds of "pleasure products." In addition to toys, lotions, and creams, Spanky's has a huge selection of DVDs and videos ($3 for 48 hours), and if you're of the fairer sex (or can pass as a lady) you'll get a 20% discount on everything! Spanky's also books a plethora of special events. Nearly every week you'll find a different pornstar waiting to sign your autograph book (or your backside). Spanky's also books adult-film "hostesses," lovely ladies who will happily pour you a cup of hot joe to keep you alert while you peruse the merchandise.

—JH

Stan's of Hollywood

Come for the porn, stay for the celeb gossip.

1117 N. Western Ave. (just north of Santa Monica Blvd.),
East Hollywood; (323) 467-1640. Open 24/7.

Here, where W.C. Fields used to procure his cigars, you can buy your favorite flavor of video, magazine, lubricant, simulated vagina toy, or other sexual enhancer. Owned by one of the largest porn-shop entrepreneurs in the West, Stan's of Hollywood offers convenient back-door parking for a quick and discreet in-and-out to pick up a wide variety of products among the *nuevo bohos* of Los Angeles.

While you're there, grab some tokens and settle into a personal viewing station in the arcade for some channel surfing: man/man . . . CLICK . . . woman/woman/man . . . CLICK . . . unusable channel . . . CLICK . . . If you're really lucky, maybe you'll get invited to stay when the arcade gets closed off for "servicing." Chat up the friendly and reportedly well-hung employees and find out which actor on your favorite sitcom is into gang-banging, as well as which other celebrities have penchants for she-males (you knew that one already though . . .), bondage, big boobs, etc.

—Nancy Pearce

I Wrote Soft-Core Porn!
A Peek into the Life of an Auteur

"The soft-core porn industry." The phrase calls to mind a vivid array of preconceptions—silicone-enhanced starlets panting and moaning on premium cable, sleazy producers who sleep with the "talent," and production values akin to the drunken camcorder-taped video archive of your last birthday party. These are all entirely accurate.

I worked for a small production company. Among its accomplishments were not one but two soft-core series for Skinemax. We're talking the eleven-o'clock-on-a-Saturday-night-and-I'm-alone-and-spankin'-it type of series best exemplified by the David Duchovny–narrated *Red Shoe Diaries*.

We had a 13-episode order and a total budget equal to what Jerry Bruckheimer spent on pretzels and chips during the filming of *Pearl Harbor*. I was the "story editor," responsible for soliciting scripts from various "writers" (making sure they were up to the high standards of late-night, non-penetration skin flicks), and tracking all the changes the producers required. Our executive producer—my boss—was one of those typical middle-aged Hollywood wanna-bes. Overseeing the day-to-day operations of the production was a young, extremely horny producer. The cast was filled with strippers, aging *Playboy* Playmates, *Penthouse* Pets, and other large-breasted, mentally challenged women. Between them, the two producers managed to sleep their way through almost the entire female cast.

Eventually I was asked to write an episode. I got paid a whopping eight hundred bucks for it, which isn't a lot, but, then again, it only took me about two hours to write. In my opus, a young man faces a crisis—what do you do when you're physically exhausted from dating two women and constantly having sex with one after the other? (If I had a nickel for every time I had to resolve that situation, I'd be writing this from the deck of my Malibu beach house.) Much to the consternation of his best friend, the protagonist decides he's going to break it off with one of the girls. He comes home only to discover both women there. And, of course, they have a threesome. There's a surprise ending, too, but I'll leave a little something to the imagination. —Josh Levitan

Shopping

Video Killed THE Porn Theater Star

Once upon a time, seedy triple-X theaters throughout the country flickered with the joys of 16mm sex: Naughty burlesque films, soft-core bondage, the latest and greatest from the Mitchell Brothers. One had only to fork over a few crumpled bucks for the privilege of sitting in the cool dark, gazing at an enormous ass or a pair of stupendous breasts projected on-screen.

When video arrived on the scene, it killed porn in two ways. Films began to be shot on video, giving an already dubious genre an uncomfortably intimate look and destroying any notion of sweetness or innocence. When projected onto a theater screen, these images took on an undeniable grotesqueness that film had once glossed over with Technicolor magic. Going to theaters was not only no longer fun, it was no longer necessary, as more people hopped on the VCR bandwagon and brought their perversions home. Why watch porn in a seat still damp with another voyeur's excitement when you could be in the satin-covered comfort of your own deluxe heated waterbed?

And so, the theaters slowly closed up shop and the great chains such as the Mitchell Brothers and **The Pussycat** began a downward spiral that would ultimately result in their virtual demise. LA is still home to The Pussycat's last hurrah, a namesake theater on Western which shows video-projected porn and the occasional 16mm oldie but goodie; and a former Pussycat lives on in an old art-deco show palace renamed **The TomKat** now resurrected as a mecca for gay smut. The lobby displays a large mural of naked men beckoning you into the large, pitch-black theater. For $10 you can sink into the red, velvety seats and lose yourself in such classics as *Cock Gun*, *Dawson's Crack*, and *College Cock 101*. If the excitement's too much, go recline on plush sofas in the cozy sitting area and enjoy a nice game of chess. Just outside the entrance such stars as Linda Lovelace, Marilyn Chambers, and John Holmes have graced the sidewalk with their handprints, footprints, and signatures à la Mann's Chinese, which makes for a great photo-op to send back to Mama.

Who knows how long this last bastion of the old school will survive, so if you're in the mood to share your porn experience with a few muscle-bound strangers or dirty old men, make sure to put this cat at the top of your sleazy to-do list. —Aurisha Smolarski & Jessica Hundley

The Pussycat: 1508 N. Western Ave. (noth of Sunset Blvd.), Hollywood.

The TomKat: 7735 Santa Monica Blvd. (east of Fairfax Ave.), West Hollywood; (323) 650-9551. Open Mon–Fri: 10 a.m.–3 a.m. Sat/Sun: 24 hours.

Agent Provocateur

Lingerie for your catwalk debut.

7961 Melrose Ave. (at N. Hayworth Ave.), Melrose; (323) 653-0229; www.agentprovocateur.com. Open Mon–Sat: 11 a.m.–7 p.m., closed Sun

Giving Frederick's of Hollywood and Victoria's Secret a run for their money, Agent Provocateur could render even the most reserved of ladies into a deadly seductress Russ Meyers could be proud of. The sexy British lingerie line runs from frilly, colorful panties and corsets to to-die-for bras and slips. And the store's décor is girly without being too kitschy: think Barbie's Dream House turned Sexpot Central. Sales staff are outfitted in high heels and short white coats and bestow plenty of personal attention on the clientele, giving the store a friendly, welcoming ambience. Unfortunately, sexy comes at a price, and a heart-breaking pair of $90 panties make these barely there goods available only to a seriously loaded clientele.

—Phuong-Cac Nguyen

Make Out

The LACMA-La Brea Tar Pits Combo

If standing under a Mark Rothko color field gets you all hot and bothered, and you know it does, then the **Los Angeles County Museum of Art** is the place for you. Take the big elevator to the Fourth Floor and walk out to the balcony. With a view overlooking the courtyard, you and your baby will have a million dollar artful make out session. If that isn't hot enough for you, take the short stroll through the park to the **La Brea Tar Pits** and the **Page Museum**, where you can play caveman. Is that a tusk in your pocket or are you just happy to see me? —JAG

La Brea Tar Pits and Page Museum: 5801 Wilshire Blvd. (between Fairfax Ave. and La Brea Ave.), Midtown; (323) 934-7243; www.tarpits.org. Open Mon–Fri: 9:30 a.m.–5 p.m., Sat–Sun: 10 a.m.–5 p.m.; tar pits free, museum accepts all major credit cards.

LACMA: 5905 Wilshire Blvd. (between Fairfax Ave. and La Brea Ave.), Midtown, (323) 857-6000; www.lacma.org. Open Mon/Tue, Thurs: noon–8 p.m., Fri: noon–9 p.m., Sat/Sun: 11a.m.–8 p.m.; museum balcony and plaza free.

Shopping

Frederick's of Hollywood

From classy to trashy.

6608 Hollywood Blvd. (between Highland Ave. and Vine St.), Hollywood; (323) 466-8506; www.fredericks.com. Open Mon–Fri: 10 a.m.–9 p.m., Sat: 10 a.m.–7 p.m., Sun: 11 a.m.–6 p.m.

Frederick's more risqué days are long gone, but you can still get one of the lacy boudoir outfits the store is known for. If you're feeling daring you can choose from a limited selection of motion lotion, body paint, and massage oils. Just don't expect kink—thigh-high boots with Lucite heels in the truly trashy shoe section is the closest Frederick's gets to shocking. But the best feature of their Hollywood store is their small (free!) Lingerie Museum, which houses vintage catalogs and some infamous Frederick's undergarment designs, such as Forrest Gump's boxer shorts, Madonna's Blonde Ambition bustier, Mae West's bathrobe, and Milton Berle's pink-sequined dress. See the world's largest and smallest bras, check out Lita Ford's metal-babe brassiere, or simply sit back in the cushy chairs scattered throughout the store while your significant other tries on something more comfortable.

—Jen Diamond

Also at: Topanga Plaza, 6600 Topanga Canyon Blvd. (between Victory Blvd. and Vanowen St.), Canoga Park; (818) 348-9311.

Stonewood Shopping Center, 261 Stonewood St. (at Firestone Blvd.), Downey; (562) 869-1090.

12 Lakewood Center Mall (at Lakewood Blvd.), Lakewood, CA (562) 634-8311.

The Block at Orange, 20 City Blvd. W. (off I-5), Orange; (714) 769-3194.

Del Amo Fashion Square, 35 Del Amo Fashion Square (at Hawthorne Blvd. and Carson St.), Torrance; (310) 371-3643.

Check web site for other locations throughout Southern California.

"Women need a **reason** to have sex—
men just need a **place**."

— B I L L Y C R Y S T A L

Insideout

Upscale threads for your buns of steel.

363 N. Camden Dr. (between Wilshire Blvd. and Brighton Way),
Beverly Hills; (310) 247-8477. Open Mon–Fri: 10:30 a.m.–6:30 p.m.,
Sat: 11 a.m.–6 p.m., closed Sun

In a part of town that's all about image, Insideout is only concerned with
what's underneath. Chris and Lesley St. James, the husband-and-wife
owners, peep into Europe's most private parts to find the latest in under-
garment wear. From the cutting-edge designs of Undressed to the femi-
nine frills of Fifi Chachnil, Insideout has just the right thing to dress up
your derrière. And guys, just so you won't feel left out, half of the store
is filled with high-end gear for your own rear ends. One of their most
irresistible temptations is the black-lace G-string with a thong made of a
strand of pearls. Speaking of pearls, the store's bestseller is the Rabbit
Pearl vibrator which uses dancing beads and a naughty little bunny rab-
bit attachment to make the girls squeal. The store also keeps all your
measurements on file so you (and the celebs who shop here) get the per-
fect fit every time.

—Evangeline Heath

La Perla

*The osso bucco of lingerie stores—go ahead and spoil yourself,
you deserve it!*

433 N. Rodeo Dr. (at Wilshire Blvd.), Beverly Hills; (310) 860-0561;
www.laperla.com. Open Mon–Wed: 10 a.m.–6 p.m., Thurs–Sat:
10 a.m.–6:30 p.m., Sun: noon–5 p.m.

With its tony Rodeo Drive address and prices to match, La Perla is a tem-
ple to impossibly sexy Italian men's and women's undergarments. This
place makes Victoria's Secret look like the blue-light special at Kmart. La
Perla is a great place to go if you're looking to buy the woman you love
a $200 bra-and-panty set. Make sure to check out the Maliza collection
and you'll see what those high prices can get you. Vavavavoom!

—JAG

*Also in the South Coast Plaza Shopping Center: 3333 Bristol St., #2213
(north of the 405 fwy.), Costa Mesa; (714) 754-7500.*

Shopping

Gone Hollywood
The Frederick's of Hollywood Story

Back when Frederick Mellinger was a horny military man with a barracks full of pinups, he had a dream: to make every woman look like Betty Grable. After returning home from the war, Mr. Frederick, as he was to become known, set about realizing this lofty goal by opening a lingerie shop on Fifth Avenue which specialized in risqué undergarments that combined function with form. Unfortunately, the success of his fledgling store was tempered by the Puritanical sentiments of New York's upper class, so Mr. Frederick decided to try again in another, more receptive locale. The logical choice was America's burgeoning den of vice, iniquity, and sexual daring: Los Angeles, more specifically Hollywood, where the stars were mad for silk stockings and French lingerie was all the rage. Thus was born the infamous **Frederick's of Hollywood**, a mecca of satin and lace which would become a Tinseltown landmark.

The always savvy Frederick immediately set up a lucrative relationship with the studios, supplying film sets with naughty nighties and creating custom-made lingerie for various celebrities. In the meantime, business at the store was booming. Never one to rest on his laurels, Mellinger was constantly looking for ways in which to improve his product. In 1950 his corporate acumen combined with his passion for lady's cleavage inspired him to invent the world's first pushup bra, The Rising Star. This would not be the last of Frederick's contributions to the world of lingerie. He would also dream up the front-hook brassiere, introduce America to the thong, and create the miracle know as the H_2O Water Bra, which uses a little touch of *agua* to spice up the lives of flat-chested unfortunates.

Today, Frederick's namesake company is still a lingerie powerhouse, although its once risqué catalog is not quite as shocking as it used to be. The Frederick's of Hollywood name, however, still maintains its aura of glamour, a signifier of all things undergarment and a monument to one man's grand obsession with ladies' lingerie. —JH

See p. xxx for a review of Frederick's of Hollywood stores and the infamous Lingerie Museum.

Malepower

It's raining menswear! Hallelujah!

6435 Hollywood Blvd. (between Wilcox Ave. and Cahuenga Blvd), Hollywood.

Offering more G-strings than Imelda Marcos had shoes, you can buy your boy one for every day of the week in every color of the rainbow. Or get wild with metallic, furry, feathered, and leather models. Silk robes line the back wall and are perfect for afternoon tea. They have satin pajamas for movie night, Hawaiian shirts for the BBQ, and date and club wear for your late-night tête-à-têtes.

—Jen Diamond

Petticoats

What hip mamas are wearing under their Diane vonFurstenberg wrap dresses.

115 N. Larchmont Blvd. (between Melrose Ave. and First St.), Larchmont Village; (323) 467-1730. Open Mon–Sat: 10:30 a.m.–6:30 p.m., Sun: 11 a.m.–5 p.m.

If your idea of fantasy play involves 400-thread-count sheets instead of say, chains and leather, then this is the place for all your princess needs: French and Italian lingerie, pima cotton pajamas, and kinky bra and panty sets in fabulous fabrics. There's not a teddy to be found in this hip boutique, located in the back of its sister store, Picket Fences. (The two stores merged when a larger space became available on Larchmont in June 2001). Basically, Petticoats sells upscale underwear and nighties for the modern Hollywood mommy set—expect to negotiate around many a designer baby stroller and the occasional Hancock Park A-List celebrity while shopping. And if your credit card's maxed out, head for the sale items in the very back of the store.

—Andrea Richards

"You know of course that the **Tasmanians,** who never committed adultery, are now **extinct.**"

— W. SOMERSET MAUGHAM

Roma Bikini

The motherload of bathing-beauty bikinis.

6501 Hollywood Blvd. (near Wilcox Ave.), Hollywood; (323) 957-1988. Open Daily: 11 a.m.–8:30 p.m.

This is a huge store which offers (as the name might suggest) bikinis as well as a healthy selection of lingerie and naughty nighties. Neon seems to be Roma's specialty, and the amount of hot pink, blazing orange, and lime green in the place could very likely blind a person. You can find all the Hollywood Boulevard standards here, but the emphasis seems to be on beachwear rather than straight-up stripper essentials.

—JH

A Touch of Romance

For the blushing bride in you.

5901 Sepulveda Blvd. (south of the 90 freeway), Culver City; (310) 793-6997; www.atouchofromance.com. Open Mon–Thurs: 10 a.m.–9 p.m., Fri/Sat: 10 a.m.–10 p.m., Sun: 11 a.m.–6 p.m.

A Touch of Romance provides a variety of sexy undergarments for the blushing bride, the horny housewife, or the man who just likes the feel of a silk brassiere. Fulfilling the standard fantasies of the satin-and-lace variety, Touch rarely deviates from the lingerie norm, so look somewhere else if you want neon fishnet or red-leather corsets. This store is all about romance, honey, not smut, so if you like a classy kind of seduction with mood music and some scented candles, grab yourself one of Touch's pink teddies and have yourself a ball. The chain also offers a selection of scented massage oils, bath salts, books and party games like An Enchanted Evening and Getting To Know You Better. Perfect stuff for suburban bridal showers, bachelorette parties, and middle-class marrieds who still like to get down.

—JH

Also at 14325 Ventura Blvd. (east of Beverly Glen Blvd.), Sherman Oaks; (818) 907-7013.

11332 South St. (east of the 605 freeway), Cerritos; (562) 402-3747.

15086 Goldenwest St. (at Bolsa Ave.), Westminster; (714) 892-3983.

1225 N. Tustin St. (south of E. Katella Ave.), Orange; (714) 538-6419.

3715 S. Bristol St. (between W. MacArthur Blvd. and Sunflower Ave.), Santa Ana; (714) 546-7442.

Trashy Lingerie

The name says it all.

402 N. La Cienega Blvd. (between Beverly Blvd. and Santa Monica Blvd.), West Hollywood; (310) 652-4543; www.trashy.com.
Open Mon–Sat: 10 a.m.–7 p.m., closed Sun

With so many different lingerie shops to choose from in the Los Angeles area, one store radiates like a god among mortals. Standing the test of time, Trashy Lingerie has spent the last 25 years providing the heaving masses with the sexiest, most outré, ready-to-wear and couture undergarments and clothing west of the Mississippi. Trashy Lingerie's prices range from deals to whoa nelly, and the customers vary from hipsters to harlots. For a paltry $10-a-year membership you can join the private cadre and Trashy will make sure that you get your fill of schoolgirl outfits, spandex catsuits, or whatever your trashy ensemble needs might be. Also, free custom tailoring makes it all a snap, and if Dolly Parton trusts her bustline to them, so should you. Check out their web site where you can browse the catalog by model and see the sexy styles on a (mostly) real gal before you buy—or if you prefer to window shop, don't miss their revolving themed window displays.

—JAG

"I've tried several **varieties** of sex.
The conventional position makes me
claustrophobic and the others give a
stiff neck or **lockjaw.**"
— TALLULAH BANKHEAD

Shopping

Walk This Way
High Heels and All

Who doesn't get a little hot under the collar for the smooth curve of a woman's sole or a nice set of manicured toes peeking out from under the straps of a pair of **Jimmy Choos**? Even the most staid and conservative of folks have a foot fetishist lurking within, and for those who like to keep themselves (and their lovers) in the most flattering of fashions, LA's got a plethora of shoe stores to choose from.

If you want to keep it high class, you can pay a visit to Beverly Boulevard's **Diavolina**, where trips abroad keep the shop well stocked with the hottest Italian and Parisian footwear: strappy sandals, delicately heeled boots, gorgeously designed bits of leather which will keep you both sexy and well-shod. And the padded walls will put you in the mood to prance. If you've still got money to burn, head over to **Emma Gold**, which specializes in hoity-toity designer boots, then pay a visit to **Robert Clergerie** or **Stephane Kelian** for Euro-chic feet.

If you're feeling on the trashier side, traipse on down to Hollywood Boulevard, where a host of local outlets specialize in the kind of stiletto-heeled perversions that can usually be found strutting the stage at the local strip club. Thigh-high vinyl boots, a pair of pink sandals with a five-inch heel, feather-trimmed slippers—the only rule here is "the smuttier the better." **Shoe Time** has holographic purple pumps with Lucite heels, **For Stars** has custom red faux snake-skin numbers, and **Maya's Shoes** (check out the numerous signed stripper eight-by-ten glossies gracing the walls) claims to stock the "highest heels in LA."

It doesn't matter whether you long for the sweet suppleness of Italian leather or the tickle of a teetering heel, whatever your tastes in shoes may be, this city's got more footwear than Mrs. Marcos's closet! —JH

See next page for high-heels hot spots.

Shopping

The High-Heels Hot Spots

Diavolina: *7383 Beverly Blvd. (between La Brea Ave. and Fairfax Ave.), Midtown; (323) 936-3000.*

Emma Gold: *8115 Melrose Ave. (west of Crescent Heights Blvd.), West Hollywood; (323) 651-3662.*

For Stars: *6326 Hollywood Blvd. (west of Vine St.), Hollywood; (323) 462-6448.*

Jimmy Choo: *469 N. Canon Dr. (between Santa Monica Blvd. and Brighton Way), Beverly Hills; (310) 860-9045; www.jimmychoo.com.*

Maya's Shoes: *6523 Hollywood Blvd. (west of Wilcox Ave.), Hollywood; (323) 962-9467; www.mayashoes.com.*

Robert Clergerie: *108 N. Robertson Blvd. (between Alden Dr. and Beverly Blvd.), Beverly Hills; (310) 276-8907.*

Shoe Time: *6548 Hollywood Blvd. (west of Wilcox Ave.), Hollywood; (323) 466-2183.*

Stephane Kelian: *8625 W. Sunset Blvd. (in Sunset Plaza) West Hollywood; (310) 289-8933. Also at 9534 Brighton Way (between Rodeo Dr. and Camden Dr.), Beverly Hills; (310) 858-0129.*

Under G's

High-priced skivvies!

23410 Civic Center Way (at Cross Creek Rd.), Malibu; (310) 456-0556. Open Mon–Fri: 10:30 a.m.–5 p.m., Sat: 11 a.m.–7 p.m., Sun: noon–6 p.m.

This upscale lingerie chain sells to the deep-pocketed residents of LA's Westside, the sort of folk who feel secure only when wearing a pair of $200 French panties. Stores in Malibu, West Hollywood, and Beverly Hills stock a selection of "European only" satin and lace—a few feet of fabric that'll cost an arm and a leg, but will certainly save your pride should a fender bender in your Mercedes SUV leave you pullin' down your pants for the medics. This is hoity-toity stuff, but beautifully made: a nice selection of everything from modest cotton tanks to barely there G-strings. You might have to mortgage the homestead for that bustier, but it'll be worth it. —JH

Also at 417 N. Bedford Dr. (between Santa Monica Blvd. and Wilshire Blvd.), Beverly Hills; (310) 273-9333. Open Sun: 11 a.m.– 5 p.m., Mon–Fri: 10 a.m.–7 p.m., closed Sat.

100 N. La Cienega Blvd., # 211, (at W. Third St.), West Hollywood; (310) 659-6049. Open Mon–Sat: noon–9 p.m., Sun: noon–8 p.m.

Shopping

Zone d' Erotica

Bring out the Goddess in you!

12820 Venice Blvd. (at Beethoven St.), Venice; (310) 391-9103.
Open 24/7.

Don't let that fancy French name fool ya, this 24-hour boutique has all
the sleaze you'll ever need, and right off the 405 freeway too! In addition
to a great selection of the usual kinkiness (shoes, lotions, toys, and lin-
gerie) you'll also find videos and magazines, fetish gear (vinyl, latex, and
leather, oh my!). Plus all the tools necessary for turning girls into boys
and boys into girls: vitamins, "transformation" creams, stage makeup,
breast forms, and (wonder of wonders!) vaginal panties or "gaffs"—
miraculous soft rubber facsimiles that will give you that coveted camel
toe! *Viva la femme!*

—JH

> "When choosing between **evils,**
> I always like to take the one
> I've **never tried** before."—MAE WEST

Erotic Woman Lingerie

I am erotic woman, hear me roar!

6461 Lankershim Blvd. (north of Victory Blvd.), North Hollywood;
(818) 762-0001. Open Mon–Fri: 10 a.m.–8 p.m.,
Sat/Sun: 11 a.m.–7 p.m.

Just like the name says, this place has everything for the "erotic" woman.
Explore your trashy side with six-to seven-inch "dancers" shoes, good
for sashaying on the bar top or diggin' into that bad boy's backside. The
store offers PVC corsets, vinyl, and some fetish wear along with stan-
dard- issue sleazy lingerie, an assortment of toys, and quite a bit of
"bachelorette party" accessories for all the nasty girls. This NoHo insti-
tution also kindly offers discounts to professional dancers and is fairly
consistent in keeping up with all the kinky trends.

—JH

Eye Candy

The quintessential Hollywood stripper store.

6524 Hollywood Blvd. (at Wilcox Ave.), Hollywood; (323) 469-1400.
Open Daily: 11 a.m.–8 p.m.

Eye Candy has skimpy cheerleader uniforms, matching butterfly pasties with G-string (they come in a handy box set!), edible undies, a selection of tamer fetish gear (mostly vinyl bustiers and the like), and the traditional trashy lingerie one would expect to view on exotic dancer hard bodies. Eye Candy also offers some eveningwear and custom designs for those willing to shell out the extra booty. The store's owner definitely has a monopoly on the Boulevard scene, and you can find similar offerings at his other stores.

—JH

*Other store: **Je'Taime:** 6611½ Hollywood Blvd, (between Whitley Ave. and Cherokee Ave.), Hollywood; (323) 465-2148.*

Forplay

Hot clothes for hot players.

6507 Hollywood Blvd. (west of Wilcox Ave.), Hollywood;
(323) 464-7800; www.forplaycatalog.com. Open Daily: 10 a.m.–5 p.m.

With three stores within spittin' distance of each other on Hollywood Boulevard, Forplay's got all your sleaze bases covered, from little Catholic Schoolgirl uniforms to pink-sequined cowgirl outfits, red patent-leather stilettos to kinky club wear. Each of their outlets is a bit different, but all of them fall within the confines of well-dressed, heavily accessorized, wanna-be sluttiness. The prices range from dirt cheap to jaw-droppingly expensive, but sometimes that silver nipple tipped Barbarella bustier is damn worth it. With extra features like black lights in the dressing room to get that "on-stage" feel and an extensive online catalog, Forplay does it right, offering wares that are playful, imaginative and meant to be worn with a sexy smirk.

—JH

*Other stores: **Forplay:** 6434 Hollywood Blvd. (between Wilcox Ave. and N. Cahuenga Blvd.), Hollywood; (323) 464-0362.*

***Forplay Too:** 6521 Hollywood Blvd. (west of Wilcox Ave.), Hollywood; (323) 464-7800.*

Shopping

Road Trip!
Destination: Tijuana

Looking to overindulge on beer, booty, and a well-made yet inexpensive booty? Then make a run for the border! A mere two-and-a-half hours from Los Angeles you will arrive at the gates of Tijuana, where the allure of cheap fun will coax you and your dollars to the other side. Park the car in California and take a taxi into TJ—it's safer, cheaper, and less hassle. Once parked, it's a quick walk through the clanging metal turnstiles and into the Land of Quetzalcóatl and Cortés, a 24 hour liquor-soaked Latin carnival.

Today's TJ pulses with the sounds of *nortec* (Baja techno) and pumping house music—it is a relatively modern and bustling city by twenty-first century standards. Start off at Avenida Revolución, the heart of the city, where dance clubs and cantinas compete for your attention with trinket shops and all-night pharmacies. From there veer off to Avenida Constitución and Boulevard Agua Caliente.

A few good bars to check out are **Baby Rock**, a super-packed disco with shooter girls (they blow a whistle and spin your head while pouring tequila down your gullet), a good sound system, and a décor lifted from a 1980s Hollywood movie. Other ones include **Baccarat**, an upscale discoteque located in the **Grand Hotel Tijuana** and **El Lugar del Nopal**, an arty bar for the *cumbia/roc en español* crowd most nights. Also a must-see is the three-story Wild West–themed club, **Rodeo Santa Fe**. Where else but TJ, would you find a live, indoor midnight rodeo and all-night Norteño dance party?

Bedding down for the night? TJ has dozens of cut-rate hotels including the grand **Hotel Caesar**, once glamorous, now not so, and the self-proclaimed inventors of the Caesar salad—more likely it's the birthplace of chlamydia. For a step up in class, there is the beautiful but expensive **Grand Hotel Tijuana,** and for some all-American comfort there is a **Holiday Inn**.

But let's not forget that, if wanted, your festivities can be down 'n' dirty. Tijuana has cleaned up considerably from its 1930s reputation as a lawless frontier outpost—rarely will you find cowboy boots and six-shooters in the pile of discarded clothes at the foot of the bed. But if you look you can still find some, um, adult fun, if needed. Some strip joints to visit are the old-school, been-open-forever, **Chicago Club, Adelitas** and, a personal favorite, **The Unicorn Club**. Good luck in Tijuana, have a safe and fun time, and don't forget to respect the culture. *Vaya con dios.* —JAG

See next page for the TJ digits.

The Digits for TJ

Hotels:

Grand Hotel Tijuana: *Blvd. Agua Caliente #4500;*
Tel: 011 52 (66) 81-70-00 or 011 52 (66) 81-70-16.

Holiday Inn: *Ave. Paseo de los Héroes #18818, Zona Río 22320;*
Tel: 011 52 (66) 34-69-01.

Hotel Caesar: *Ave. Revolución and Fifth #1079, Zona Centro;*
Tel: 011 52 (66) 85-16-66 or 011 52 (66) 85-16-06.

Clubs:

Baby Rock: *Calle Diego Rivera #1482.*

Baccarat: *Blvd. Agua Caliente #4500.*

El Lugar del Nopal: *Cinco de Mayo #1328 and Ave. F.*

Rodeo Santa Fe: *in the Pueblo Amigo shopping center on Ave. Paseo Tijuana in the Zona Río.*

Strip Clubs:

Adelitas: *at Ave. Constitución and Coahuila.*

Chicago Club: *Ave. Constitución and Coahuila.*

The Unicorn Club: *Ave. Revolución between Sixth and Seventh.*

Playmates

Pasties galore meets octohussie.

6438 Hollywood Blvd. (between Wilcox Ave. and Cahuenga Blvd.), Hollywood; (323) 464-7636; www.playmatesofhollywood.com. Open Mon–Sat: 10 a.m.–8 p.m., Sun: noon–7 p.m.

A Boulevard classic, Playmates is one of the original trashy-lingerie and stripper-wear outlets. Still frequented by the best in the biz, the store features soft-core bondage gear, garter belts, reasonably priced swimwear, and large piles of thongs and crotchless panties which you can sift through at your leisure. Their pièce de résistance is the stacked pasties bins, nicely organized with handy labels describing each drawer's contents (e.g., velvet/hologram/vinyl/fake fur/stars/with or without tassels). Their specialty pasties include a sweet set of sequined Christmas trees for spreading the Yuletide cheer. A fun, comfortable atmosphere and convenient location (right by Mann's Chinese Theater and the Hollywood Wax Museum!) make Playmates a favorite of the adventurous tourist.

—JH

Ultra Vixen Vampwear

Made with love, really.

1710 Wilcox Ave. (near Hollywood Blvd.), Hollywood; (323) 466-9199.
Open Mon–Sat: noon–8 p.m., closed Sun.

The place for handmade stripper gear; and we're talking made by dancers for dancers. A tiny shop just next to the Mustard Seed Christian Book Store (oh the irony!), Ultra Vixen offers quality clothes at a quarter of the cost of their Hollywood Boulevard competitors. Small, friendly, and chock-full of goodies (jewelry, belts, and tiny battery-charged lights for your bellybutton!), Ultra offers one-of-a-kind items like tailored blue jeans, perfectly cut bikinis, and sequined butterfly halters—all made on the premises by Vixen seamstresses. The establishment is guarded over by a large white parrot and a helpful staff, and the down-home feel has won them a host of loyal fans. Comfortable, cheap and unique, Ultra Vixen is hard to beat.

—JH

Z'Gan

Strip-store schlock.

6512 Hollywood Blvd. (west of Wilcox Ave.), Hollywood;
(323) 462-8707. Open Daily: 11 a.m.–8 p.m.

Complementing the seemingly endless wall of thongs at Z'Gan are an innumerable lineup of headless, armless, and legless torsos clad in a variety of swimwear and revealing lingerie. The store has the usual selection of undergarments, which run from tame to wild. But you'll want to go here for the really great, cheap shoes; elaborate headdresses and full-length feather robes; a nice array of wigs; and black, white, and red angel wings, for when you're feeling both naughty and nice.

—JH

"A lady is one who **never** shows her
underwear **unintentionally**."
— LILLIAN DAY

Shopping

Interview With Pornstar Chloe
a.k.a. Chloe the Anal Queen

There are pornstars and there are pornstars. Chloe is the latter, the Queen of Anal, star of *Tampa Tushies 3* and other amazing works, she flies high above the rest.

Q: So you're known as the anal queen of LA?

A: Am I? Yeah, I guess I am. I'm still the reigning anal queen in the industry, and I don't know how I've managed to hang on to that title because so many other girls do so many more crazy things with their butts than I do with mine. So I think it's quality not quantity. Because I'm actually very choosy about what I stick in my ass. I really get off on anal sex, and I prefer anal sex over vaginal sex. Maybe that's why I've managed to hang on to that title. Anal queen of LA. That's something I'll be able to tell the grandkids.

Q: So when you're on camera, is that all real?

A: The orgasms are real, the sex is real, the acting is acting.

Q: So tell me about your groupie days—Hollywood in the '80s.

A: Hollywood in the mid- to late-'80s was a nonstop party. Sex, drugs and rock-and-roll. Pre-HIV scare. I actually didn't do drugs during those years, I waited until I was 17, but I was drinking with the best of them. So from 13 to about 16 I was going through what I call the Slut Years. Which is when I learned how to do pretty much everything I know how to do sexually. I would like to thank local bands in LA for teaching me what I know, because I make a pretty goddamn good living at it now. But it was a dream. Sunset Boulevard, you'd get out there, and you wouldn't even have to go into a club. Because the party was out on the street. And everyone would dress up, it would be all glitter, glam, Faster Pussycat, Warrant, Poison, and lots of hair, and lots of cool clothes, and things that jingled, sparkled. It was my sexual awakening, and yeah, I was drunk through most of it.

Q: So what do you think about LA and sex, now?

A: Sex in LA. I'm starting to realize that, yes, it's still out there. I think that somebody can have a pretty healthy sexual relationship in LA now, but it's definitely not like it was back when I was out there, and not using condoms and fucking anything that walked! —Jen Liu

Funky Town

Get yer glow-in-the-dark and leather gear.

7415 Melrose Ave. (at N. Vista St.), Melrose; (323) 655-1079; www.funkytowninc.com. Open Mon–Sat: 11 a.m.–8 p.m., Sun: noon–8 p.m.

The main room of this Melrose store displays a great collection of playful T-shirts, leopard-fur photo albums, and enough rhinestones to keep any drag queen happy. But the real magic at Funky Town is the ultraviolet room in the back. This hip little cave holds a secret world of fluorescent boas and glow-in-the-dark angel wings that come to vibrant life in a black-light world. Whether your pole work is done on the main stage or simply on the four-poster in the bedroom, a little piece from Funky Town's collection will add an ethereal touch that will keep your loveplay kickin'.

—Aaron Reardon

Hot Topic

Goth goes to the mall!

220 Santa Monica Place (at Broadway), Santa Monica; (310) 260-8617; www.hottopic.com. Open Mon–Sat: 10 a.m.–9 p.m., Sun: 11 a.m.–6 p.m.

Moms and dads of Middle America might be surprised to find that the cult of Goth, born in the dank recesses of mid-'80s London, has spread across the sea and through the years, infesting hordes of suburban adolescents like a velveteen plague. The resulting demand for silver crucifixes, pink studded dog collars and tattered lace is the inspiration behind this remarkably successful mall store. Providing an angst-filled youth with a variety of starter-level Goth, S&M and rocker gear, Hot Topic features everything from chain mail bras and witchy ball gowns to tartan bondage pants and G-strings emblazoned with the word *easy*. Perfect for the grim-faced teen with a fondness for black fishnets and bouts of self-pity.

—JH

Check web site for locations at malls throughout the Southland.

Red Balls on Fire

Freakophiles in pleather unite!

7365 Melrose Ave. (between N. Fuller Ave. and N. Martel Ave.),
Melrose; (323) 655-3409; www.redballs.com. Open Mon–Sat:
11 a.m.–8 p.m., Sun: noon–8 p.m.

If aliens are among us, then Red Balls on Fire provides their wardrobe.
No matter what activity causes you to sweat, Red Balls has the appropri-
ate accessory. From bargain bins stacked with colored sunglasses to red
zippered fur straight jackets, the Los Angeles extension of this interna-
tional retailer sells all that is unusual in clothing and accessories, cranks
the trance, and stocks its shelves with the latest in fringe fashion.
Everything in Redballs is stylized to reconfigure your form from mere
human to *anime* action hero. It seems to be working—judging by the
clientele you can catch more freaks with pleather than you can with
designer labels.

—Aaron Reardon

> "The only **unnatural** sex act
> is one which you cannot **perform.**"
> — A L F R E D K I N S E Y

Shrine

For the bloodsucker in you.

7574 Melrose Ave. (at Curson Ave.), Melrose; (323) 655-1485.
Open Mon–Sat: 11 a.m.–8 p.m., Sun: noon–8 p.m.

Shrine is the only store on Melrose to carry a full range of gothic attire.
From vinyl and rubber to Victorian gothic and velvet gowns, Shrine is
home away from home for the modern vampire. If sexy-ass Elvira makes
you hot or you want to roleplay a little "Gomez and Morticia," then the
darker side at Shrine will beckon you with its red-velvet walls and leather
corsets. Just don't get freaked if the staff doesn't cast a reflection.

—Aaron Reardon

Shopping

I Was A Post-Structuralist Pornographer

It is October 1998. I have just finished collecting a pop quiz from my students at one of Los Angeles most exclusive (read: expensive) private high schools. The brats got nailed with a few questions on Jacques Tati, Jean Renoir, and (to break with the Gallic theme) Werner Herzog. When the last paper is turned in, I stuff the lot of them into my briefcase, run to my beleaguered 1986 Honda Civic and hightail it across the San Fernando Valley to my other job. I make pornography. The hard-core shit. The term "anal piledriver" is part of my professional argot.

Let's take a few steps back. In May of 1998 I completed an MFA at an exclusive (see above) art school in Southern California. My master's thesis was a post-structuralist documentary about the history of philately. (Yeah, I know.) Like most people with skills no one can use, ambitions no one takes seriously, and $80,000 in student loans, I took the only job I was qualified for: teaching. Which (news flash, America!) doesn't pay the bills.

So, along comes a phone call from a grad-school chum named Todd Vickers. At art school, Todd was a real anomaly: a happily married, piercing-and-tattoo-free bibliophile who didn't make work expressly designed to highlight his fantastically outré world-view/sexual politics/family problems. And, perhaps most tellingly, none of his clothes came from Goodwill. Todd was a good old-fashioned nerd, so when he told me that he was a salaried porn web designer, I was a little surprised.

Turns out there was an opening for a "video artist" at the smut shack where he worked. Having spent the better part of the '90s constructing willfully obscure slabs of video funk designed to bore the average viewer into a coma, I felt eminently qualified for the position. Of course, they weren't looking for someone to spice up the 24-hour potty-cam site with endless, static shots of escalators (an old specialty of mine); actually, they wanted someone who knew how to use a Macintosh. "Are you familiar with [insert intimidating-sounding software names here]?" I once failed a Microsoft Word test at a temp agency. My high-tech illiteracy coupled with what I considered to be an incompatible primary gig persuaded me to decline the offer. That is, until Todd threw out a ballpark hourly wage. I immediately experienced a most remarkable increase in computer literacy.

I figured lying my way into porn was a venial sin at worst. And ain't no sin like a good sin.　　　　　　　　　　　　　　　　—Chuck Bronco

Contents

The Pick-Up Scene
in El-Lay

The beautiful thing about love is that you never know where you'll find it. Possibility lurks in the air, and while they say looking too hard will chase love away, it can't hurt to be watching sly out of the corner of one eye. The man of your dreams, the mother of your children, your soul mate in eternal bliss—if you're an optimist you take comfort in the fact that he or she is out there somewhere and all that's left to do is to stumble into one another.

The question is where.

Is your Romeo lurking in the crowded dark corner of a tiny bistro? Is your Juliet shaking her thang on a nightclub dance floor? Or is your would-be lover simply slouching ahead of you in the check out line, thumbing the *TV Guide* while the cashier rings up his pack of Pall Malls and pint of vanilla?

Maybe you can't count on finding your destiny at the local Ralph's market, but it helps to keep your options open. There are literally hundreds of clubs, bars, and unexpected places to stumble into that soul mate in the endless sprawl Joan Didion called "a suburb looking for a city;" the real trick is to get out of your house (or hotel or motel or rented bungalow) and go. While the pages that follow comprise merely a tip of that mammoth LA-pick-up-spot iceberg, it will at least give you a sweet little taste of the possibilities.

So put on your best dress, throw on some cheap cologne, and paint the town red. You may not find love, but you might just find friendship, free drinks or cheap sex, which are the next best things.

469-CALL

<div style="border:1px solid">

After-Hours

Who wants to sleep when you can dance, dance, dance? Los Angeles has a slew of good spots to get your groove on while the rest of the world sleeps. Pity them.

</div>

Club Nympho

At Sky Sushi: 7901 Santa Monica Blvd. (at N. Fairfax Ave.), West Hollywood; (323) 654-4682. Open Thursdays: 2 a.m.–6 a.m.

If a night of high-priced cocaine and silicone-enhanced companionship is just so damn magical you can't stand for it to end, then rev up the Lexus and mosey on over to the aptly named Nympho, Sky Sushi's Thursday-evening after-hours. Themed nights like Sexy Pajamas keep the clothing to a minimum and atmosphere appropriately risqué. Expect a crowd of the beautiful and open-minded variety.

—JH

Does Your Mama Know (DYMK)

At Coconut Teaszer: 8117 W. Sunset Blvd. (at N. Crescent Heights Blvd.), Sunset Strip; (323) 654-4773; www.doesyourmamaknow.com. Open Saturdays: 3 a.m.–9 a.m.

Right in the heart of Sunset Strip, Does Your Mama Know is one of the longest-running after-hours clubs in town. A mixed crowd of late-night crawlers sporting an air of availability make this the place to go if you've had no luck by 2. If you're still alone at dawn, take solace in the fact that the bar opens at 6 a.m., and then go ahead and drown those sorrows in a sea of cheap beer.

—JH

"Whether a **long** one or a **thick** one it matters not, as long as it **satisfies** in abundance."

— ISLAMIC PROVERB

Giant

At Park Plaza Hotel: 607 S. Park View St. (at W. Sixth St.), MacArthur Park; (323) 464-7373; www.giantclub.com. Open Saturdays: 9 p.m.–4 a.m.

With zoned-out ravers; Armenian men in overalls, cowboys hats, and no shirts; cute gay boys; scantily clad ladies; and umpteen rooms of slamming music, Giant is the club with a little bit of something for everyone. Now in its new posh digs at the Park Plaza Hotel, you can dance in art-deco delight as the world's hottest DJs spin the night away. Some advice: Get there early, because the line is massive, just like the club.

—JAG

It's Not THE Heat, It's THE Humility
On Not Getting Laid in Los Angeles

Los Angeles, perhaps more than anywhere else in America, is a city whose very foundation—hollow and seismically active as it may be—is built on sex, or at least the promise of sex. From the grimy anonymity of Hollywood Boulevard to the plastic fantasia of HOLLYWOOD™, the disposability of skin-deep beauty and puddle-deep intellect hangs thick in the air like mid-summer smog. How frustrating, then, to not actually be having sex in Los Angeles.

Not having sex can be frustrating in any zip code, but nowhere is one more painfully aware of one's chastity than in LA, where checking out the driver in the next car is the number-one stoplight activity. That's just the law of this particular jungle, and sleeping in the jungle alone sucks. To live in LA involuntarily celibate is to see the city as a decidedly unsexy dystopia of missed chances and missed connections. (Whether or not any of this is actually true is, like so much else in LA, gloriously beside the point.). If Miami is "One big pussy, waiting to get fucked," as Tony Montana famously slurred in *Scarface*, then Los Angeles is one big tittie bar, waiting to throw you out and kick your ass if you get too close to the object of desire. This dynamic pervades the very geography—the beautiful homes in the hills lord over the city like dancers on a runway, there to be admired from a distance. The Hollywood sign might as well have a big pole in the middle.

Look but don't touch, every man for himself. By himself. Of course, romanticizing not getting laid is clearly the desperate act of someone who really, really needs to get laid. I think Kierkegaard said that. Or maybe Jim Morrison. —Steve Kandell

 NIGHTLIFE

Pick-Up Scene

Last Man Standing

At The Garage: 4519 Santa Monica Blvd. (at Virgil Ave.), Silver Lake; (323) 288-6173. Open Sundays: 6 a.m.–3 p.m.

If you still haven't had enough, head over to The Garage for some ass shaking, some booty smackin', and cold beer for brunch! Opening just when most after-hours close, Last Man Standing is for the truly devout partier. Remember what Mama said; "Early birds get the cheap drafts!"

—JH

Move

At Grand Ave.: 1024 Grand Ave. (between Olympic Blvd. and 11th St.), Downtown Los Angeles; (310) 885-6544, (213) 891-2775; www.clubmove.com, www.clubnakedla.com. Open Fridays: 9 p.m.–6 a.m.

This is where the beautiful people go when the rest of you peons are getting some shuteye. Hot gal go-goers, DJs kickin' the latest and greatest, specialty theme nights (Club Naked, anyone?), and a see-and-be-seen atmosphere make this the spot for hot action pick ups! Bring your Motorola three-way and as little clothing as possible.

—JH

The Downtown Professional Scene

Downtown—all tall buildings and big money. Where do folks who work in our fair city's psychic heart drink and play? Look no further than the places below.

Cole's P.E. Buffet

118 E. Sixth St. (just east of S. Main St.), Downtown Los Angeles; (213) 622-4090. Open Daily: 9 a.m.–10 p.m.

If you're looking for that special dynamite drink at lunch, bartender Marti Mazarei is your pal. If asked nicely, Marti will serve something strong—have a gin and tonic, or that extra martini, won't you—with an extra-good corned beef on rye sandwich. Bottoms up!

—Steve Allison

McCormick & Schmick's

633 W. Fifth St. (at S. Grand Ave.), Downtown Los Angeles;
(213) 629-1929. Open Daily: 11a.m.–11p.m.

With its massive Happy Hour on Fridays from 3:30 p.m.'til closing,
McCormick & Schmick's is the best bargain bet Downtown. If you can't
pick up a chick here, it's probably because you can't pick yourself up off
the floor. Bon appétit.

—Steve Allison

Millennium Biltmore Hotel's Gallery Bar

506 S. Grand Ave. (at W. Fifth St.), Downtown Los Angeles;
(213) 624-1011. Open Mon–Sat: 4:30 p.m.–1 a.m., closed Sun.

This is just one—maybe the best too—of the many bars and dining
establishments at the historic Biltmore, making it the first choice for
illicit affairs (they even have an area called the Rendezvous Court). Just
bring your dark sunglasses and a hat.

—Steve Allison

Windows Steaks & Martinis

Transamerica Tower, 1150 S. Olive St. (between W. Olympic Blvd. and
W. 11th St.), Downtown Los Angeles; (213) 746-1554. Open Tues–Sat: 5
p.m.–10 p.m., closed Mon and Sun.

Over 50 types of martinis served means you're sure to find a very strong
drink that she'll like, which is always good. The view of Downtown's indus-
trial side doesn't hurt things, and Windows also has one of the best steaks
in town—red meat always does a good job of sopping up that booze.

—Steve Allison

"I **dress** for women and
undress for men."
— A N G I E D I C K I N S O N

Pick-Up Scene

Beverly Hills the Agent's Way

Travel west of La Cienga Boulevard to mingle with the industry's movers and shakers. Want a stiff drink, a stiff bill, and stiff fake breasts? Then these are the places for you.

C Bar

8442 Wilshire Blvd. (east of N. La Cienega Blvd.), Beverly Hills; (323) 782-8157. Open Mon–Fri: 5:30 p.m.–2 a.m., Sat: 6:30 p.m.– 2 a.m., Sun: 8 p.m.–2 a.m.

The swank factor at this art deco-style Beverly Hills hideaway is severely enhanced by the caviar blinis and the wide selection of vodka martinis. If none of the hip Industry folks or open-minded execs from the Flynt Publications building next door look your way, you can always take home the plastic mermaid hanging off the edge of your cocktail glass.

—JAG

The Club Bar at the Peninsula Beverly Hills

9822 Little Santa Monica Blvd. (south of Wilshire Blvd.), Beverly Hills; (310) 551-2888. Open Daily: 1 p.m.–12:30 a.m.

Looking for love, good people watching, or a new agent? Perhaps you just want to people-watch. This is the place for all of the above. Very expensive and super-duper flashy, The Club Bar at the Peninsula is the nexus for Industry bigwigs and pretenders on the make. Which are you?

—JAG

Polo Lounge at Beverly Hills Hotel

9641 Sunset Blvd. (at N. Beverly Dr.), Beverly Hills; (310) 276-2251. Open Daily: 7 a.m.–1:30 a.m.

Super-expensive and still chic after all these years, the Polo Lounge was and still is the place to have an intimate meeting with a client or for an after-work rendezvous. Stick to the piano bar to meet the cashmere-clad coquette of your dreams, then take her to the main restaurant or the out-door covered patio area. In any one of the cozy spots, you can't go wrong.

—JAG

I'm With THE Band
Groupies Rock The Strip

Pick-Up Scene

Los Angeles, the land of dreams and illusion, is at least a temporary destination in the career of any self-disrespecting rock star. And if these streets (most notably, Sunset Boulevard) could talk, they would tell many a salacious story of groupies and the bands' members they've loved.

Former San Fernando Valley girl and author of the groupie bible *I'm With the Band*, Pamela Des Barres is the original and most (publicly admitted) accomplished groupie; hell, she even had her own LA-based band for a bit, the Frank Zappa–mentored GTO's (Girls Together Outrageously), and how many groupies could say that?

Young Pamela repeatedly resisted Mick Jagger's advances because she thought she and Jimmy Page were exclusive steadies. Of course, Mick eventually convinced her that Jimmy was no more a saint than any touring musician would be, thus breaking Pamela's will. And really, who didn't bonk Jimmy back then? All the famed groupies had relations with Jimmy: Lori Maddox (who supposedly broke up Pamela and Jimmy's "relationship"); Sable Starr (alleged inspiration for Sid Vicious's tragically obsessed "must-have-a-Sex-Pistol" girlfriend/groupie Nancy Spungen, who did not sleep with Jimmy but was linked to the least sexually active Rolling Stone, Keith Richards); Connie Hamzy, who begat the "Quantity vs. Quality" theory of groupies, popularized by the "gimme-gimme" '80s hair bands and their hordes of literal cocksuckers. Des Barres was also attached to Don Johnson and The Who's Keith Moon.

Almost all of this groupie action happened on the infamous Sunset Strip. Clubs like The Whiskey, The Roxy, and the dearly departed (especially Gazzari's, Sea Witch, and Pandora's Box) helped usher in the rock-and-roll lifestyle most of us take for granted. But the real action was at the Hyatt House, a.k.a., the Riot House. This is where Led Zeppelin rode Harley-Davidsons through the hallways and The Who threw TVs from the balconies. This was groupie central, where dreams were made and hearts were broken.

Sadly, these days are no more—either today's rock stars are too concerned with sensitive-guy appearances to keep a supply of "band aids," or the tell-all hasn't been written yet. We're waiting for Pamela Anderson's autobiography. —Sally Kleinbart & Jon Alain Guzik

Pick Me Up IN THE San Fernando Valley

Face it, the Valley sucks. Really, it does. I grew up in Tarzana, whoo hoo!, and look what happened to me—I'm writing a guidebook to LA called *Horny?*. That said, if you live, or even love, in the Valley, there is a tiny glimmer of hope for your love life. Not much. And as Dante says about the SFV, "Abandon All Hope Ye Who Enter Here."

There are a few coffeehouses and bars in the Valley that rock in that "we're in the suburbs but we're not giving up yet" kind of way. **Lulu's Beehive** in Studio City is a good place to grab a cuppa coffee and ogle the actor/actressy girls and boys, and they're open late, which is more than you can say for the rest of Studio City. Also, **Starbucks** on Ventura just West of Laurel Canyon and the **Horseshoe Coffeehouse** in Sherman Oaks are prime East Valley pick-up spots too.

If you need a little more than just caffeine to keep you from going nuts in the Valley, there are a few good bars. Try the old school Mexican charm of Valley institution **Casa Vega**. Here, everyone has a tan, is an actor, musician, grip, spokesmodel, pornstar—whatever—and they all love to party, party, party. You won't find more fun on Ventura Blvd., the East Valley's main strip. Also, try **The Blue Room** in Burbank and **Viva Fresh Mexican Restaurant**, the Valley's only remaining cowboy bar for all your country-and-western needs.

In the West Valley, there are the **Pickwick Pub**, a good English pub; **Casey's Tavern,** a low-key old-man bar slowly being overrun by the disaffected youth of today; and **The Scotland Yard**, with its good selection of beer and the occasional DJ (where you can, if you close you eyes, feel like you are over the hill).

But the Valley is more than just bars and coffeehouses, it's also a good place to take a hike, and maybe make out. Try the **Manson Caves**, where Charlie and the whole brood loved and murdered at Santa Susanna Pass and Topanga Canyon Boulevard. Also, my fave make-out spot is south of Ventura Boulevard at the top of Vanalden Street in Tarzana; with a good view of the shimmering Valley below, you can have your cake and eat it too. If these don't work, do what I did as a kid: pimp some beer and hang out in a parking lot. You're bound to get laid like that.

—JAG

See next page for the Valley digits.

The Digits for the Valley

The Blue Room: *916 S. San Fernando Rd. (at Alameda Ave.), Burbank; (323) 849-2779.*

Casa Vega: *13301 Ventura Blvd. (at Fulton Ave.), Sherman Oaks; (818) 788-4868.*

Casey's Tavern: *22029 Sherman Way (west of Topanga Canyon Blvd.), Canoga Park; (818) 992-9362.*

Horseshoe Coffeehouse: *14568 Ventura Blvd. (west of Van Nuys Blvd.), Sherman Oaks; (818) 986-4262.*

Lulu's Beehive: *13203 Ventura Blvd. (west of Coldwater Canyon Blvd.), Studio City; (818) 956-2233.*

Manson Caves: *at the Santa Susanna Pass and Topanga Canyon Blvd., Canoga Park.*

Pickwick Pub: *21010 Ventura Blvd. (west of DeSoto Ave.), Woodland Hills; (818) 340-9673.*

The Scotland Yard: *22041 Sherman Way (west of Topanga Canyon Blvd.), Canoga Park; (818) 703-9523.*

Starbucks Coffee Co: *12170 Ventura Blvd. (at Laurel Canyon Blvd.), Studio City; (818) 762-9368.*

Viva Fresh Mexican Restaurant: *900 W. Riverside Dr. (at S. Main St.), Burbank; (818) 845-2425.*

Parking lots in the Valley are bountiful!

The Windows Lounge at the Four Seasons Hotel

300 S. Doheny Dr. (north of Olympic Blvd.), Beverly Hills; (310) 273-2222. Open Daily: 10 a.m.–2 a.m.

The Windows Lounge at the Four Seasons Hotel is a great place for a business meeting by day or just an after-work drink in posh and comfortable surroundings. Sit back and listen to the piano player, have a port or two, and while away the time thinking about love and money.

—JAG

"I'm always looking for **meaningful**
one-night stands."
– D U D L E Y M O O R E

Pick-Up Scene

The Celeb Scene

Regular folks love to go star watching. Love it! These are the choice spots to see them at night. If the places listed below aren't up to snuff, try cruising the shops in Beverly Hills. That usually works . . .

Bar Marmont

8221 W. Sunset Blvd. (at N. Harper Ave., just west of N. Crescent Heights Blvd.), Sunset Strip; (323) 650-0575. Open Daily: 6 p.m.–1:30 a.m.

This is still the place, with a butterfly-bedazzled ceiling and a million stars. Bar Marmont is a swell joint to take out-of-towners looking for some LA razzle-dazzle. Put a few back and ask that starlet to sneak into the Chateau's hotel pool with you. It's worth the drink in the face.

—JAG

Dan Tana's

9071 Santa Monica Blvd. (between N. San Vicente Blvd. and N. Robertson Blvd.), West Hollywood; (310) 275-9444. Open Daily: 5 p.m.–1 a.m.

Old-school Hollywood flocks to this dimly lit and crowded West Hollywood restaurant right down the street from The Palm. The drinks are stiff and expensive and the food is swell, and the joint is always packed with celebs. How can you go wrong with a place that names a steak after Dabney Coleman?

—JAG

Les Deux Cafés

1638 Las Palmas Ave. (just south of Hollywood Blvd.), Hollywood; (323) 465-0509. Open Daily: Sun–Tues: 6:30 p.m.–11 p.m., Wed–Sat: 6:30 p.m.–2 a.m.

Proprietress Michelle Lamy holds court at this hip Hollywood haunt. Expensive people flock here for expensive food like a moth to a light bulb. The adjacent Cabaret Room hosts celebrity art parties. Just make sure you are well-dressed and beautiful if you aren't on the list.

—JAG

Skybar

8440 Sunset Blvd. (east of N. La Cienega Blvd.), Sunset Strip;
(323) 848-6025. Open Daily 11 a.m.–2 a.m.

Owned by Cindy Crawford's hubby and still, sort of, red-hot. Once the place
to see and be seen by A-list TV and movie folks, the Skybar is now filled with
those B-list TV and movie folks. You'll ask, "Er, um, what's his name?" a
lot here.

—JAG

Trader Vic's

9876 Wilshire Blvd. (at Santa Monica Blvd.), Beverly Hills;
(310) 274-7777. Open Daily: 5 p.m.–1 a.m.

The Polynesian décor and punchy tropical drinks have been drawing in
stars for, like, a million years. Jackson Browne and The Eagles used to
hang here, and nowadays you can still spot a celebrity or two hankering
for a mai tai (which was reputedly invented here in 1944). Vic's has stiff
drinks, cute girls, and is still packed to the rafters on the weekends.

—JAG

Curious?

Wanna party with buff queer boys and hot dykes? Who doesn't? If these
hot spots don't bring out the queen in you, nowhere will. Have fun and
wear your hot pants.

Akbar

4356 W. Sunset Blvd. (south of Fountain Ave.), Silver Lake;
(323) 665-6810. Open Sat–Thurs: 7 p.m.–2 a.m., Fri: 6 p.m.–2 a.m.

Akbar has it all—cute gay punk rock boys, a good jukebox with exotic
French pop, and $2 wells on Mondays and $3 cosmos on Wednesdays.
And the gorgeous portraits of reclining, nude odalisques will surely put
you in the mood.

—JAG

Club 4067 at Catch One

4067 W. Pico Blvd. (between Arlington Ave. and Crenshaw Blvd.), Mid-City; (323) 734-8849. Open Saturdays: 9 p.m.–4 a.m.

Catch One hosts some very naughty theme nights (call for a schedule), but Club 4067 is certainly one of the most fun. A gay/straight, mostly black and Latino crowd (everyone feeling the brotherly/sisterly love) gets their groove on to house and hip-hop while go-go dancers of all persuasions heat up the temperature on the two dance floors. Open 'til 4 a.m. for those late-night trysts.

—JH

The Factory

652 N. La Peer Dr. (between Melrose Ave. and Santa Monica Blvd.), West Hollywood; (310) 659-4551. Open Daily: 10:30 p.m.–3 a.m.

A fun industrial-themed gay hangout that's friendly to straights. With two full bars and an entrance connecting to the neighboring Ultra Suede lounge, The Factory offers everything for the curious straight male and his fag-hag friends. You can rub up against WeHo's finest as you dance, dance, dance.

—JH and JAG

Fubar

7994 Santa Monica Blvd. (two blocks west of N. Fairfax Ave.), West Hollywood; (323) 654-0396. Open Daily: 4 p.m.–2 a.m.

This place is as democratic as it gets. The crowd ranges from hip celebs to Hollywood scenesters to ragged-looking Silver Lakers to WeHo muscle boys, and every single one of 'em is looking for action. Come on Sundays for the dollar drafts and watch the kids break the sexual binary.

—JH

"I believe that sex is a **beautiful thing** between two people. Between five, it's **fantastic.**"

— WOODY ALLEN

Pick-Up Scene

Baila, Baila, Baila
Dancing in the Ranchera *Scene*

If you want to dance to Latin music in Los Angeles, you have three options: salsa, regional Mexican, and tropical-music nightclubs. At Mexican clubs, you'll find tall men in white cowboy hats and crisp shirts unbuttoned down to their chests and sweet secretaries and *mamis* on their weekend outings. The music—*norteñas, rancheras*, and occasionally *boleros*—is sweet, soulful and organic, played on accordions and sometimes incorporating mariachi stylings. Tropical-music clubs, depending on the ownership, play everything from Mexican *rancheras* to *merengue*, with a good sprinkling of *cumbia*, Colombian dance music with a throbbing, infectious back beat. The basic difference between *norteña* and *cumbia*—we're talking dance steps here—is that, as one *norteña* devotee told me, "*A mi me gusta abrazar a la mujer*," which more or less translates to "I like to dance close." Dancing to *norteñas*, the man's hand is firmly on the woman's back, and they circle around one another as fast or slow as the song requires. It's not unlike prom dancing. In *cumbia*, traditionally the partners' feet must always be facing one another at a respectable distance. It is a dance of courtship (I remember a beautiful boy I met at a *cumbia* club years ago gently pushing me away every time I tried to get closer to him), though nowadays, *cumbia* has been somewhat salsa-fied. And, if you aren't having enough fun, the club may throw in a bit of *merengue*, which always leads to a shocking amount of crotch rubbing.

Are these clubs good places to go if you're, er, horny? Well, the chances for meeting people are very good for both sexes, especially if you speak Spanish (or are willing to try) and don't mind being the same height as your male partner or towering over that pretty lady in the tiny dress. There's no better way to meet a person than that old standby, "*¿Quieres bailar?*" It's good to be aware of Latin club etiquette—partners almost always sit between songs, and flirting while dancing is nonexistent. In fact, partners hardly talk or look at one another. Still, I rarely leave without a few new friends. Just like any other club, men show up alone more than women, who come with their men or in groups. Whatever the case, it's all about the dancing, which, as everybody knows, can be the sweetest physical high of all.　　　　—Melissa Bellovin

See p. 120–121 for Melissa's picks of the best ranchera *and tropical-music clubs in town.*

Pick-Up Scene

Eastside Hipsters Unite

Have a penchant for underfed musician and artist types who subsist entirely on cheap beer, cheap coffee, and continuous bong hits? Looking for a lover whose collection of rare vinyl rivals only your own? Then east of Western Avenue is the place for you.

The Drawing Room

1800 Hillhurst Ave. (north of Hollywood Blvd.),
Los Feliz; (323) 665-0135. Open Daily: 6 a.m.–2 a.m.

Oh the joys of the mini-mall barroom. In the mornings this place is host to alcoholic early-risers, but by night it's bustling with neighborhood young'uns searching for a little sympathy. The décor may not be the classiest (a well-used dart board, some dusty trophies), but bartenders are bawdy and there's always a nice feeling of drunken camaraderie hanging in the stale air.

—JH

The Roost

3100 Los Feliz Blvd. (east of Glenfeliz Blvd.), Atwater Village;
(323) 664-7272. Open Daily: 10 a.m.–2 a.m.

A red-pleather wonderland in the heart of Atwater Village, The Roost features all the dive essentials: cheap but strong drinks, a killer jukebox, and a dart board perfectly situated to endanger any and all bathroom visitors. The cranky owner and the complimentary popcorn keep a drunken single just sober enough for sloppy sex with a newfound friend.

—JH

"The function of **muscle** is to pull
and not to **push** except in the case of the
genitals and the tongue."
— L E O N A R D O D A V I N C I

The Short Stop

1455 W. Sunset Blvd. (at Sutherland St., between Echo Park Ave. and Elysian Park Ave.), Echo Park; (213) 250-5902. Open Daily: noon–2 a.m.

Once a hangout for off-duty cops, The Short Stop is now filled to the brim with Silver Lake scenesters on the make. The drinks are moderately priced, and although the place is a dump, pool tables and faux-wood paneling lend a certain charm. You'll have fun despite yourself, especially if you lose your cool long enough to bust a move on the always raging dance floor.

—JH

Spaceland

1717 Silver Lake Blvd. (at Effie St.), Silver Lake; (323) 661-4380. Open Daily: 5 p.m.–2 a.m.

An Eastside staple. Host to both big-name and local rock acts, Spaceland attracts the sort of wildlife indigenous to the area, namely blank-eyed boys with identical shag cuts and the women who love them. A pool table and a Ms. Pac-Man grace the back room, and when the band sucks, you'll be thankful for the refuge.

—JH

Taix

1911 W. Sunset Blvd. (east of Alvarado St.), Echo Park; (213) 484-1265; www.taixfrench.com. Lounge Open: Mon–Sat: 11 a.m.–2 a.m., Sun: noon–9 a.m.

It's pronounced "Tex" and it's been dispensing clogged arteries since 1927. Imagine if Pea Soup Andersen's (you know the ones along the 5), transmogrified into an old-school French restaurant in Echo Park. That's right, Hap Pea and Pea-Wee are on the stage devastating open-mic nights Thursday thru Saturday nights, drinking the Taix Brew and eating some-Escoffier inspired cuisine. Good for dates, or maybe to meet one. *Bonne chance.*

—JAG

Pick-Up Scene

Pick Me Up in Pasadena

With its genteel vibe and sense of history—not to mention several college campuses—Pasadena, the City of Roses, is a great place to meet your prospective perennial or a one-night passionflower. Dig J.Crew-clad babes? Think Old Town Pasadena. The roving shoppers and night-crawlers hit the sidewalks en masse, hopping from shops to restaurants to bars on foot, which takes the usual barrier of automotive isolation out of the pick-up equation. Families, seniors, and couples turn out too, so the air just smacks of the sort of innocence that really turns some folks on. If the good ol' meat market is your thang, then meat you shall have! **Moose McGillycuddy's**, **McMurphy's Tavern**, **Q's Billiard Club**, and **The Muse** are all within walking distance and all heat up with twentysomethings blowing off steam.

If cuties in specs with a jones for caffeine are more your bag, hang out at **Equator** for lattes and killer pastries, **Relaxation** for popular tapioca pearl drinks, or move on over to the Playhouse District's magic coffeehouse–bookstore–movie theater combo. In East Pasadena try the two **Starbucks** on Foothill—one at Rosemead and the other at Halstead—they're only a couple blocks apart so both can be visited in your search for the hottest little espresso in town. Art students and grungier types frequent **The Colorado**, a hole-in-the-wall bar and former hangout for the lead singer of Stone Temple Pilots.

But the hands-down best way to pick up people in the 626 is to take a class at **Pasadena City College**. Here you will find thousands—I said *thousands*—of attractive men and women of all ages. Be sure to hang out in PCC's quad, where the men lounge (bare-chested on warm days) under the trees and where miniskirts and stilettos are de rigueur for the ladies.

Now that you've picked up, it's time to hook up. And Pasadena is home to a plethora of splendid outdoor make-out places. Drive to Eaton Canyon (off Altadena Drive) and enjoy the natural surroundings as you get in touch with your natural instincts, or cruise to the top of Lake Avenue and walk up into the mountains—though you may have to negotiate high schoolers sucking face. But if you really want a view to induce some heavy breathing, drive up Linda Vista Avenue to Lida Street, hang a left on Figueroa Street, drive to the end, and walk up the hill—Los Angeles and the San Gabriel Valley await as the perfect screen-kiss backdrop. If none of these stellar spots works, you might want to look within for the reason why you haven't been laid in the last five years. —Robert D. Petersen

See next page for the Pasadena digits.

The Pasadena Digits

Book Alley: 611 E. Colorado Blvd. (between S. Lake Ave. and S. Los Robles Ave.), Playhouse District; (626) 683-8083; www.bookalley.com.

Bungalow News: 746 E. Colorado Blvd. (at N. Oak Knoll Ave.), Playhouse District; (626) 795-9456; www.bungalownews.com.

The Colorado: 2640 E. Colorado Blvd. (at San Gabriel Blvd.), East Pasadena; (626) 449-3485.

Equator: 22 Mills Pl. (south of E. Colorado Blvd.), Old Town Pasadena; (626) 564-8656.

Laemmle Playhouse 7: 2588 E. Colorado Blvd. (between S. San Gabriel Blvd. and S. Altadena Dr.), Playhouse District; (626) 844-6500; www.laemmle.com.

McMurphy's Tavern: 72 N. Fair Oaks Ave. (at W. Union St.), Old Town Pasadena; (626) 666-1445.

Moose McGillycuddy's: 119 E. Colorado Blvd. (between S. Raymond Ave. and S. Arroyo Pkwy.), Old Town Pasadena; (626) 304-9955.

The Muse: 54 E. Colorado Blvd. (between S. Fair Oaks Ave. and S. Raymond Ave.), Old Town Pasadena; (626) 793-0608.

Pasadena City College: 1570 E. Colorado Blvd. (between Hill St. and Bonnie Ave.), Pasadena; (626) 585-7123; www.paccd.cc.ca.us.

Q's Billiard Club: 99 E. Colorado Blvd. (at S. Raymond Ave.), Old Town Pasadena; (626) 405-9777.

Relaxtation: 43 N. Fair Oaks Ave. (between Union St. and E. Colorado Blvd.), Old Town Pasadena; (626) 314-9868; www.relaxtation.com.

Starbucks Coffee Co.: 3699 E. Foothill Blvd. (at N. Rosemead Blvd.), East Pasadena; (626) 351-9994. Also at 3429 E. Foothill Blvd. (at Halstead Ave.), East Pasadena; (626) 351-8065.

Vroman's Bookstore: 695 E. Colorado Blvd. (between N. Lake Ave. and S. Los Robles Ave.), Playhouse District; (626) 449-5320; www.vromansbookstore.com.

Zona Rosa Café: 15 S. El Molino Ave. (south of E. Colorado Blvd.), Playhouse District; (626) 793-2334.

"I've been around **so long** I knew Doris Day before she was a **virgin.**"
— GROUCHO MARX

Pick-Up Scene

Hetero Heaven

You're a straight and on the make. You love to party hardy and how. These are the spots for you. Backwards baseball caps for the boys and micro-minis for the girls. And for God's sake, kids, use a condom!

Dublin's

8240 W. Sunset Blvd. (west of N. Crescent Heights Blvd.), Sunset Strip; (323) 656-0100. Open Daily: 10 a.m.–2 a.m.

If your dream of heaven is a giant sports bar filled with a million televisions sets, free peanuts, and lots of brew, not to mention packed with a million and a half young guns on the make, then this is the afterlife for you. Saint Peter, let me in.

—JAG

"During **sex** I fantasize that
I'm **someone** else."
– R I C H A R D L E W I S

Hooters

321 Santa Monica Blvd. (between Third St. and Fourth St.), Santa Monica; (310) 458-7555. Open Mon–Thurs: 11 a.m.–midnight., Fri/Sat: 11 a.m.–1 a.m., Sun: 11 a.m.–11 p.m.

"Welcome to Hooters . . . Hottest girls on the planet . . . How may I help you?" Aw, yeah. Hooters. What can you say about this place that hasn't already been written? You know the drill. Girls in short-shorts, stripper tights, and tight, and I mean *tight*, T-shirts. Also, sports, sports, and more sports, good-ass chicken wings, lots of booze, and did I mention the girls? God bless America!

—JAG

Also at: 130 Pine Ave. (between E. Broadway and E. First St.), Long Beach; (562) 983-1010.

2406 Newport Blvd. (at 24th St.), Newport Beach; (949) 723-5800.

96-98 E. Colorado Blvd. (between N. Fair Oaks Ave. and S. Arroyo Pkwy.), Pasadena; (626) 395-7700.

Madison's Neighborhood Grill

1037 Broxton Ave. (between Weyburn Ave. and Kinross Ave.),
Westwood; (310) 824-6250. Open Daily: 5 p.m.–2 a.m.

Deep in the heart of Westwood, this fratty UCLA hang is the hot spot for
pretty white college students deep in lust. Here, the Top 40 hits are
always blasting, and the place is always packed to the rafters. Marxism in
action, Long Island iced teas for everyone!

—JAG

Maloney's on Campus

1000 Gayley Ave. (at Weyburn Ave.), Westwood; (310) 208-1942.
Open Daily: 11 p.m.–2 a.m.

This pseudo-Irish pub is known around UCLA-infested Westwood
more for its Abercrombie-esque clientele than its sturdy pint of
Guinness. Irish may be the décor, but horny college kids is the atmos-
phere. At least they card hard; no fake ID-toting freshman here.

—Rebecca Lorimer

Miyagi's

8225 W. Sunset Blvd. (west of N. Crescent Heights Blvd.), Sunset Strip;
(323) 650-3524. Open Daily: 5:30 p.m.–2 a.m.

This Sunset Strip Japanese-themed joint has three levels, five booze and
seven sushi bars, and lots of clean-cut twentysomethings playing grab-
ass. In the old Roxbury's on Sunset location, memories of Shannen
Doherty slapping Bonita Money still flow through its veins. Ah,
Hollywood, you never fail us.

—JAG

"Men are creatures with two legs
and eight hands."
— J A Y N E M A N S F I E L D

Pick-Up Scene

Moose McGillycuddy's

119 E. Colorado Blvd. (east of S. Orange Grove Blvd.), Pasadena;
(626) 304-9955. Open Daily: 11:30 a.m.–2 a.m.

With two floors for dancing, 18 televisions for sports, and Happy Hour
specials for days, this Pasadena hot spot is a chum bucket of single San
Gabriel Valley hets. So go ahead, strap on your beer goggles and go muff
diving, you are in your element.

—JAG

901 Club

2902 S. Figueroa St. (at 29th St.), Downtown Los Angeles;
(213) 749-0865. Open Mon–Thurs: 9 a.m.–2 a.m. and after
Saturday night USC football games, closed most Fri–Sun.

After the 2-9 (see 29th Street Café) closes at midnight, many 'SCers
migrate down 28th Street to Figueroa where the trashy 901 Club awaits.
This is a place where Spring Break mentality is far from seasonal, and the
cheap drinks make horny kids way hornier. The alumni who come back
to try and get their freak on look downright pathetic sitting at the bar as
college couple after couple start making out right next to them.

—Rebecca Lorimer

29th Street Café

2827 S. Hoover St. (at 29th St.), Downtown Los Angeles;
(213) 746-2929. Open Mon–Fri: 11:30–midnight, closed Sat/Sun.

Because USC has a serious lack of decent places to drink, the 2-9, as the
kiddos call it, becomes flooded with Trojans (both kinds) on a nightly
basis. Athletes, Greeks, and happy smokers on the outside patio fill the
café/bar to the brim until moving ceases to be a possibility. Everyone
stands in place with their plastic cup of beer, so the swiveling heads tend
to cause major accidents. Watch out for that blonde ponytail!

—Rebecca Lorimer

I Like To Score
Club Kids Get It On

It's easy to score in LA club land if what you're looking for is pounding bass, pulsating glow sticks, and synthetic neuro-chemical pyrotechnics. Scoring anything of the naughty bits/human flesh variety can prove a more difficult task if you're not already on the inside of a deeply entrenched subcultural phenomenon that has its own tightly knit posse of devotees. Speaking and listening, usually two vital elements in the get-laid equation, are confounded by aural madness of the sort found in dance clubs.

On the upside, just about any club is a great place to find yourself on the receiving end of some loved-up E-tard in search of a Roll-Aid. Just look for saucer eyes and start hugging, and if you play your cards right, you'll be balls deep in no time. The best place to find one of these folks is at **Giant**, LA's only real superclub, which regularly features the best house and trance DJs in the world (i.e., Paul Oakenfold, Digweed).

If you are one of those actress-type chicks who can't get enough of cowboy hats and "I ♥ NY" T-shirts with one dance move that consists of raising your hands over your head and wagging your silicon assets (or, conversely, if you are a Buck Rogers kind of guy who digs said chicks and body modifications), then head directly to **Garden of Eden**, **Key Club**, **Blue**, **Sugar**, **Sixteen-Fifty** (formerly **Vynyl**), or the **Viper Room** for any of their weekly glitterati-packed nights. And guys—don't forget your black ribbed stretch-Ts, black slacks, Schwimmeresque coiffure, and shiny shirts.

For the true sounds of the underground and hardcore party people (and candy ravers camped out in bass bins), hit **Red** or **Traffic** on Friday nights (trance, techno), and **Spaceland** (Wednesdays) or the **Martini Lounge** (Thursdays) for jungle.

Don't forget your Vap-o-Rub, hug without prejudice, and carry a spare Blow Pop or two if you're looking to hit the hook shot at the end of the night. —Marty "Gemini" Jimenez

See next page for more details on the LA club scene .

See next page for more details on the LA club scene .

The Digits for LA Clubs

Blue: 1642 N. Las Palmas Ave. (between Hollywood Blvd. and W. Sunset Blvd.), Hollywood; (323) 468-3863. We like The Ibiza Foam Party (every other Tues night) and Magic (most Fri nights).

Club 7969: 7969 Santa Monica Blvd. (at N. Edinburgh Ave.), West Hollywood; (323) 654-0280. We like Release (every Wed).

Garden of Eden: 7080 Hollywood Blvd. (at N. La Brea Ave.), Hollywood; (323) 465-3336.

Giant: Park Plaza Hotel, 607 S. Park View St. (at W. Sixth St.), MacArthur Park; (323)464-7373; one Sat each month; call ahead.

Goldfingers: 6423 Yucca St. (between N. Cahuenga Blvd. and Wilcox Ave.), Hollywood; (323) 962-2913. We like Vinyl Dynasty (Wed nights).

Grand Ave: 1024 S. Grand Ave. (south of W. Olympic Blvd.), Downtown Los Angeles; (310) 885-6544 or (213) 891-2775.

Key Club: 9039 W. Sunset Blvd. (east of N. Doheney Dr.), Sunset Strip; (310) 274-5800. We like God's Kitchen (Sat nights).

Leonardo's: 831 S. La Brea Ave. (between W. Olympic Blvd. and Wilshire Blvd.), Hollywood, (323) 936-7155.

Martini Lounge: 5657 Melrose Ave. (at N. Gower St.), Hollywood; (323) 467-4068. We like Respect (Thurs nights).

Red: Ninth St. (between Hill St. and Broadway); Downtown Los Angeles; info line: (313) 390-9889. www.neoteq.net/redhome.htm.

Sixteen-Fifty (formerly Vynyl): 1650 Schrader Blvd. (between Hollywood Blvd. and W. Sunset Blvd.), Hollywood; (323) 465-7449. We like Deep (first and third Sun of the month) and Revival (second and fourth Sun).

Sky Sushi: 7901 Santa Monica Blvd. (at N. Fairfax Ave.), West Hollywood; (323) 654-4682.

Spaceland: 1717 Silver Lake Blvd. (north of W. Silverlake Dr.), Silver Lake; (323) 661-4380.

Spundae: 6655 Santa Monica Blvd. (behind Arena, between Seward St. and N. Las Palmas Ave.), Hollywood; (323) 462-5508; www.spundae.com. Sat nights.

Sugar: 814 Broadway (at Lincoln Blvd.), Santa Monica; (310) 899-1989. We like Pure (Sat nights).

Traffic: Fridays, call for locations, (323) 433- 3630.

Viper Room: 8852 W. Sunset Blvd. (at Larrabee St.), Sunset Strip; (310) 358-1880.

Late-Night Haunts

Who wants to sleep when you live in such an exciting and vibrant city? Or maybe you just live in Los Angeles and want to make this city exciting and vibrant. Here are a few diners open all night that will bring out the tiger in you!

Canter's

419 N. Fairfax Ave. (between Melrose Ave. and Beverly Blvd.), Fairfax District; (323) 651-2030. Open 24/7.

The infamous Canter's Deli is just the place if you want to end the evening with a stack of pastrami and a few looks of maternal disapproval from a gray-haired waitress who's seen your kind before. Try the matzo ball soup (delish!) while you flirt over the booth in a last-ditch effort to get laid. After 2 a.m. most of the crowd here is at least half in the bag, so take heart, the odds are with you.

—JH

Fred 62

1850 N. Vermont Ave. (at Russel Ave.), Los Feliz; (323) 667-0062. Open 24/7.

You may have to wait an eternity at this retro-styled über-diner for some overpriced French fries, but if it's 4 a.m. and you're in dire need of some hot grub and company, then Fred 62 ain't half bad. Drunken (but fashionable!) hipsters flock here once the Eastside bars close shop, so enjoy the scenery while taking the edge off an imminent hangover.

—JH

Norms

470 N. La Cienega Blvd. (between Melrose Ave. and Beverly Blvd.), Sunset Strip; (323) 655-0167. Open 24/7.

Space-age-modern Norms on La Cienega is a great place to wind down your evening of mirth. Always packed with post-club party-goers, Norms has all the grease you need to empty out the booze you've been filling you gullet with. If the bar didn't work out, maybe you'll find a love connection here. Irish Nachos, anyone?

—JAG

Pick-Up Scene

The Pantry

877 S. Figueroa St. (at W. Ninth St.), Downtown Los Angeles;
(213) 627-6879. Open 24/7.

Did you know that The Pantry uses 30 tons of celery, 2,190 gallons of
syrup, and 15 tons of sugar each year? Me neither. Open 24/7 since 1924,
The Pantry's always been there for late-night Los Angeles, serving up
appropriately greasy steaks, chops, and pancakes. A great place to pick
up cute post-club Latina girls or grab some post-coital protein.

—JAG

"**Sex** is like money:
only **too much** is enough."
— JOHN UPDIKE

AA, NA, OA
Any Way You Spell It, Equals S-E-X

Alcoholics Anonymous (and all its offshoots: Narcotics Anonymous,
Cocaine Anonymous, Gluehuffers Anonymous, on and on, world with-
out end, amen) is a 12-step program to help people addicted to alcohol.
That is people who cannot function normally, cannot even begin to
understand a life without being high in some way, do not know when to
say when. It is not a secret society, a society of secrets, a religion, a cult,
or a hip place to hang out. It is a serious, anonymous program that has
helped many messed-up people live better lives.

That said, it is also a great place to get laid. Face it, take away the junk
from the junkie and you got a hot, heroin-chic, skinny little lust monkey
just jonesing to fill that void with some sort of ecstasy that doesn't come
in the form of a pill, pipe, spike, or bottle.

Here in LA (Lusters Anonymous?) you've got the ex-rockers, movie
star, models, zoo keepers, sitcom writers all trying to clean up so as to get
their careers back on track. So not only can you get laid but you can also
boff someone FAMOUS. Most meetings are open to anyone who comes
through the door. There are also Al-Anon meetings for friends and fam-
ily who are affected by being around an alcoholic—good if you're look-
ing for someone co-dependent. Meetings are easy to find: Just look for
tattoos, cigarettes, and coffee. Or look in the phone book. AA has an
easy-to-reach hot line.

Sanamluang Café

5176 Hollywood Blvd. (at Kingsley Dr., east of Western Ave.), Hollywood; (323) 660-8006. Open Daily: 10 a.m.–4 a.m.

Convenient to most of Hollywood's nightspots and employer of some of the hottest waitresses in town, this Thai staple is packed with club kids— Asian, Anglo, straight, gay, and otherwise—into the wee hours. If you're not jacked up already, the potent Thai iced coffee should do the trick as you slurp suggestively on your noodles while making eyes at the babes at the next table.

—JAG

Pick-Up Scene

The pluses:

+ You will meet people you think are hot. Sober people tend to stick together, so it's easy to end up going out for coffee with a group of them.

+ You will get phone numbers. It is the program's 12th step that talks about helping other alcoholics, and that includes making oneself available in a TIME OF NEED.

+ You may even get sober.

The minuses:

− If you don't belong in an AA meeting (i.e., you can drink/drug like a "normy"—rhymes with "horny"), it will begin to show pretty soon and you will be shunned.

− You may think you are really lucky to get this hot babe only to find out they are still getting over their "old ways" and they have stolen your wallet or purse in the morning.

− Going to AA may screw up your drinking/drugging for the rest of your life. AA's program seeps in very fast and you may feel guilty next time you sip, dip, sniff, or puff.

Remember: Alcoholics need love too. And sex. And where else are they going to find it—a bar? As they say in every meeting: "Keep coming back—it works!" —Noel

Alcoholics Anonymous: (323) 936-4343, www.aa.org.

Narcotics Anonymous: (800) 863-2962, www.na.org.

Swing It, Sister
The Great Husband Swap

As is the way with most social deviancies, swinging—once relegated to boho free lovers or horny artistic types looking to "expand their horizons"—became the favorite hobby of many a suburban nine-to-fiver circa 1975. Like all good things '70s, swinging is back—and while Bob and Cindy down the block may seem like a normal couple (picket fence, two kids, and a new Toyota), don't be surprised if they're spending their weekend "gettin' and givin'" with a host of naked unknowns.

The craze for swappin' the flesh with other exploratory marrieds has spread throughout these fine States, but it's right here in the Southern California suburbs where you'll find the mother lode of organized swingers clubs. Some, like the infamous **Freedom Acres** (one of the oldest clubs in the country) or naughty **Naked City** (see p. 153) are established locations which provide couples with amenities conducive to meeting and mating, while others are merely "social clubs" which hold meet-and-greets in hotels or private homes.

If the long years together have sucked the well of passion dry and you're looking to put the zing back in your marriage, swinging may be just the thing for you. But it's not all peaches and cream. Drawbacks do exist, such as jealousy and hurt feelings, the possibility of disease, or the imminent disappointment you'll experience at the realization that not all swingers look like Pam and Tommy Lee. But if you can put aside your emotional attachments, throw on a condom, and turn off the lights, swinging just may give you back the sex you deserve.

Freedom Acres offers one of the best starting points for those desiring to dip their toes in the cool waters of swing with their informative and easy-to-understand web site. You can find out what to expect (sex!), what the rules are (no means no!), and how to locate other private and public clubs in the area. For those who want to take it slow in the city, Beverly Hills nightclub Calibar offers **Impulse**, a night with an emphasis on "expanding your relationships" (wink wink, nudge nudge). —JH

"Tell him I've been too **fucking busy—
or vice versa.**"

— D O R O T H Y P A R K E R
when asked why she had not delivered her copy on time

Impulse: at Calibar, 9667 ½ Wilshire Blvd. (between Brighton Way and Bedford Dr.), Beverly Hills; (310) 777-0065. Second Saturday of each month: 9:30 a.m.–1:30 p.m.

Freedom Acres: private location in San Bernardino County, members only, couples only. Couples should call (909) 887-6898 or (909) 887-8757 for more info. Open Fri: 8 p.m.–4 a.m. and Sat: 8 p.m.–10 a.m.

Both on-premise (as in, sex allowed) and off-premise (as in, come back to my place later) clubs abound in the Southland (and elsewhere) in the darnedest places from La Habra to Buena Park. The mother of all resources to find one near you is **NASCA International,** www.nasca.com.

Meeting M/A/Ws—Model/Actor/Whatevers

They are models, they are actors, they are whatever. When not running lines or practicing their poses, they are out and about. Los Angeles is full of these M/A/W types. Beware.

Deep

1707 Vine St. (between Hollywood Blvd. and Franklin Ave.), Hollywood; (323) 462-1144. Open Wed–Sat: 8 p.m.–2 a.m., closed Sun–Tues.

At this sceney Hollywood-meets-Caligula night spot you can sip cosmos with a beautiful crowd as you watch sexy half-naked dancing girls (and the occasional boy) bump and grind in a glass box behind the bar. A sex-themed club where the food is good too? Who'd a thunk it?

—JAG

El Carmen

8138 W. Third St. (west of Crescent Heights Blvd.), Fairfax District; (323) 852-1556. Open Mon–Fri: 5 p.m.–2 a.m., Sat/Sun: 7 p.m.–2 a.m.

Nestled among the Mexican wrestling posters and supple leather masks of their combatants is the foxy and thirsty El Carmen crowd. The mix of reasonably priced, well-crafted cocktails and that certain ambience of sweaty, makeup-clad Mexican men grappling each other will make you shut up and get in the ring.

—Chad E. Brown

Pick-Up Scene

4100 Bar

4100 Sunset Blvd. (at Manzanita Ave.), Silver Lake; (323) 666-4460.
Open Daily: 8 p.m.–2 a.m.

Alternately known as the Manzanita Room, the 50/50 Bar, and now the
4100 Bar (and formerly rough-and-tumble gay leather bar Detour), this
hotbed of Eastside locals is big enough to stretch out in, but cozy enough
for whispering, usually in the ear of your new friend. Gazelle-like bar-
tenders make the drinks strong, and the patrons, both gay and straight,
spend the night choosing tunes from the free jukebox and choosing
potential bedmates from the delectable selection.

—Travis Stevens

Jones

7205 Santa Monica Blvd. (between N. Gardner St. and N. La Brea
Ave.), West Hollywood; (323) 850-1726. Open Mon–Fri: 3 p.m.–
1:30 a.m., Sat/Sun: 5:30 p.m.–1:30 a.m.

On any given night at Jones, you can pull up to the long wooden bar,
order a martini, and find a host of some of the most attractive and
approachable people in Hollywood. If the deep-red lights and the six-
foot pinup girls painted in the decadent back room don't put you in the
mood, then the bathroom walls covered with snapshots of flashing
patrons sure will.

—Aaron Reardon

Kane

5574 Melrose Ave. (between N. Rossmore Ave. and N. Wilton Pl.),
Hollywood; (323) 466-6263. Open Mon–Fri: 6 p.m.–2 a.m., Sat/Sun:
8 p.m.–2 a.m.

Kane's copper-lined bar provides grounding for the sexual electricity
that crackles about the crowd when this hotspot gets fired up. Grab a
large leather booth and sweet-talk your favorite boy, or fall for the seduc-
tion of the three scantily clad sirens who emerge to dance as DJs spin
music over the dance floor.

—Aaron Reardon

Pick-Up Scene

Lava Lounge

1533 N. La Brea Ave. (north of W. Sunset Blvd.), Hollywood;
(323) 876-6612. Open Daily: 9 p.m.–2 a.m.

The Lava Lounge distills sex by immediately bathing patrons in a thick curtain of red light. This hipster hangout plays host to some of the best live surf, punk, and funk acts and DJs around. The dance floor provides an area where you can get sweaty with new friends, while tiny tables in the back allow for more discreet interactions. The lava rocks won't be the only things smoking.

—Aaron Reardon

Max's Bar & Grill

442 N. Fairfax Ave. (between Beverly Blvd. and Melrose Ave.),
Fairfax District; (323) 651-4421. Open Daily: 6 p.m.–2 a.m.

Beautiful bartenders mix the finest love potions, and a packed house of various cliques all eye each other with delicious hormonal urges. If you're a weekend warrior, a Sunday sinner looking for quiet hangover salvation, or merely a mid-week rocker, Max's goes off eight days week.

—Travis Stevens

Vida

1930 Hillhurst Ave. (between Franklin Ave. and Los Feliz Blvd.),
Los Feliz; (323) 660-4446. Open Tuesdays: 10 p.m.–2 a.m.

Usually an upscale restaurant, on Tuesday nights Vida is packed to the brim with the pretty people, most of them dewy-skinned and barely of age. As the resident DJ spins "Raw Power" at a deafening volume, horny young ladies and gents make obvious eye contact while pushing and shoving their way toward the cheap well drinks and free fried macaroni-and-cheese-ball appetizers.

—JH

"The last **sexual frontier** isn't some intergalactic data fuck: it's **your ass.**"

— L I S A P A L A C

Pick-Up Scene

Mods and Rockers

For those about to rock, we salute you. These bars could, as Mick says, "make a dead man cum." Shag haircuts, hip huggers, and a stripper girl-friend are recommended, though you may meet the latter at any of these joints.

Boardner's

1652 N. Cherokee Ave. (south of Hollywood Blvd.), Hollywood; (323) 462-9621. Open Daily: 11 a.m.–2 a.m.

Old-school Hollywood bar turned '80s metal hangout turned club-kid nightspot has had more incarnations than John Travolta's career. The jukebox still has all the rock you'll need and all the cheap beer (and girls) you'll want. If you squint, you can still see the ghost of Randy Rhoads and Bogart, and that's saying a lot.

—JAG

Bob's Frolic Room

6245 Hollywood Blvd. (east of Vine St.), Hollywood; (323) 462-5890. Open Daily: 6 a.m.–2 a.m.

Even though the really un-rock Pantages theater is next door, the Frolic Room is still a great place to see the heart of rock-and-roll. This writer once witnessed a sexy young hipster chick do the bump-and-grind to The Doors classic "LA Woman" on the jukebox, and you can't get more rock-and-roll than that.

—JAG

Burgundy Room

1621 ¹/₂ N. Cahuenga Blvd. (south of Hollywood Blvd.), Hollywood; (323) 465-7530. Open Daily: 8 p.m.–2 a.m.

A super-cool hang right in the heart of new Hollywood, the Burgundy Room has all the rock that's fit to play, either by a mullet-headed DJ or from the best jukebox west of the Lower East Side. A leather motorcycle jacket and Chuck Taylors are de rigueur.

—JAG

Auto Erotic
Nobody Walks in LA

No other city in the world loves its automobiles like LA. Here your beat-up VW bus or your supercharged Jaguar is not only a means of transport but a necessary and beloved member of the family, a literal means of survival. Sure, we've got those buses and that subway thingy, but why take those when you can poison the environment in your blown 1971 Hemi 'Cuda? Cruising is all Angelenos know, and although they may never actually speak to each other (save the occasional cursing), there is a sense of camaraderie when you're breathing the same exhaust on the cross-town 10.

It seems logical that this automobile worship would translate into a sexualizing of chrome and steel, and LA certainly seems obsessed by both the speed and the style of their autos. Rockabilly boys rev their deuce coupes down Vermont Avenue, airbrushed lowriders gather for redemption at the annual **Blessing of the Cars,** and emaciated blondes cruise Rodeo in their sugardaddys' Mercedes S-Class.

The Sunset Strip on a weekend evening is a cruiser's paradise, as progressively more intoxicated carloads full of partiers smile, wave and moon each other along the crawl toward Robertson. Down on Crenshaw folks do the same in their tricked-out Six-Four Impalas, and out in the desert, dragsters meet in the dry lake beds of Muroc to kick up some dust and put the pedal to the metal. If you'd rather put on the parking brake, the city also offers innumerable places to pull over and neck, from the beaches of Malibu to the scenic overlooks scattered among the Hollywood Hills.

Throughout the year folks can get their auto fix at several annual events and races, their need for speed fulfilled by both legal and illegal drag and off-road competitions. Just like to watch? The **Petersen Automotive Museum** houses an amazing collection of vintage cars and provides a comprehensive history of how the auto changed Los Angeles and the world.

It doesn't matter whether you get a little wet at the thought of Connolly leather seats in your British-racing-green Bentley or if a Mopar muscle car is more your type, LA is the place to strap on your seat belt and rev your proverbial engines. —JH & JAG

Petersen Automotive Museum: 6060 Wilshire Blvd. (at Fairfax Ave.), Miracle Mile; (323) 930-2277. Open Tues–Sun: 10 a.m.–6 p.m.

Blessing of the Cars: Annually, fourth Saturday of July, (323) 663-1265.

For more info on drag and off-road racing visit: www.nhra.com

Pick-Up Scene

Rainbow Bar and Grill

9015 W. Sunset Blvd. (between N. San Vicente Blvd. and
N. Doheny Dr.), Sunset Strip; (310) 278-4232. Open Mon–Fri:
11 a.m.–2 a.m., Sat/Sun: 6 p.m.–2 a.m.

Long-ago dreams of metal bands and stripper chicks still live at the
Rainbow Bar and Grill—*the* place to be back in the Reagan era. If you
really and truly want to act out your Ozzy circa-1984 fantasies, then this
is the place for you. You've been warned.

—JAG

Gettin' Multi-Culti

Los Angeles contains one of the largest collections of cultures in the
world, and there is really no better way to get in touch with them than
by dancing up a storm at a nightclub. Have fun and enjoy all that Los
Angeles has to offer.

Red

Ninth St. (between Hill St. and Broadway), Downtown Los Angeles;
info line: (310) 390-9889; www.neoteq.net/redhome.htm.
Open Fridays: 10 p.m.–6 a.m.

With some of the best DJs in the Southland spinning trance and jungle,
this place goes off and it doesn't close until 6 a.m. With a mix of zoned-
out club kids, Asian partiers, and who knows what, you're bound to have
a good time.

—JAG

Conga Room

5364 Wilshire Blvd. (at S. La Brea Ave.), Miracle Mile; (323) 938-1696.
Open Wed–Sat: 9 p.m.–2 a.m., closed Sun–Tues.

With Jimmy Smits and Jennifer Lopez as its celeb backers, this is high-
end clubbing with a Latin flavor. A huge yet comfortable room hosts
jazz, rock, and Latin acts, both local and big-name. The crowd here is
made up of young and successful professionals of all colors, with an
upscale edge. Expect the scent of custom-mixed oils and lots of high-
priced hair wraps.

—JH

Florentine Gardens

5951 Hollywood Blvd. (between N. Bronson Ave. and N. Gower St.), Hollywood; (323) 464-0706. Open Daily: 9 p.m.–2 a.m.

The term "back that ass up" actually refers to the Florentine Gardens on a Saturday night. With a long line of dressed-to-impress 18-and-over clubgoers waiting to get in, the booty bumping starts in line—this is the place to get the digits and cop a feel (all without paying the $12 cover, $4 for a bottle of water, or some serious cash money on the high-priced hoochy inside).

—Barb Choit

PaPaz

1716 N. Cahuenga Blvd. (between Hollywood Blvd. and Franklin Ave.), Hollywood; (323) 461-8190. Open Wed–Sun: 8 p.m.–2 a.m., closed Mon/Tues.

This club has all you need to get your Latin groove on—from *roc en español* to salsa, *merengue*, and *cumbia* nights, you can't go wrong. And if you ain't got the moves down, there are free dance lessons on Thursdays.

—JAG

The Room

1626 N. Cahuenga Blvd. (south of Hollywood Blvd.), Hollywood; (323) 462-7196. Open Daily: 8 p.m.–2 a.m.

One of Hollywood's only truly integrated bars, The Room hosts a variety of dance nights where folks of all backgrounds converge to prowl for a partner. Tiny, crowded, and dark as pitch, at times (with the help of a good DJ) The Room becomes a pleasantly libidinous grope-fest. Perfect if you prefer a little diversity with your perversity.

—JH

Also at 1325 Santa Monica Blvd. (between Euclid St. and 14th St.), Santa Monica; (310) 458-0707.

Pick-Up Scene

Road Trip!
Destination: San Luis Obispo

If you're looking to bust out from under the blanket of smog and exhaust that covers the LA basin (cozy!), one of the best escape routes is north on the 101 freeway. Persistence and patience will eventually lead you and your honey out of suburban tract-house sprawl and onto gorgeous Pacific Coast Highway (if you've got more time, just hop on PCH in Santa Monica). Hugging the coastline, you'll make your way through picture-perfect Santa Barbara, where you have two road-trip options. You can either climb over Route 154, which offers spectacular views atop the Santa Ynez mountains and risk your life trying to pass the slowpoke in front of you, or you can proceed on the 101 up to Buellton, gateway to the quaint Danish village of **Solvang**.

Choosing 154 allows you to take a short trip west on Route 246, where you can stop for tea and Old West flair in the little town of Santa Ynez (once a busy pony express outpost). Then add a quick jaunt to the local **Santa Ynez Mission** to pray forgiveness for all the sinning you'll be doing later.

Staying on the 101, on the other hand, would allow for an eastbound side trip on the 246 to Solvang, a kind of Denmark by way of Disney, complete with steins of beer, blutwurst, and a whole lot of senior citizens in nylon jogging attire. Either way, both options dump you out on Highway 101 a half-hour before reaching San Luis Obispo, home of **Sycamore Mineral Hot Springs**, **Madonna Inn**, and a whole lot of horny college students.

Accessed from the Avila Beach exit, Sycamore is an upscale spa with all natural sulfur springs—rent a private redwood tub and boil with your baby for less than you spent on the gas getting there. It's also a full-fledged hotel offering tubs for two in your room or on the balcony for six to eight guests(!). If a more decorative setting is your style, opt for the infamous Madonna Inn. This garishly gorgeous masterpiece of American eccentricity houses numerous theme rooms, some with waterfalls, rock showers, and enormous boulder fireplaces. You can play prehistoric in the Cave Room, suck face in the back of the Cadillac bed of your own private '50s drive-in, or cavort among the gold cherubs and red velvet of a Sun King–era suite. Several suites go on for miles with multiple beds of the XL variety—bring some friends or just crawl into fresh sheets every few hours. In the morning have some coffee and strudel at the adjoining European bakery, then make your way, bleary-eyed, back to the mundane. —Jessica "Sexpot" Hundley

See next page for San Luis Obispo digits.

The Digits for San Luis Obispo

Madonna Inn: 100 Madonna Rd., San Luis Obispo; (800) 543-9666 or (805) 543-3002; www.MadonnaInn.com (pictures of every room on web site).

Santa Ynez Mission: 1760 Mission Dr. (west of Pine St.), Solvang; (805) 688-4815.

Sycamore Mineral Hot Springs: 1215 Avila Beach Dr., San Luis Obispo, (805) 595-7302, www.sycamoresprings.com.

Westside Scenesters

If you want pretty and fit folks looking for love in a genial atmosphere, the Westside is the spot. Get in your spanking new Beemer, drive your ass on down west of Sepulveda, and throw some of that cash around. Nothing is sexier in this part of town than conspicuous consumption! Everyone loves a big spender.

Buffalo Club

1520 W. Olympic Blvd. (between 14th St. and 17th St.), Santa Monica; (310) 450-8600. Restaurant Open Daily: noon–2:30 p.m. and 6 p.m.–10 p.m. Bar Open Daily: 6 p.m.–2 a.m.

Since Tom Cruise had his 39th birthday party here recently, you should too. This is a nice place to throw a post-premiere party or just a party of your own. Filled with the crème de la crème of the Westside scene. Bring plenty of cash and wear Armani—you'll need it.

—JAG

Circle Bar

2926 Main St. (between Ashland Ave. and Pier Ave.), Santa Monica; (310) 392-4898. Open Daily: 5 p.m.–2 a.m.

A former old-man bar in the heart of Main Street has now transmogrified into a hip enclave of slumming Westside yuppies—a cute bunch, if that's your bag. They have a great selection of tequila, a pool table in the back, and the place goes off like gangbusters on the weekends. Drinks are stiff, so take a cab.

—JAG

Pick-Up Scene

Pick-Up Scene

Cock and Bull

2947 Lincoln Blvd. (between Ashland Ave. and Pier Ave.),
Santa Monica; (310) 399-9696. Open Daily: 10 a.m.–2 a.m.

Another downtrodden bar turned luxe, the Cock and Bull is a fine place
for a pint and a game of pool or darts. It's also a much more laid-back
spot than its Santa Monica bar brethren. And if English blokes float your
boat, this is just the ship for you.

—JAG

Hal's Bar and Grill

1349 Abbot Kinney Blvd. (at California Ave.), Venice; (310) 396-3105.
Open Daily: 6 p.m.–12:30 a.m.

Honey-skinned Westside yuppies looking for love look no further than
this jumpin' spot on once sleepy, now hip Abbot Kinney. The bar is six
deep on the weekends, so your pickings are very good. Just make sure to
dress nice and buy that girl a drink. Two Veuve Clicquots, please.

—JAG

"No one is more **carnal**
than a recent **virgin.**"
— J O H N S T E I N B E C K

Liquid Kitty

11780 W. Pico Blvd. (between Barrington Ave. and Bundy Dr.),
West Los Angeles; (310) 473-3707; www.thekitty.com. Open Mon–Fri:
6 p.m.–2 a.m., Sat/Sun: 8 p.m.–2 a.m.

Martini-glass signage blinks outside. Inside, loud Esquivel-style music
plays for advertising/middle-management types still chasing the James
Bond, space-age-bachelor pad, lava lounge dream. Go if you like your
atmosphere stylishly kitschy, your lovers well-heeled, and your drinks
stirred, not shaken.

—Jonathan Sandford

Renee's Courtyard Café

522 Wilshire Blvd. (between Fourth St. and Fifth St.), Santa Monica;
(310) 451-9341. Open Daily: noon–2 a.m.

Think Mediterranean village vibe with a pretty courtyard for the avid
smokers. Renee's small intimate rooms get very crowded on weekends;
expect an overload of hard bodies who enjoy flaunting tight abs and firm
asses. But it's still a nice place for a quiet drink during the week.

—JH

<div style="border">

Just Beachy

As long as you're wearing flip-flops and a fine tan, you'll be golden at any
of these beach scene bars and clubs. This is the place where the sun always
shines, the men are men, the women are ladies, and where most are bring-
ing home some serious bacon, even if they are wearing zinc on their nose.

</div>

Baja Cantina

311 Washington Blvd. (north of Pacific Ave.), Marina Del Rey;
(310) 821-2252. Open Daily: 10 a.m.–2 a.m.

Crowded Mexican theme bar with a fratty beach-bum atmosphere. This
Marina Del Rey hot spot is perfect for those Margaritaville types who like
a little south-of-the-border feel to their mating games. Free chips and
salsa keep the liters of tequila in check, and the ambience lends itself to
nights of hot Latin love. ¡Viva Baja!

—Jonathan Sandford

The Brig

1515 Abbot Kinney Blvd. (between California Ave. and Venice Blvd.),
Venice; (310) 399-7537. Open Mon–Fri: 6 p.m.–2 a.m., Sat/Sun:
7 p.m.–2 a.m.

Just a few blocks from the infamous Venice boardwalk, The Brig was once
populated by aging hippies and intoxicated salty dogs with sand still in
their shoes. In recent years renovations have revamped the dive décor and
upped the drink prices, but you can still smell the history and taste the sea.

—JH

Pick-Up Scene

Chez Jay

1657 Ocean Ave. (between Colorado Ave. and Pico Blvd.),
Santa Monica; (310) 395-1741. Open Mon–Fri: noon–1:30 a.m.,
Sat/Sun: 9 a.m.–1:30 p.m.

This Santa Monica institution is best experienced six inches above the
creaky wood floor, cozied up to the bar. The strong pouring arm of the
grizzled bartenders (as well as their sage advice) will have you buying
that sailor or mermaid a cocktail in no time. After some free peanuts to
break the ice, retire to a quaint booth among the fishnets and starfish.

—Chad E. Brown

Gotham Hall

1431 Third Street Promenade (between Santa Monica Blvd. and
Broadway), Santa Monica; (310) 394-8865. Open Daily: 5 p.m.–2 a.m.

Located deep in the outdoor consumer paradise of Santa Monica's Third
Street Promenade, Gotham Hall does its best to emulate Euro chic while
maintaining its California mellow. Nobody walks in LA, but a few hun-
dred do stroll down the Promenade, so throw back a few martinis and
watch the crowds march by. If you grow weary of the people-watching,
the beach and pier are within stumbling distance.

—JH

Make Out

The Booth at Clifton's Cafeteria

A hidden jewel of the ol' skool LA kind, the Booth at Clifton's Cafeteria
is worth the journey Downtown. Climb the stairs and sneak past the
ropes to the wooden booth precariously perched high above the dining
room. It is dark and cramped and hot and sweaty, a sexy conduit.
Grab a chicken-fried steak on the way out: you'll need your protein.
—JAG

*648 S. Broadway (at Seventh St.), Downtown Los Angeles; (213) 627-1673.
Open daily: 6:30 a.m.–7:30 p.m., all major credit cards accepted.*

Love Among the Stacks
At the Central Library

Although you're unlikely to see Larry Flynt's name on the list of bene-factors, the Downtown **Central Library** may offer the prurient visitor the greatest wealth of free pornography available in the city. Admittedly, you'll have to wade through pages of dull anthropology textbooks and anatomy manuals to find the really juicy photos of scantily clad, au naturel tribespeople and/or steamy reproductive-system diagrams. But who said foreplay had to be fun and easy? Alas, for the onanist, private accommodation is limited. Few of the Central Branch's restroom stalls feature such luxuries as doors, and the few doors that do exist are so short the guy washing his hands can see what's written all over your face.

Fortunately, however, more interesting options abound. Searching for a mate at the library is distinctly more precise than at dating services or singles bars: here one can choose one's lover with the help of the Dewey Decimal system. Yearning to get into the pants of a struggling writer? Literature, Floor Three. Wanna bang somebody with better financial prospects? Business and Economics, Floor Two. Got a hard-on for French Revolution buffs? History, Lower Level Three. You get the picture. But Lutwidgeans beware: The Children's Literature Department on the second floor is strictly off-limits.

Of course, if you come up empty, why not take a second gander at the bevy of beautiful staff librarians. Most are shy, ill-tempered, and strange looking. But beware of the raging hump-beasts within. Here are a couple of pick-up lines to melt the most frigid of bibliophilic hearts:

- "Hey doll, nice stacks."

- "Ahem, really, isn't there some other way I can work off these overdue charges?"

- "So, how about later on you show me how to get into your night slot?"

- "Is it true there's another way to renew your circulation?"

- "I'm searching for a book that will help end my terrible sexual obsession with short, myopic, stuttering research librarians. Maybe you can help?"
 —Justin Clark

630 W. Fifth St. (at Flower St.), Downtown Los Angeles; (213) 228-7515; www.lapl.org/central/clhp.html. Open Mon–Thurs: 10 a.m.–8 p.m., Fri/Sat: 10 a.m.–6 p.m., Sun: 1 p.m.–5 p.m.

Pick-Up Scene

Pick-Up Scene

Ranchera and Tropical Clubs

If you love a man in a cowboy hat who knows how to dance, head for one of these here bars. Most spots have cover charges on the weekend hovering around $6, but call ahead to be sure. See p. xxx for the word on the scene.

Club Bahia

1130 W. Sunset Blvd. (between Elysian Park Ave. and the 110 fwy.), Silver Lake; (213) 250-4313. Open Fri: 8 p.m.–3 a.m., Sat: 8 p.m.–5 a.m., Sun: 8 p.m.–2 a.m., closed Mon–Thurs. $8 cover Fri/Sun before 10 p.m., $12 cover Sat.

This cavernous, airy, neon-lit nightclub houses some serious dancers and lots of sexy stilettoed girls in miniscule dresses. The DJ plays a broad range of music, but the live bands (call first) lean toward *cumbia* and *merengue.* Very good for singles.

—Melissa Bellovin

El Paso del Norte

4164 Cesar Chavez Ave. (west of N. Eastern Ave.), East Los Angeles; (323) 261-6759. Open Fri–Sun: 8 p.m.–2 a.m., closed Mon–Thurs. Friday nights are free.

To fulfill your carving for regional Mexican music, head on over to El Paso del Norte, where there are possibly more white-straw cowboy hats than anyplace else in Los Angeles. You're in East LA, but it's easy to imagine that you're dancing the night away in a border town way down south. Uh-uh *Horny?* readers, there's no dirty dancing here, just tall mustachioed *vaqueros* and *vaqueras* engaging in courtly steps to melancholy-sweet *norteñas.*

—Melissa Bellovin

"**Give me** chastity and continence—but not **yet.**" — SAINT AUGUSTINE

Guatelinda

4916 Hollywood Blvd. (west of N. Edgemont St.), Hollywood;
(323) 666-7070. Open Wed–Mon: 9 p.m–2 a.m., closed Tues.

Guatelinda is a very good Central American nightclub playing a broad range of music. While the club is somewhat heavier on couples than singles, the live *cumbia* music is so good that you might be satisfied to just sit by yourself and listen.

—Melissa Bellovin

"The penis mightier than the sword."
— MARK TWAIN

La Hacienda

849 S. Broadway (between W. Eighth St. and Ninth St.), Downtown Los Angeles; (213) 489-2399. Open Wed and Thur: 8 p.m.–2 a.m., Fri: 10 p.m.–6 a.m., Sat: 8 p.m.–5 a.m., Sun: 8 p.m.–4 a.m.

If the nightclub scene puts you off, then chill at La Hacienda, a bar restaurant downtown that's popular with single male cowboys and older couples. Eat a little, drink a little, and listen to the live *ranchera* music on Sunday afternoons.

—Melissa Bellovin

La Zona Rosa

1010 Cesar Chavez Ave. (between N. Mission Rd. and Vignes St.), Boyle Heights; (323) 223-5683. No cover Tues–Thurs and Sun, $8–10 cover Fri/Sat.

For the place to hear both Mexican and tropical music, stop by La Zona Rosa, a slick Mexican-owned chain with varied music and clientele. The club houses plenty of neon, disco balls, and fabulously carpeted walls, and the waitresses have to be seen to be believed. On Thursday nights at 1 a.m., the *Concurso de Piernas* takes over—a contest in which a bevy of lovely ladies compare their sexy thighs for cash prizes.

—Melissa Bellovin

Pick-Up Scene

Pan American Nite Club

2601 W. Temple St. (at N. Rampart Blvd.), Pico-Union; (213) 386-2083. Open Wed–Mon: 8 p.m.–2 a.m., closed Tues. Free on Wed, $6–8 cover other nights.

There are no live bands at this tiny, crowded nightclub, but the very good DJs bring in crowds of primarily Central American clientele, making it a very happening spot.

—Melissa Bellovin

Love in Aisle Three—Grocery Stores for Singles

If food and sex go hand in hand, then it follows that there's no better place to find the lover of your dreams than in the produce section of your local grocery. Stock up on the week's necessities, look helpless, and wait for that brawny fellow to carry your bags to your car and your body to the bedroom.

Bristol Farms

Love among the Syrah and Edam.

7880 W. Sunset Blvd. (at N. Fairfax Ave.), Sunset Strip; (323) 874-6301; www.bristolfarms.com. Open Daily: 8 a.m.–11 p.m.

Hot spots for sexy people-watching and great places to buy a good bottle of wine, Bristol Farms locations are the unsurpassed meat markets for both. The Sunset Strip location has the Laurel Canyon/Hollywood Hills down-to-earth sexy types. The Beverly Hills location is frequented by fashionistas from Beverly Boulevard and Beverly Hills agenty types; and Valley outlets are divorcé dating central. Still, you can't beat Bristol Farms if you want to bump up a social-dating—or even food—strata.

—JAG

See web site for other locations.

"**I regret** to say that we of the **FBI** are powerless to act in cases of oral-genital **intimacy**, unless it has in some way **obstructed** interstate commerce."

— J. EDGAR HOOVER

469-CALL

The Shooting Gallery
Digging Chicks at Art Openings

Ahh, Los Angeles and its wonderful art scene. Here, where three of the world's great art schools—CalArts, Art Center, and UCLA—are located and where the art galleries and museums are overflowing with works of greatness and profundity. But if you really want to get down with art, you'll find that the LA art scene is a great place to meet a super cutie with an attitude problem.

First off, art-school kids are Crazy with a capital C; but on occasion, crazy means good. Especially when it comes to boot-knocking. Ask yourself these questions before dating an art-school student or graduate. Do you like waking up and seeing your girl writing a poem, buck naked in the moonlight? Or having your boy paint you in colored macaroni and then discuss why he chose the orange for your eyes when they are hazel? If you answered yes to these questions, proceed to the head of the class. Also, for those with ambiguous sexual leanings, the art scene is paradise. Gay? Straight? Neither? Can't decide? Art school—or better yet and way cheaper, an art-school cutie—is for you.

A Brief Overview of Art-School Cuties:

CalArts = weird, conceptual, and usually deep in debt.

Art Center = commercial, driven, and usually deep in debt.

UCLA = figurative, but kinda abstract too, and has money to buy you a beer. Tuition is real cheap.

The gallery scene in Los Angeles is much the same. Everyone is either weird or likes to help weirdoes. Which are you? It helps if you wear black (or even better, some sort of a costume), smoke like a diesel, and brood . . . a lot! When those bases are covered, go to a gallery opening and drink way too much cheap red wine and talk about the art in a roundabout way to the cutie girl or boy next to you. Points added if you make real obscure references that no one gets—quoting Walter Benjamin is sure to get you laid in certain circles. One caveat: Make sure not to be cloying, ever. No one in the art scene likes a happy person. Especially me. I'll see you on **Chung King Road**. I'll be the one in the denim suit with the odd haircut smoking those bummed cigarettes. —Jon Alain Guzik, CalArts, MFA 1998

See next page for where to find your art-school lover or gallery babe.

Pick-Up Scene

Where to Find Your Art-School Lover or Gallery Babe:

Bergamont Station: The art at this industrial-style collection of galleries (plus the Santa Monica Museum of Art) is hit or miss, but there's enough variety here to make it worth your while. *2525 Michigan Ave. (west of Cloverfield Blvd., south of Olympic Blvd.), Santa Monica; (310) 829-5854.*

Chung King Road: On Saturday nights the growing number of galleries which have taken over Chinatown's picturesque inner core host an art and beer free-for-all. When the keggers are kicked, head over to nearby Hop Louie (great jukebox) or Quon Bros' Grand Star (karaoke weeknights, piano bar weekends) for mai tais and madness. *Chinatown Galleries: on Chung King Rd. (enter through courtyard off N. Hill St. and north of College St.). Hop Louie: 950 Mei Ling Way (between N. Broadway and N. Spring St.), Chinatown; (213) 628-4244. Quon Bros' Grand Star: 943 Sun Mun Way (between N. Hill St. and N. Broadway), Chinatown; (213) 626-2285.*

Echo Park Avenue: Youngsters dressed in the decade of the day (sparkly leg-warmers if the '80s are in this week) mill about the sidewalk at Saturday-night receptions. Culturally driven photographs at Fototeka, paintings and installation pieces at Delirium-Tremens, Ojalá, and The Pink Gallery. *Echo Park Avenue Galleries located on the 1500 block of Echo Park Ave. (at Morton Ave., a few blocks north of W. Sunset Blvd.). Delirium-Tremens: (213) 861-6802. Fototeka: (213) 250-4686. Ojalá: (213) 250-4155. The Pink Gallery: (213) 977-8839.*

Fais Do Do: Wide-eyed UCLA grads and cute arty lesbians frequent this just–east–of–Culver City club and restaurant. *5257 W. Adams Blvd. (west of S. La Brea Ave.), Mid-City; (323) 954-8080.*

La Luz de Jesus Gallery: Sex, drugs, and rockabilly are common themes at Billy Shire's landmark gallery and store, and openings bring out all the hep cats in classic automobiles. *At Wacko, 4633 Hollywood Blvd. (between Vermont Ave. and Hillhurst Ave.), Los Feliz; (323) 666-7667.*

Mr. T's Bowl: Art Center kids booze it up it in this friendly Highland Park dive. Bands included. *5621 1/2 N. Figueroa St. (between N. Ave. 56 and N. Ave. 57), Highland Park; (323) 256-4850.*

Mayfair

The freshest fare amid the fairest flesh.

5877 Franklin Ave. (west of N. Bronson Ave.), Beachwood Canyon;
(323) 464-7316. Open Daily: 7 a.m.–midnight.

Yeah, the food might be outrageously overpriced, but it's worth it if you happen to enjoy gazing at beautiful men and women while you're fondling an overripe cantaloupe. The store's proximity to the foothills of swank Beachwood Canyon (home to celebs and successful artist types who claim to loathe the Westside hierarchy) makes this Mayfair a virtual cornucopia of eligible other halfs. Just seductively stalk the shopper of your choice and observe what goes into his or her basket. Ghiradelli chocolates, fresh sunflowers, and a fine merlot are a yea, while Pampers, Ding-Dongs, and *TV Guide* make for a definite nay. If you've got the guts, offer your prospective lover your coveted two-for-one coupons, then walk up to the nearby Hollywood sign to swap the spit.

—JH

Also at 2725 Hyperion Ave. (between Griffith Park Blvd. and
Rowena Ave.), Silver Lake; (323) 660-0387.

"How do you **keep** the sex fresh?
Put it in **Tupperware**."
— G A R R Y S H A N D L I N G

Ralphs Supermarket, Third & La Brea

How to date a supermodel.

260 S. La Brea Ave. (at W. Third St.), Miracle Mile; (323) 937-3264;
www.ralphs.com. Open 24/7.

While away your time looking at all the M/A/Ws (model/actor/whatevers) here at Supermodel Ralphs. Filled with sexy Miracle Mile/Beverly/Fairfax hunnies, it is, as the Michelin Guide says, worth a trip just to get your hummus on and ogle all those pretty young things. This Ralphs, above all others, excels as a prime 24/7 cruising spot. Since most of the clientele are out-of-work actors, they are always ripe for the picking. Who's even hungry?

—JAG

Trader Joe's

A one-stop dating experience.

610 S. Arroyo Pkwy. (at California Blvd.), Pasadena; (626) 568-9254; www.traderjoes.com. Open Daily: 9 a.m.–9 p.m.

Tofu, cheap wine, and love under the tomatoes. For max-hot girl and boy action and a place to stuff your gullet, look no further than Trader Joe's—each location offers a treasure trove of hot young things getting their shop on. With cheap prices on booze and healthy food to make that potential love interest a nice meal, it's like a beer bust every day of the week. And who doesn't like all those hard nipples in the frozen-food section?

—JAG

Also at 7304 Santa Monica Blvd. (between La Brea Ave. and Fairfax Ave.), West Hollywood; (323) 851-9772.

2738 Hyperion Ave. (between Griffith Park Blvd. and Rowena Ave.), Silver Lake; (323) 665-6774.

263 S. La Brea Ave. (at W. Third St.), Miracle Mile; (323) 965-1989.

10011 Washington Blvd. (between Robertson Blvd. and Motor Ave.), Culver City; (310) 202-1108.

Check web site for other Southland locations.

Whole Foods

A few good reasons to go organic.

239 N. Crescent Dr. (north of Wilshire Blvd.), Beverly Hills; (310) 274-3360; www.wholefoodsmarket.com. Open Daily: 8 a.m.–9 p.m.

Just to let you know, this writer saw the sexy-as-all-get-out Angelina Jolie here. Right in front of me, perusing the Odwallas, there she was. Oh! My! God! She is sexy. Those lips, those eyes. Man alive, wow. And she wasn't the only sexy bird in the place. This Whole Foods is filled—filled I tell you—with hot soccer moms and Earl Jean'd hipster chicks buying overpriced health food. This is the Westside spot to people-watch while fulfilling your organic jones. Ain't life grand?

—JAG

Check web site for other Southland locations.

Make Out

Dodger Stadium

With the sounds of the home-team crowds cheering you on, making out at **Dodger Stadium** is in a league of its own. Find a nice, quiet place, perhaps way off to the third-base line, look for an empty area under a Dodger Blue awning and kiss away! If you're lucky, you might just steal home.

—JAG

1000 Elysian Park Ave. (off Sunset Blvd.), Elysian Park; (323) 224-1HIT. Baseball season: April–October.

Coffeehouses

If you like your coffee like your men—strong and hot—or if you prefer your ladies like your tea—full of sugar and spice—then grab a lotta latte and take a sip of LA's coffeehouse scene.

Anastasia's Asylum

Catch a babe and a buzz.

1028 Wilshire Blvd. (between Ninth St. and Tenth St.), Santa Monica; (310) 394-7113. Open Mon–Thurs: 6:30 a.m.–1 a.m., Fri: 6:30 a.m.–2 a.m., Sat: 8 a.m.–2 a.m., Sun: 8 a.m.–1 a.m.

With its darkly painted walls and dimly lit interior, Anastasia's is the perfect place to linger over a latte and bat your eyelashes at the many pensive MFAs and rosy-cheeked hippie gals who frequent the joint. If you'd rather study your prey in more detail, sidewalk tables reveal all in the harsh light of day. A cute waitstaff is an added bonus, and a light menu will keep you fortified in your search for that deeply sensitive, highly intelligent, caffeine-addicted lover you've been longing for.

—JH

"Woman's **virtue** is
man's **greatest** invention."

— C O R N E L I A O T I S S K I N N E R

Pick-Up Scene

Bourgeoisie Pig

Sexier than it's ever been . . .

5931 Franklin Ave. (just east of N. Bronson Ave.), Los Angeles;
(323) 464-6008. Open Daily: 7:30 a.m.–2 a.m.

Recently revamped, but still dark, overpriced, and filled with cast-off antiques, The Pig is the place to meet that struggling screenwriter of your movie-premiere dreams—if you can get him to glance up from his laptop long enough to take notice. Sip *chai* with your harem or flip through a book of Rumi verses while leaning seductively against a brace of satin cushions and he just might. The Pig serves up the usual coffeehouse fare (bad art, velvet couches, and pretentious pseudo-intellectuals) with a few notable exceptions, namely a nice pool table and a truly exotic back room that looks as if it were hoisted from the Cleopatra "opium den" set. Open till 2 in the a.m., The Pig is a perfect place for lonely writer types and randy insomniacs.

—JH

Have Your Cake AND Eat It Too!

You aren't satisfied with plain ol' real-life sex—no, no, you want more, you want some chocolate tits and ass, you want naked-girl-shaped cakes and edible marzipan dildos. Damn, you are a bigger perv than you knew—good for bachelor parties, bridal showers, and real funky-ass bar mitzvahs.

—JAG

Exotic Cakes: *1068 S. Fairfax Ave. (north of Wilshire Blvd.), Miracle Mile; (323) 938-2286, Fax: (323) 938-2570, toll-free: (888) 747-CAKE (2253). Also at 20812 Ventura Blvd., #108 (west of DeSoto Ave.), Woodland Hills; (818) 346-4553 Fax:(818) 346-372.*

Naughty Cakes: *order one at www.NaughtyCakes.com or call (866) 772-CAKE(2253).*

Satisfy the sweetest tooth with carnal candy from:

Chocolate Fantasies: *order at www.chocolatefantasies.com or call (800)595-9936.*

Erotic Chocolate Shoppe: *order at www.eroticchocolates.com or call (888) 848-0844.*

Café Tropical

Two hipster hangs for the price of one.

2900 W. Sunset Blvd. (at Silver Lake Blvd.), Silver Lake;
(323) 661-8391. Open Mon–Sat: 6 a.m.–10 p.m., Sun: 7 a.m.–10 p.m.

This hipster hang is the perfect place to relax over a café con leche and a guava *empanada* and read the *L.A. Weekly* while looking for a tattooed cutie to take home to your cramped Silver Lake hideaway. Also, if you're sober, the AA meetings on-site can't be beat for people-watching. It's right next door to the **Silverlake Lounge** (see p. 40) so you can get beamed on caffeine and see an indie-rock band (or a drag show with a Latin flair on the weekends) all within a couple feet of each other.

—JAG

Urth Café

Coffee, tea, or Buddha?

8565 Melrose Ave. (west of N. La Cienega Blvd.), West Hollywood;
(310) 659-0628; www.urthcafe.com. Open Mon–Thurs: 6:30 a.m.–
11 p.m., Fri–Sun: 6:30 a.m.–midnight.

After a long day of shopping for pricey furniture or clothing on West Melrose, why not relax in boho comfort at über-organic Urth Café. Usually stuffed with too-sexy-for-their-pants M/A/Ws, Urth is open late enough to take advantage of the roaring fireplace. It's a perfect place to find that special person to read lines with you, and as an added bonus you can peruse your spiritual side at the Bodhi Tree bookstore around the corner. *Om, om, om . . .*

—JAG

"Masturbation: the primary sexual activity of mankind. In the nineteenth century, it was a disease; in the twentieth, it's a cure." — THOMAS SZASZ

Doggy Style
Or, What We Talk About When We Talk About Flea Dips

There's at least one spot in Los Angeles where you can witness animal sex, primal and unbridled, any time of the day. Unfortunately, this animal sex is being had by actual animals, but the **Silver Lake Dog Park**, a bone's throw from the reservoir, isn't a bad place for humans to work on their mating skills either.

This is an oddly anonymous sort of cruising, as people only seem to know each other by their dogs' names. But be warned: If someone's sitting on a bench wearing headphones and reading a book, they really don't want to be asked how old Sam is. It's dog-park code for Not Interested. Trust me on this one.

Of course, Silver Lake isn't the only pooch park in town. Just below the Hollywood sign in **Beachwood Canyon Dog Park** is where the fairly rich and moderately famous come to throw Frisbees at Fido. **Runyon Canyon Park** is more dirt trail than park, but there are plenty of cute, physically active humans getting exercise along with their dogs and enjoying the view up top.

If ocean breezes are more your style, check the hotties at Venice's **Westminister Dog Park**. If you want a latte for you and your Lassie, head over to the **Hydrant Café**, where the gourmet doggie fare looks so good you may want to try a cookie yourself.

Over the hill, **Calabasas Bark Park** is a great place to walk your doggy if you like that West Valley heat; and the East Valley's **Laurel Canyon Off-Leash Dog Park** and the **Sepulveda Basin Dog Park** are also good, but expect the cruising quotient to be lower, this being the 'burbs and all. Word to the wise, however: You should really have a dog with you in order for any of this to work.
—Steve Kandell

"Yes, there will be **sex** after death; we just won't be able to **feel it**."
— LILY TOMLIN

Where To Walk the Dog

Beachwood Canyon Dog Park: *Near the top of Beechwood Canyon.*

Calabasas Bark Park: *4232 Las Virgenes Rd. (near Country Creek Rd.), Calabasas; (818) 878-4242.*

Hydrant Café: *1202 Abbot Kinney Blvd. (at California Ave.), Venice; (310) 401-BARK; www.hydrantcafe.com.*

Laurel Canyon Off-Leash Dog Park: *8260 Mulholland Dr.(west of Laurel Canyon Blvd.), Studio City; (818) 766-8445.*

Runyon Canyon Park: *Vista St. past Franklin Ave. turns into Runyon Canyon Rd., Hollywood.*

Sepulveda Basin Dog Park: *17550 Victory Blvd. (at Sepulveda Blvd.), Encino.*

Silver Lake Dog Park: *1850 Silver Lake Blvd. (at Pelt Pl., just south of the reservoir), Silver Lake.*

Westminister Dog Park: *1234 Pacific Ave. (between Westminister and Main St.), Venice.*

Also, check out www.freeplay.org for more dog-park locations.

Stores Around Town

For savvy shoppers who like to get a bang for their buck, finding that perfect pair of Gucci shades can often lead to the additional discovery of that perfect pair of double Ds. Watch for other material girls (and guys) prowling the shops in search of new clothes, new shoes, and a new special someone.

Aron's Records

Rock-and-roll, hoochie coo.

1150 N. Highland Ave. (north of Santa Monica Blvd.), Hollywood; (323) 469-4700; www.aronsrecords.com. Open Sun–Thurs: 10 a.m.–10 p.m., Fri/Sat: 10 a.m.–midnight.

If indie-rockin' hotties in black leather cuffs with cheap dye jobs and a taste for obscure prog rock is your cup of latte, then the cup overflows for you at Aron's Records. With late hours and numerous bins of used music to pore over, Aron's is the prime spot to relive your salad days and get a date with hot college kids who dig bands you've never heard of. An added bonus is the staff, almost all cute with post-apocalyptic hair—you can pine away and get a history lesson on Brian Eno.

—JAG

Barneys New York

The meat market of the upper crust.

9570 Wilshire Blvd. (at Camden Dr.), Beverly Hills; (310) 276-4400; www.barneys.com. Open Mon–Wed: 10 a.m.–7 p.m., Thurs: 10 a.m.– 8 p.m., Fri/Sat: 10 a.m.–7 p.m., Sun: noon–6 p.m.

While shopping at the hippest department store this side of the Seine, dress nice. No one, and I mean no one, likes a slob. That said, if you are a girl, go to the Fourth Floor and pretend to look for a gift for your brother. The boys here are of the tousled-haired, expensive T-shirt, and designer-jeans variety. They are cute. They are M/A/Ws. Ask the nearest hottie for helpful advice. "Do you like this shirt?" will work. If he's wearing too much of one designer, say Gucci or Dolce, he's gay. FYI: Don't try to change him because he's your size and you like his pants—he's gay. Forever. If you happen to be a boy looking for girls, grab a platonic girlfriend and loiter on the Third Floor, the Co-Op section. There, amid the racks of expensive hipster wear, you'll find the cutest fashiony girls west of a Chelsea art opening. Pace yourself and don't leer. Watch out for boyfriends or her cock-blocking gal pals. Caveat emptor!

—JAG

The Beverly Center

More cute mall rats than should be legal.

8500 Beverly Blvd. (at N. La Cienega Blvd.), West Hollywood; (310) 854-0070; www.beverlycenter.com. Open Mon–Fri: 10 a.m.– 9 p.m., Sat: 10 a.m.–8 p.m., Sun: 11 a.m.–6 p.m.

The ultimate retail pick-up spot in Los Angeles. With more than 160 stores to choose from, the Beverly Center has to have at least one shop with your future ex in it. For great people-watching, grab an Orange Julius and take a seat in the food court. Remember, this is Los Angeles, so the food court ain't filled with the same folks you'd find at the Podunk Mall. Here, where all those shoppers and workers take their breaks, is nothin' but wall-to-wall tight jeans, good shoes, and oral fixations. Be brave and ask out that girl at the Diesel Store or that cute boy at Louis Vuitton. Worst-case scenario, you walk out with some stylish new duds.

—JAG

Book Soup

Culture, Sunset Strip style.

8818 Sunset Blvd. (at Holloway Dr.), Sunset Strip; (310) 659-3110;
www.booksoup.com. Open Daily: 9 a.m.–midnight.

If bookish Ivy Leaguers are your thing, there's plenty of them here. If hip
Hollywood Hills–dwelling actor types are for you, ditto. If you crave
bookworms, most of the staff is beyond compare. You like a good selec-
tion of books and magazines from all over the world? This is the place
too. If the book scene is too staid for you, take a hike across Sunset and
check out Tower Records, filled with music-loving hotties of all types.
You might just walk out with more than the latest Madonna album.

—JAG

Tower Records: 8801 Sunset Blvd. (at Holloway Dr.), Sunset Strip;
(310) 657-7300. Open Daily: 9 a.m.–midnight.

"To err is human—but it feels divine."
— MAE WEST

Fred Segal

Fashionista pick-up spot.

8100 Melrose Ave. (one block west of N. Crescent Heights Blvd.),
West Hollywood; (323) 651-4129.

Cute fashionistas of all walks flock to this hip Melrose Avenue institution
and its Santa Monica twin. With several separate shoe, sportswear, and
luggage sections, you can see about three to six million gorgeous people
in your travels from department to department. For max people-watch-
ing, take a seat at the delish Italian restaurant on-site and have some
lunch. The waitstaff is fine, the food is great, and that girl who looks like
Reese Witherspoon probably is. If it's not, then at least she's a beautiful
starlet in training. Give her some lessons, won't you?

—JAG

Different owner, different shops, beachier vibe at 500 Broadway
(at Fifth St.), Santa Monica; (310) 458-9940.

Skylight Books

They can read too!

1818 N. Vermont Ave. (between Hollywood Blvd. and Franklin Ave.), Los Feliz; (323) 660-1175; www.skylightbooks.com. Open Daily: 10 a.m.–10 p.m.

Deep in the heart of lovely Los Feliz, Skylight is one of the best independent stores in a city far too short on quality booksellers. Spacious and well-stocked, with smart and friendly cuties behind the counter (as well as in front of it), Skylight is the place to meet that rarest of LA beasts: the intellectual. You can swap your *New Yorker* subscription for his *Atlantic Monthly*, or discuss the valuable merits of the Bloomsbury group (aah, literacy and free love—a match made in heaven!). Hover by the poetry section for sensitive types or hang by the travel section if you're looking for adventure. In a city where a good haircut means more than a good head on your shoulders, Skylight and its readings, classes, and book clubs will give you an in to the life of the mind.

—JH

Third Street Promenade

Everything (and everyone) you want in the cool ocean breeze.

Third St. (between Broadway and Wilshire Blvd.), Santa Monica; www.thirdst.com.

If you aren't really a beach person but you like the sun, good-looking people, shopping, and eating, then the Third Street Promenade is truly paradise on Earth. There are blocks and blocks of retail establishments you love (Urban Outfitters! Hear Music! Banana!) and men and women you like even more. Not to mention you are right around the corner from one of the best places in all of Los Angeles, the Santa Monica Pier (see p. 139). If there is a better way to while away the hours on a hot sunny day, I want to know.

—JAG

To get to the Santa Monica Pier: *Take Colorado Ave. west and when it ends, the Pier begins! (Or look for the roller coaster and Ferris wheel, visible from blocks away.)*

Make Out
Disneyland

With its long lines and long rides, Disneyland is the über-spot for PDA. Some advice: The Haunted Mansion. It always breaks down, it's dark and scary, the cars are enclosed and private—a perfect place to get to third base. Remember, there are no doors and no windows, but there's always my way out! —JAG

1313 S. Harbor Blvd., Anaheim (just off I-5); (714) 781-4565; www.disneyland.com. Open Daily: 8 a.m.-midnight.

Pick-Up Scene

Contents

TAKE YOUR CLOTHES OFF AND HAVE FUN
In THE Buff

If there's one thing we learned while writing this book it's that everyone is different and that proclivities (sexual or otherwise) vary. What we already knew is people like taking their clothes off and getting good and naked. (If you don't, you are really reading the wrong book!) And nowhere else in the US of A besides Los Angeles (where almost everyone is sexy and tan and fit and, most of all, willing) is that a good thing.

More than anything *Horny?* wants to help you explore that inner nudist in you just waiting to jump out. *Horny?* wants to help you take off you pants, take off your top, take off your underwear (but leave on the stockings and the gloves), and let you run around, naked as a jay bird, nude as the news, in the warm Southern California sun (or inside a clean, well-lit room). It would make us very happy to see that.

So let us take you to the area's nude beaches, to the best hotels (and the dirtiest adult motels), to the most…er…relaxing massage parlors and spas. Let *Horny?* help you get naked more often, because you are worth it, because you are sexy and because, most of all, we just love to see you happy!

Keep in mind that while all these beaches have played host to public nudity for decades, remarkably enough not a single one of them is legally zoned as "clothing optional." The chances that you'd actually be arrested are next to nil, but take heed nonetheless—tickets are sometimes issued.

Abalone Cove, Palos Verdes

Though the shores can get a little rocky, there are several hundred yards of smooth, sandy beaches, and the water is clear. The crowd here is fairly mixed, with the distant, more secluded areas of the beaches frequented mostly by gay men. Though this is a popular beach, it's never too crowded and stays very low-key. The big plus of Abalone Cove is the tide pools located towards the tips of the rocky points. These tide pools are teeming with sea life: starfish, sea urchins, anemones, small fish, and crabs can be closely observed and even carefully touched—all while completely nude! It sure as hell beats a trip to Sea World. There are actually two beaches at Abalone Cove, and although there really is no single trail that leads to either of them, they're pretty hard to miss. Hiking the trails can be a pretty wild experience too.

To Abalone Cove from Los Angeles: Take Pacific Coast Highway (Hwy. 1) south, turn right onto Palos Verdes Boulevard. Then bear right on Palos Verdes Drive West. This will turn into Palos Verdes Drive South. When you see the Wayfarer's Chapel on your left you'll want to find a parking spot. Walk south along the ocean until you reach a gated road with signs reading ABALONE COVE TIDE POOLS and NO NUDE SUNBATHING (a dead giveaway). Take that black gravel road and watch for a worn path darting off to the left side just as you begin to approach the fencing on the edge of the cliff. Take the rather steep (but bearable) trail down to the sand. Farther beyond the Abalone Cove gate, there's another trail that leads to the other beach. This trail is well worn into the roadside brush just on the oceanside edge of the Palos Verdes Drive South. A good marker is the intersection of Peppertree Drive across the street—about 100 feet south of that cross street you'll find the trail.

—Matt Maranian

"**Sex-appeal** is the keynote of our whole **civilization**."

— H E N R I B E R G S O N

Black's Beach

Black's Beach is the southernmost section of San Onofre State Beach. Wrap something around yourself, hike down to the sand, head south, and pretty soon you will see naked volleyball players. You can disrobe at any point, but most people pick a spot before shedding layers and applying sunscreen in every nook and cranny. If you are expecting the cast of *Baywatch* to flounce by, forget it. Be prepared to see people of all shapes and sizes, every inch of them! This is a popular spot for men to hang out together, lots of military types from Camp Pendleton not asking and not telling in the sand. Plenty of straight folks hang out, too, so don't be shy. Swimmers please note: The water is cold, and surfing naked is not as fun as it sounds (especially if you have lots of body hair—it could take days to pick all the wax out!) The vibe is good, no hassles and plenty of lifeguards are on duty—in swimsuits, of course! If the water seems a tad warmer than the rest of So Cali, don't worry, it's only the nuclear plant.

Also, check out www.blacksbeach.com

To Black's Beach from Los Angeles: Take Interstate 5 south, through Orange County toward San Diego. Exit Interstate 5 at Basilone Road. San Onofre State Beach will appear on the right. Park in the southernmost lot and you'll find Black's Beach just below the nuclear power plant and Old Man's longboard spot.

—Erin Holmes

Make Out

The Santa Monica Pier

Looking to mix memories of childhood pleasures with your current levels of grown-up libido? **The Santa Monica Pier** offers the usual smattering of obscure street performers (look, he's painted silver and he's not moving!), boardwalk games, a roller coaster, and, best of all, a Ferris wheel—he perfect locale for serious groping and illicit tongue baths. After you've spent all your dough on that giant stuffed panda, head down to the water for a walk in the moonlight or some serious "under the boardwalk" action. —JH

200 Santa Monica Pier (at Ocean Ave.), Santa Monica, (310) 458-8900. www.santamonicapier.org.

In THE Buff

Gaviota Beach, Gaviota

This is a scenic and very secluded beach with clear, swim-friendly waters. The shore stretches on forever, and you can experience that surreal feeling of walking hundreds of yards along the shoreline stark naked without ever passing another human. There are only a couple dozen people here at any one time—a varied and unassuming bunch—and because the location is somewhat remote, those who make the trip are looking for a peaceful and quiet escape. It's not unusual to spot a school of dolphin jumping along the shoreline or a giant starfish holding tightly to the rocky points of the beach. The perfect place to groove away a sunny day and evening sunset.

To Gaviota from Los Angeles: Take the 101 freeway north past Santa Barbara. About 30 miles north of Santa Barbara you'll take the Mariposa Riena exit. Make a U-turn back onto the freeway going south and drive a half-mile to a dirt parking area just to the side of the road on your right. Look for railroad-crossing lights as a landmark. There are a cluster of blue garbage cans left of the wide and well-worn trail down to the beach.

—Matt Maranian

"Graze on my **lips;** and if those hills
be dry stray lower,
where the **pleasant** fountains lie."
— WILLIAM SHAKESPEARE

More Mesa Beach, Goleta

This beach is one of the most active and, in many ways, the most fun. It attracts a wide cross section of people, mostly from the Santa Barbara area: septuagenarian health-food nudists, "alternative"-looking college kids, hetero and gay couples, hippie families, and those oiled up and questing for a George Hamilton–on–a–rotisserie terminal tan. At More Mesa the beach activities that would normally be really annoying (like Frisbee tossing and volleyball) somehow seem perfectly acceptable when performed naked. The vibe is friendly and the people are cute. It's one of the very few nude beaches where light-handed, innocent flirtation doesn't come off as sleazy. You'll spot an occasional swimsuit here, but those wearing them are embarrassingly conspicuous.

To More Mesa from Los Angeles: Take the 101 freeway north just beyond Santa Barbara. Exit on Turnpike Road and turn left. Make a right on Hollister Avenue., a right on Puente Drive, and then another right on Vieja Drive. Start looking for Mockingbird Lane: you're going to park on Vieja, as close to the intersection of Mockingbird as you can get. Walk all the way down Mockingbird; then follow the dirt trail (it's an easy walk, but not a short one) to a steep, seemingly endless log stairway down to the beach.

—Matt Maranian

Point Dume, Malibu

Though miniscule, the nude beach at Point Dume does have the advantage of being so nearby. Sometimes this beach is a total skin show, sometimes 50/50, sometimes not at all. Generally, during the week is a pretty safe time to get naked, but weekends can be hit-and-miss—always have a swimsuit nearby just in case the Coast Guard gives you any trouble. This beach is also a favorite for amateur porn photographers and often serves as a location for many adult-video box cover shoots as well. Get there early and you might get an eyeful!

To Point Dume from Los Angeles: Take Pacific Coast Highway (Hwy. 1) north into Malibu. Turn left on Westward Beach Road and follow it all the way down to the end of the parking lot (where they will gouge you with the parking rates). Walk to the southernmost end of the beach to the rocky edge. Follow the path through the rocks to the other side of the beach.

—Matt Maranian

Make Out
El Matador Beach

Gorgeous, clean and semi-private, this sweet stretch of Malibu sand offers not only a lovely spot to watch the setting California sun, it also provides plenty of caves and coves for all of your advanced necking needs. After your session of suckface, stop at Neptune's Net for some fried shrimp and burly-biker gazing. Just remember, hot oil and chapped lips don't mix! —JH

Watch for the signs on Pacific Coast Highway (one mile north of Trancas Canyon Rd.), Malibu; parking lot on the left ($2).

In THE Buff

Rincon Beach, Carpinteria

This beach is smack-dab in the center of a county park, complete with picnic areas and public restrooms. The beach rambles on for about a mile, and as with most nude beaches, the farther out you walk to the most remote end of the beach, the more naked people you'll find frolicking in the surf. The farthest end of this beach also happens to be the most beautiful, and though long portions of the shoreline can get a little rocky, there are sections private enough that just about anything goes.

To Rincon from Los Angeles: Take the 101 freeway north to Carpinteria. Exit at Bates Road and turn left. Bates will lead you straight down to the parking area. Bear right into the lot marked Rincon Park. You'll find a pathway down to the water just to the edge of the picnic area.

—Matt Maranian

"I never miss a chance to have sex or appear on television."
— GORE VIDAL

Summerland Beach, Summerland

Things generally stay pretty quiet here even on weekends. Though popularly known as "the gay beach," it attracts all types. There's a lengthy stretch of shoreline and the water is swim-friendly, but you see oil rigs on the horizon line, which is kind of a bummer. All the naked action takes place on the other side of the rocky point that has been reinforced with steel (to prevent landslides), and which is easily passed through. It's a perfectly decent nude beach conveniently close to Los Angeles, but not especially noteworthy for any particular reason.

To Summerland from Los Angeles: Take the 101 freeway north about five miles beyond Carpinteria. Take the Summerland exit and turn left. When you reach Evans Avenue. turn left again and pass under the freeway. Once you're on the other side of the freeway, make the first and only left you can onto Wallace Avenue. then turn right on Finney (watch closely for Finney, it's almost nonexistent). There's ample parking on Wallace, as well as a lot just off Finney, and it's all very obvious where to go.

—Matt Maranian

Nymphs Roam THE Forest OF THE Château Marmont

In THE Buff

"If you must get into trouble, do it at the **Château Marmont**."
—Columbia founder Harry Cohn to his stable of mischievous talent.

Since its opening on February 1, 1929, the Château Marmont has been the epicenter of Hollywood glamour and glitz, the site of many a sordid scandal and notorious Tinseltown tryst. Bogart gardened, Harlow honeymooned, Zeppelin road a Harley through the front lobby, and Belushi bit the dust in a Château bungalow.

Built as a luxury apartment house and furnished (after its new owner took over in 1932) with the antiques and castoffs of many a fallen Depression-era millionaire, the Château was billed as "Los Angeles' first earthquake-proof building, constructed without regard to expense," a claim that seems to have been true, considering the fact the structure still stands proud and tall in the very heart of the Sunset Strip. Modeled after a Château in the Loire Valley, the thick stucco walls of the Marmont breathe with that precious LA rarity: history. You can feel, in the arched ceilings of the lobby, in the midnight blue pool, amid all the greenery in the back garden, the ghosts of celebrities past.

The Château continues to live up to its reputation, housing everyone from rock stars to aging novelists, and its atmosphere still lends itself to acts of chaos and debauchery. If you want an authentic piece of the great LA myth, grab your dark glasses and a willing companion and check into the Château for some Hollywood high style. You and your partner can bask in the celebrity spotlight and act out all your fantasies of stardom. (Fight with your underage lover! Tell your agent to go to hell! Overdose on sleeping pills!) To select just the right soundtrack for your adventure, choose from the hotel's extensive audio library. If you're in the mood for something quieter, you can always snuggle up poolside in your terry-cloth Château robes, sip an aged cognac from the Bar Marmont (see p. 90) or gobble up the Milk and Cookie Special (it's yummy!) in a vain attempt to regain a semblance of innocence. —JH

8221 W. Sunset Blvd. (west of Crescent Heights Blvd.), Sunset Strip; (800) 292-8328; www.ChateauMarmont.com.

Adult Motels

A Sexy Ass Primer

The joys of adult motels are truly limitless, and cheap to boot. Here you can stain the sheets to your heart's content, yelp like Tarzan at the top of your lungs, have a little in-room party action and, if you're lucky, go from the dirty bed to the greasy hot tub in under 10 steps!

If you like your motel as sleazy and nasty as possible—peeling paint and ramshackle décor—you know it, er, um, adds to the excitement level. Really, who doesn't occasionally like to feel like a cheap hooker on an edgy outcall, and that goes for the boys too! Also, many adult motels let you rent the room for a few hours, though technically they're not s'posed to. That way you don't have that pesky I-have-to-pay-for-the-room-when-I-ain't-using-it feeling.

The best cheap motels are in the middle of nowhere. Here you can really get it on, and you'll know that you can't be too loud when the room next door is filled with three metal dudes and a couple of strippers living like The Scorpions on their '81 world tour. Try your luck at the motels on or near San Fernando Road in Burbank or near LAX, catering to airport flyaway types—they all look real real nasty. Also, there is a place in Azusa (everything from A to Z in the USA) called the **Stardust Motel**, where you can get your shtup on under mirrored ceilings and sit in a pink heart-shaped Jacuzzi, all for less than a night at a fancy high-brow hotel. If you want to get out of town, try the motels on Pearblossom Highway in Palmdale to whet all your white trash fantasies. Marlboro Reds and tall boys of Bud not included.

Adult motels may not be for everyone. You really don't want to take your uptight significant other to a room with cigarette burns on the carpet and a round vibrating bed, but if you've brought the right person (or three), you can feel like Caligula in your very own dime-store Rome. And make sure to bring your own spaghetti sauce. —JAG

Stardust Motel: *666 E. Foothill Blvd. (east of N. Cerritos Ave.), Azusa; (626) 334-0251.*

Riviera Adult Motel: *2723 S. El Camino Real (off I-5), San Clemente; (949) 492-1425.*

By the Airports: *Just look for a sleazy place with an "XXX" or "Adult" sign!*

Argyle Hotel

A grand piece of '40s art deco on the rockin' '80s Sunset Strip.

8358 W. Sunset Blvd. (west of N. Crescent Heights Blvd.), Sunset Strip; (323) 654-7100; www.argylehotel.com.

A classic and almost defiant structure standing at the heart of the Sunset Strip, the Argyle Hotel is a monument to the glamour of Hollywood past. Reserve a suite for the evening and perfect your Bogey and Bacall. Chill martinis and teach each other how to whistle while gazing out of the half-moon window over the Los Angeles skyline, or head down to Fenix Lounge and savor a Scotch-and-water by the pool.

—Aaron Reardon

"I'm a **nice girl.**
I hate it on the first date
when I accidentally **have sex.**"
— EMMY GAY

Hollywood Roosevelt Hotel

Hollywood hotel swingin' since the 1920s.

7000 Hollywood Blvd. (east of N. La Brea Ave.), Hollywood; (323) 466-7000; www.HollywoodRoosevelt.com.

The Hollywood Roosevelt Hotel opened in 1927 and has been welcoming the swinging 'Wood ever since. Named in honor of President Theodore Roosevelt and built at a cost of $2.5 million (that's like a zillion or two dollars in today's money), this is a great place to end your tour of the town's streets of gold. Sit by the David Hockney painted pool and watch the day go by as you swig mai tais, or spend a few hours listening to faded Hollywood royalty (Cybill Shepard! Tony Danza!) shuck and jive at the Cinegrill cabaret bar. The best part about the hotel is you can get your freak on watching the crowds gawking at the hand and foot prints at the Chinese Theater across the street, and if you're really, really good, you may get your own sweet nothings dipped in cement too.

—JAG

Hotel Bel Air

Feel like a royalty, even for just a night.

701 Stone Canyon Rd. (between Tortuoso Way and Chalon Rd.),
Bel Air; (310) 472-1211.

You want nice, you want opulence and comfort, you want to be treated like royalty, you want to walk around manicured grounds and frolic among swans, and hobnob with the rich and famous? Well, who doesn't? At the Hotel Bel Air, you get all that and more, but be warned, all of this comes at an extremely expensive price, namely from 450 smackers to over three grand a night! But, it's worth it! If you can't afford to spend the night, drive up (free valet parking!) to the Hotel and get a Campari-and-soda and a delish dessert at the English men's club-esque hotel bar. That alone can tip the scales on a first date or make your significant other want to get with you again and again!

—JAG

Hotel Figueroa

Do it to me in the mission position.

939 S. Figueroa St. (at Olympic Blvd.), Downtown Los Angeles;
(213) 627-8971; www.figueroahotel.com.

Deep in the heart of downtown lies a California Mission–style masterpiece, a bit of 1920s decadence that still lives up to its mystique. The Hotel Figueroa is about as romantic as it gets, and once you've gotten past the wandering homeless man with the lazy eye and the drunken sports fans from nearby Staples Center, you'll find an oasis of unrivaled luxury. Beautifully restored, the hotel features a great restaurant and bar, all in a Marrakesh-by-way-of-DeMille setting. Don't be surprised to find smoldering Dietrich types sipping martinis in the shadows or swarthy men watching you hungrily from the corners. FYI: On Sunday afternoons, at the palm-lined pool, you'll find all the bikini-clad party people shimmying to a great resident DJ.

—JH

"One more **drink** and
I'll be **under** the host."
— D O R O T H Y P A R K E R

L'Ermitage Hotel

A super swanky hotel in Beverly Hills with a faboo spa!

9291 Burton Way (west of N. Doheny Dr.), Beverly Hills;
(310) 278-3344; www.lermitagehotel.com.

The L'Ermitage Hotel is the epitome of LA luxe. Nestled deep in the heart of Beverly Hills on Burton Way and with one of the best spas in the 90210, you begin to know why the stars like to check in to L'Ermitage. Also super close to the fantabulous shopping on Rodeo Drive and Barneys on Wilshire (be still, my beating heart)—if the pricey rooms don't break you, the shopping will. Throw on a terry-cloth robe, relax your happy feet in the tub, and pretend that your sitcom just got renewed for another season. You'll worry about the hefty bill later.

—JAG

Millennium Biltmore Hotel

Noir elegance resounds through Downtown.

506 S. Grand Ave. (between Fifth & Sixth St.), Downtown Los Angeles;
(213) 624-1011 or (800) 245-8673; www.millennium-hotels.com.

Designed by the same firm that created New York's Waldorf-Astoria and Helmsley Park Lane hotels, the 11-story Biltmore oozes resplendence from every corner of its marble-and-granite edifice. Completed in late 1923, it was quickly regarded the grandest hotel west of Chicago, and its Crystal Ballroom soon played host to decadent fashion shows and the Academy Awards. Angeleno power families from the Chandlers to the Dohenys threw many a soiree in the cathedral-ceiling-and-Italian-mural-bedecked chambers, as did Democratic nominee John F. Kennedy, president-elect Ronald Reagan, and the 1984 International Olympic Committee. Besides ballrooms, the 683-room Biltmore has five restaurants, two bars and several luxury amenities, as well as an attentive staff of retro-attired bellhops and desk clerks. Pony up for a suite, and relish old American royalty's opulence that left commoners aghast at the hotel's extravagance. The Biltmore often has weekend packages for locals to get out of town.

—Heather Marcroft

In THE Buff

Road Trip!
Destination: Palm Springs

One of the best and most romantic weekend getaways from Los Angeles is a trip to the desert, most of all Palm Springs and the surrounding areas, Joshua Tree and Anza-Borrego Desert State Park. A great way to start your trip is with a leisurely drive. Take your time and sightsee on the way. Cruise down the 10 freeway, stop for some dim sum in Monterey Park, visit the world's largest truck stop in Fontana, or check out my personal favorite, the gigantic outlet mall in Cabazon. Really, is there a better way to start a weekend than with a bargain at the Gucci store?

Once in Palm Springs, you have a choice of great places to stay, with resorts and hotels spanning the spectrum from the luxe-modern comfort of the **Orbit In** to the old-school charm of **Merv Griffin's Resort Hotel & Givenchy Spa**. Also, a new crop of small, hip boutique hotels, all in excellent mid-century refurbished buildings, have opened in the surrounding areas. The good ones are **Hope Springs**, **Caliente Tropics**, and the **Miracle Manor**.

Once you are bedded down, take a stroll along Palm Canyon Drive and get your shop on at one of those great Palm Springs antique or thrift stores. Filled with everything from pricey mid-century modern tchotchkes to great old T-shirts, they're always good for a find or two. Go ahead and splurge, you're on vacation. Bring a nice outfit because there are some really great supper clubs and restaurants. Try real old-school places like **Lyon's English Grill**, **Banducci's Bit of Italy**, or a newer retro joint like **Muriel's Supper Club**. They all have top-notch lounge acts and good food to boot.

Now that you are full and can't shop no more, what to do (besides you know what in the hotel room)? Take a stroll through the 1,200 acres of New Age splendor at **The Living Desert**. Established in 1970 and dedicated to preserving the plant and animal life of the desert, this park holds nearly 400 different fascinating desert animals representing more than 150 species. A definite must-see for you and your hot-blooded honey. A bit further afield, the nearly lunar landscape of **Joshua Tree National Park** (with its modest entrance fee and wide variety of hiking trails) makes for a cheap date in the afternoon. For fun, see if you can find Gram Parsons' grave. Or try **Anza-Borrego Desert State Park**, the largest state park in California, with its beautiful desert landscape. It's the perfect place for some fun in the sun. Just like Palm Springs. —JAG

Stops on the Way

Desert Hills Premium Outlets: *48400 Seminole Dr. (northeast of the 10 fwy.), Cabazon; (909) 849-6641.*

Empress Harbor Restaurant: *111 N. Atlantic Blvd. (at W. Garvey Ave.), Monterey Park; (626) 300-8833.*

NBC Seafood Restaurant: *404 S. Atlantic Blvd., (south of W. Garvey Ave.), Monterey Park; (626) 282-2323.*

Places To Stay

Caliente Tropics: *411 E. Palm Canyon Dr. (at S. Calle Palo Fierro), Palm Springs; reservations, (866) 468-9595; www.calientetropics.com.*

Hope Springs: *68075 Club Circle Dr. (north of Hacienda Ave.), Desert Hot Springs; (760) 329-4003.*

Merv Griffin's Resort Hotel & Givenchy Spa: *4200 E. Palm Canyon Dr. (at S. Cherokee Way), Palm Springs; (760) 770-5000; www.palmsprings.com/merv.*

Miracle Manor: *12589 Reposo Way (south of Desert View Ave.), Desert Hot Springs; (760) 329-6641.*

Orbit In: *562 W. Arenas Rd. (west of S, Patencio Rd.), Palm Springs; (877) 99-ORBIT; www.orbitin.com.*

Places To Eat

Banducci's Bit of Italy: *1260 S. Palm Canyon Dr. (between E. Mesquita Ave and E. Palm Canyon Rd.), Palm Springs; (760) 325-2537.*

Lyon's English Grill: *233 E. Palm Canyon Dr. (at S. Palm Canyon Dr.), Palm Springs; (760) 327-1551.*

Muriel's Supper Club: *210 S. Palm Canyon (at E. Arenas Ave.), Palm Springs; (760) 325- 8839.*

Things To Do

Anza-Borrego Desert State Park: *Entrance, two miles west of downtown Borrego Springs at the east end of Palm Canyon Rd., just off County Road S-22. Visitor info: (760) 767-4205.*

Joshua Tree National Park: *North Entrance, I-10 and Highway 62. South Entrance Cottonwood Spring, via I-10. Visitor Info (760) 367-5500.*

The Living Desert Wildlife & Botanical Park: *47-900 Portola Ave. (off Highway 111), Palm Desert; (760) 346-5694.*

Peninsula Beverly Hills

Escort your way upstairs.

9882 Santa Monica Blvd. (south of Wilshire Blvd.), Beverly Hills;
(310) 551-2888; www.Peninsula.com.

Filled with both the really successful and those nasty posing Hollywood
types, the Peninsula Beverly Hills is a great place to look for that
Westside love connection or just spend a few thousand dollars on a
swank weekend getaway. You can relax post-detox or, if you're a gentle-
man of the higher-income ranks, meet very attractive young things just
waiting to be taken care of. If none of these activities interests you, try
waiting in the lobby to hand Harvey Weinstein your new script. God
bless Hollywood.

—JAG

"My **mother** is Welsh,
my father is Hungarian—
which makes **me** Wel-Hung."

— B I L L Y R I B A C K

The Standard

See and be seen in 1970s future-luxe style.

8300 W. Sunset Blvd. (west of N. Crescent Heights Blvd.), Sunset Strip;
(323) 654-2800.

Warhol-print wallpaper, blue Astroturf by the pool, a space-age-bachelor-
pad lobby filled with mid-'60s futurist/modernist furniture and lots of skin-
ny Japanese kids looking for action makes The Standard one of a kind.
Cheap in comparison to its Sunset Strip brethren, the hotel's atmosphere is
perfect for making burgeoning pop stars, indie film actors, and whip-thin
supermodels feel at home away from home. Get a slick cut at the barber-
shop, some hot pie at the 24-hour restaurant, gaze at the abstract experi-
mental projections in the hallway, gawk at the bored, half-naked model in
the giant fish tank behind the front desk (no joke!); then take your one-
night stand up to the suite for some stylishly hip foreplay, feeling smug in
the knowledge that there is some other attractive, wealthy and fabulous up-
and-comer doing the very same in the next room.

—JH

More Bang for Your Buck
How To Get the Most Out of Your Escort

Getting an escort in LA is a lot like going to the movies. The preview looked great, the excitement is exquisite, then the movie starts and you immediately want your $8.50 back. In a town where image is everything, thousands of out-of-work models and actresses will promise you the moon in their ads (usually found in the back pages of alternative newspapers like the *L.A. Weekly*). However, the reality is that many of these women are professional con artists. You may end up paying $300 or more on a really bad private striptease with a "no touching" rule in effect if you don't do your homework. Here are a few tips and tricks to avoid a "disappointing film experience."

• **A picture is not worth a thousand words.** While many of the pictures of the escorts look great, don't count on the woman you get actually being the one pictured in the ad. Make sure to ask the agency (or the girl directly) if your date is in fact the one in the ad. Often it is advisable to look girls up on the Internet if you really want to make sure you are getting a specific escort.

• **Make sure to get the price up front and assurance that what you're asking for is covered in that amount.** Ask if the escort is "full service" or not. "Full service" usually means sex, or at least consensual touching, if that's what you're looking for. More than one escort has been known to arrive at a hotel room, then act confused/surprised/naïve when it comes down to what she's actually there for.

• **Know the way out.** If you get cold feet when the escort arrives, or if the girl is not to your liking, you can send her back. Make up an excuse (you have a meeting) and call back the service while the girl is there. Usually, for cab fare ($20–$40) they will send you another girl or call it even.

It is possible to enjoy a good Hollywood blockbuster film from time to time, and it is also possible to hook up with a good escort in LA. Try to actually get the girl on the phone before she comes over to find out what kind of person she is. A little intuition goes a long way in finding that special someone for your pleasure. —Nick LeBon

"Sex is an emotion in motion."
— MAE WEST

Westin Bonaventure Hotel

Take the ride of a lifetime.

404 S. Figueroa St. (at Fourth St.), Downtown Los Angeles;
(213) 624-1000; www.westin.com.

Looking all futuristic and modern like something out of the year 2112 or *Blade Runner*, the Bonaventure Hotel is a little piece of postmodernism in a city full of architectural nightmares. In fact, famous American postmodernist Fredric Jameson wrote about it in his 1991 masterwork *Postmodernism, or, The Cultural Logic of Late Capitalism* (use that trivia at certain parties and you're sure to score points). That aside, the Bonaventure has a spinning bar on the top floor with pricey but stiff drinks (you can keep the glass with some of the libations) and great weekend room rates, so you can get busy while watching the city of the future below you unfold. And to quote *L.A. Bizarro*, it's a great place to look for other people getting it on while taking the glass elevators halfway to the stars. Bring on the night!

—JAG

> "Sexuality is the lyricism of the masses."
> — CHARLES BAUDELAIRE

Beverly Hot Springs Skin Care

Piping hot!

308 N. Oxford (at Beverly Blvd.), Koreatown; (323) 467-0913.
Open Daily: 9 a.m.–9 p.m.

Beverly Hot Springs Skin Care is well-known for a number of reasons: It's the only natural hot spring in Los Angeles (and, trust me, their artesian well is piping hot), it is a haven for relaxation where some of the best deep-tissue massages can be had, and most everyone who goes there gets buck naked. The ultra-hot spring water is divine and the shiatsu massages are amazing, but don't expect to ogle the opposite sex—men and women only see each other in the lobby. A variety of treatments are offered, but relaxation doesn't come cheap: The entrance fee is $40 (soak as long as you like) and a full massage will set you back another $70 or so, plus tip.

—H.C. Brown

Tossing Morality TO THE Wind
At Naked City Los Angeles

In THE Buff

Nudist retreats and clothing-optional resorts enforce stringent rules with respect to "inappropriate" behavior. Single men rarely gain admittance; prolonged staring, physical contact, and cameras are strictly verboten; and penile erections are concealed. However, at **Naked City**, those rules were only made to be broken.

In business since 1981, Naked City is like a mélange of Russ Meyer movies on bad acid. The grounds span 22 acres of desert hilltops dotted with abandoned trailers and crumbling carports. A dirt road leads to Mammary Mountain, the Naked City check-in point. Take it all off in the parking lot, slather with sunscreen, and head for the clubhouse where a buzz at the intercom system will prompt one of the Naked City employees—all nude women—to invite you in.

"Welcome to Naked City . . . " a voice calls from a round bed fitted with a silver sequined dust ruffle positioned by the front door. This is the infamous Dick Drost, owner and proprietor of Naked City. A hybrid of Hugh Hefner, Andy Warhol, and Stephen Hawking, Drost proves to be extremely sweet, quick to put nervous guests at ease with a bottomless reserve of lines like "We accept Visa, MasterCard and Masturbate . . . ".

As outlined in its flyer-cum-mail-order catalog, Naked City sponsors several annual events, among them the "Ms. Nude California" and "Ms. Nude World" pageants, which allow cameras for a $30 fee. Popular too is the "Nude Olympixxx," featuring many games not practiced by the ancient Greeks, like "Nude Chocolate-Pudding Wrestling."

All in all, your chances of scoring big at Naked City are increased due to the fact that everyone here has already taken off their clothes, conveniently eliminating one time-consuming step from the process of bedding down a total stranger. And the lay of the land? Surprisingly attractive for a swing establishment located deep in the hills of Riverside County. At once filthy, frightening, and peculiarly fun, the Naked City experience isn't an easy one to shake off, try as you might. Even those hiding a past littered with a string of sloppy one-night stands and sleazy self-compromise will somehow feel less pure after a visit to the peak of Mammary Mountain.

—Matt Maranian

Box 2000, Homeland, CA 92548-2000, (909) 926-BANG. Call for directions and send a SASE for a current calendar of events; admission $30 for single men, $10 for male-female couples, and $1 for single women.

In THE Buff

Keeping It Up
For HardArt Phallic Replicating Service

HardArt offers the single greatest gift idea on the planet Earth: Imagine the surprise (or horror) on the face of your loved one when presented with an exact, life-sized replica of your own erect penis—fashioned into an incense burner, Canopicesque jar, or rubber dildo!

Such is the business of Bill Hall and Jerry Lands of HardArt, quite possibly the country's most unique cottage industry. Clients have been putting their penises in HardArt's capable hands for nearly five years, and in turn, HardArt has produced an imaginative and ever-evolving line of custom-replicated penis products. You can take home one of their simple "phallic sculptures" for a mere $50, or invest a little more for a Romanesque Eagle Plaque, priced at $200. Since it's necessary that the process be somewhat hands-on, clients are often understandably ill at ease—but after working closely with several hundred erect penises, Bill and Jerry have the process down to a science. Once you're "prepped" and ready to get dunked, timing is everything. Bill starts furiously mixing the quick-setting casting goo and Jerry helps to get you positioned onto their "glory table"—basically a massage table with a sizable opening in the center through which hang your "goods" (gravity works to your benefit here). Immediately your member is slipped into the mix (much like being slipped into a wet mouth) and from then on it's pretty smooth sailing; the setting time only takes about three minutes. If you want your mold "complete," you'll have to shave your balls, but since most men are reluctant to take a razor blade to their scrotum, many opt for the shaft-only variations.

For those yearning for a phallic replication to call their own, but find the HardArt casting process a bit daunting—good news! At no additional cost, HardArt can accommodate even the most bashful of clients with their Home StarterPak; an easy, step-by-step, do-it-yourself kit that allows you to complete the first stage of the replication process in the privacy of your own home. You then send your initial mold back to HardArt and they do the rest. In four to six weeks, violà! A self-aggrandizing objet d'art is delivered right to your door. —Matt Maranian

1515 Rendall Pl. (off Silver Lake Blvd.), Silver Lake, (323) 667-1501.

Glen Ivy Hot Springs

Babes and bubbles.

25000 Glen Ivy Rd. (off the 15 fwy.), Corona; (909) 277-3529;
Reservations: 1-888-CLUB-MUD.

A "peaceful and spiritually rejuvenating" spot for hundreds of years, the Glen Ivy (or Temecula, as they were called then) Hot Springs were used first by Native Americans and then later by road-weary cowboys taking a break from their search for the promises of the West. In the early part of the twentieth century an upscale resort was built around the natural springs and Paul Muni, W.C. Fields and even the young pre-Presidential Ronald Reagan soaked themselves here. Today the springs house not only several outdoor pools and indoor "Roman Baths," but the facilities also offer facials, saunas and dips in hot mud. You may not get quite naked here (bathing suits are required in most areas), but for $25 you and a willing partner can soak in the healing water all day long, then go back to work out the rest of your "kinks" in the privacy of your own bedroom.

—JH

Splash Spa

Where every day is Valentine's Day.

8054 W. Third St. (east of S. Crescent Heights Blvd.), Mid-Wilshire; (323) 653-4410. Open 11:30 a.m.–4 a.m. 365 days a year since 1979.

When you think of classic, immaculate, invigorating spas, don't think Splash. Complete with nature-themed rooms that look a whole lot better when the lights are off, this dive is an '80s throwback (the neon sign out front says it all) with fixtures and accoutrements that are just about of that period. Offering sundries ranging from lubricant to condoms, the friendly and courteous staff almost makes up for the general ickyness of the place, but definitely ask for a tour before renting one of their by-the-hour rooms. Speaking of by the hour, don't be shy to take a professional with you; masseuses are clearly welcome at Splash.

—H.C. Brown

"I like to **wake up** each morning feeling a **new man.**" — J E A N H A R L O W

In the Buff

Parlor Games
Massages Get Racy

When most people think of massage they envision scented candles, fresh towels, and a husky Swedish lady in a white coat diligently working out the toll modern life has taken on their backsides. Others, however, may have a different notion of what a massage should entail.

If your idea of relaxation is more along the lines of a rubdown and efficient "oral or manual stimulation," then there are numerous hole in the wall establishments offering "Oriental massage" or "acupressure" which will offer up the aforementioned goods. Working just below the radar of the law, these "parlors" are often merely brothels in disguise, with young Asian and Mexican women doing most of the illicit "massaging." While some parlors limit their offerings to hand jobs and cheap feels, there are certainly quite a few where the exchange of goods extends far beyond the usual "shiatsu" or "Swedish."

But be warned! Low on hygiene (not to mention ethics), these parlors are only for those in search of a truly sordid experience. If you prefer more innocent contact or just some basic relief for that pain in your lower back, than a swanky day spa or a holistic retreat is more along your lines.

If sleaze is your preference, however, there is plenty of information on massage parlors to be had in the back pages of the *L.A. Weekly*, *New Times*, or in the smut directory *L.A. Xpress*. And if you must explore, make certain to wear a condom, be sweet to the ladies, and tip very, very well. —JH

Contents

S&M, B&D, YOU & ME
THE Fetish Scene

In the mood for a good flogging? Looking for a little corporal punishment to take the edge off? Searching for that certain special Satanist? LA's fetish scene may not be up to par with smutty cities like San Francisco and New York, but we like to think it's only the eternal sunlight and happy-go-lucky atmosphere that keeps the angst and melancholia to a minimum.

Who wants a spanking when you can skip merrily through Runyon Canyon or watch that pink sun set at Zuma Beach? Who's in the mood for a whippin' after a day of cloudless skies and tepid weather?

Not that life in Los Angeles is always Pollyanna perfect. If the gridlock on the dreaded 405, the asphyxiating smog or another failed audition has you down, there's simply nothing better than giving up control to a vicious dominatrix or taking out your aggression on a more than willing slave.

LA has several legally licensed dungeons to feed the city's need for pain (and pleasure). The fetish, Goth, and punk scenes thrive in the form of clubs, bars, and annual free-for-alls. Whether you're an SMBD novice or a scarred and seasoned professional, LA will meet all your very naughty needs. With our innate love of drama and fondness for perversion, we are not a city to ostracize. It matters not if your secret wish is to be a pretty little pony or to sip some whiskey with a fellow vampire; the city of (dark) angels awaits your command.

Fetish | SMBD

Looking for a something a little out of the ordinary? Have a predilection for pale skin, the color black, and the feel of a bull whip against your bare back? Find your inner sadist at LA's fine selection of fetish stomping grounds. Regrettably, the venerable Sin-a-Matic (spanking machine and all) closed its doors in September of 2001 after an 11-year run. These other options should ease the pain. Do note that like all of LA's clubs, locations and days of the week are very likely to change—call ahead or check local listings to be safe.

Bar Sinister

Leave your morals at the door.

Saturdays (9:30 p.m.–2 a.m.) at Boadner's: 1652 N. Cherokee Ave. (just south of Hollywood Blvd.), Hollywood; (323) 769-7070; www.barsinister.net.

A dress code like "black . . . and little of it" gives one a good indication of the Bar Sinister drill. Roaming vampires, wandering witches, and the living dead gather on Saturdays to drink, dance, and howl at the moon. The upstairs "Playroom" offers various "performances" (the place to be if you deserve a good spanking), and Goth go-goers downstairs show lots of snow-white skin. Just the place to meet your (dark) soulmate.

—JH

Club Noire

No mirrors allowed!

Second and fourth Saturday of the month (9:30 p.m.–4 a.m.) at Lil Wonder Bar: 2692 S. La Cienaga Blvd. (just south of Venice Blvd.), Culver City; www.clubnoire.com.

Offering up "dark wave, Gothic and vampyric" grooves in a "dark place where you belong," Club Noire provides the gloom and doom you crave. If sweaty vinyl and melancholia gets your black heart burning, hop on your broom and join in the devilish bacchanal.

—JH

Your Pain Is Their Pleasure

At the Annual Fetish Ball

What ever happened to those freaks and geeks from high school who played Dungeons & Dragons, were theater die-hards who seldom broke a Renaissance-era brogue, or were morbids who fancied themselves vampires? They grew up and now assemble each year at the **Fetish Ball**. A thousand or so descend upon promoters extraordinaire Joseph Brooks and James Stone's S&M soiree each summer. Stone (also of Sin-a-Matic) and Brooks, an LA legend responsible for such clubs as Bang!, Sin-a-Matic, Coven 13, Club Makeup, and Shout (as well as a gender-bending authority featured on VH1's *From the Waist Down* series), inaugurated the fete in 1991. The annual gathering quickly garnered a national reputation and a fervent following that hastens the likes of said freaks and geeks, Ron Jeremy wanna-bes, reel-life Valley porn fixtures, and Industry hangers-on (maintaining the hip quotient). Though many a perverted old man in chaps sans underthings struts about the festivities hoping to latch on to a dominatrix, there's more eye candy than nightmarish eyesores: *Hustler*-quality babes in standard PVC, rubber, and vinyl; stilettos, elbow-length gloves, and chains on both sexes, as well as a plethora of hoods, capes, and massive angel wings; a handful of Heidis and lederhosen-clad boys; customarily over-the-top drag queens; superheroes, Disney characters, animal costumes, and altogether random getups, including a DWP repairman. (2001's standout was a man dressed as a penis, replete with hairy testicles.)

Theme rooms radiate industrial/techno music, glam rock, alterna, etc. (spun by DJs Virgo and Jason Lavitt, another star of the club circuit). Those opting not to dance venture to the dungeon to subject themselves to spankings, floggings, or to a unique contraption in which victims lie inside a latex vacuum and have candle wax dripped on them, among other horrors. The highlight of the Ball is a celeb-studded midnight musical extravaganza, featuring Goth/industrial headliners and members past and present of Garbage, Guns N' Roses, Nine Inch Nails and other refugees from club Makeup, while fetish fashion and burlesque shows sustain the randy factor throughout. But the real action doesn't come from the performers—it comes from the prurient patrons, who begin their own whipping circles on the smoking patio and don't think it too gauche to engage in private strip teases and lap dances. Pathological desire is no longer de rigueur—if you can afford the $45 ticket. —Molly Mormon

Pictures can be viewed at www.fetishball.com. Location changes each year (2001 was held at the recently revamped Hollywood Athletic Club).

Fetish | SMBD

Rack's IN THE Mail
From JT's Stockroom

Deep in the heart of Los Angeles, nestled among the low-slung mid-century buildings and lush green trees of Silver Lake, beats a black heart made of leather, latex, and steel, where dreams are made and sexy nightmares begin. It is called **JT's Stockroom**, and it is where all of your B&D, S&M, and fetish desires shall be lived out. Like so many strange things happening behind suburban closed doors, you must visit JT's on the Internet. Visits to command central are of the pick-up-the-stuff-you-ordered-over-the-phone variety (read: this is a warehouse, not a store), but thousands of customers a year crawl on hands and knees to their phones and computers to place their orders.

JT's Stockroom is not for the cheap or the faint of heart. The quality of the merchandise is excellent because JT's Stockroom makes almost all of its leather and latex goods in-house and by hand. And quite a selection it is. You want leather or latex restraints and collars? Perhaps you want them in metal? How about handcuffs, leg cuffs, spreader and suspension bars, bondage slings, and sport sheets? Or perhaps you need S&M toys like whips and floggers, crops and canes, paddles and slappers, or ticklers, gags, and blindfolds? JT's Stockroom's got them and in a huge variety of styles and sizes. Plus you get a free lollipop with each order, and isn't that kind?

They even have electrical tools and what looks like painful chastity gear for both men and women. Pushing the boundries in sex, JT's Stockroom lives by its motto, "All the Best in Sexual Technology"—and my, how technology does progress. —JAG

2140 Hyperion Ave. (north of Lyric Ave.), Silver Lake; (800) 755-TOYS, (323) 666-2121; www.stockroom.com. Catalog available for $3 or shop on the web site. Note: street address for order pick-ups only, not for shopping!

"Home is **heaven** and orgies are vile,
but you need an **orgy** once in a while."
— O G D E N N A S H

Dungeon

On the seventh day, one needn't rest.

Sundays (9:30 p.m.–2 a.m.) at Blue: 1642 Las Palmas Ave. (just south of Hollywood Blvd.), Hollywood; (323) 468-3863.

Have a thing for Vampira? Did the Wicked Witch of the West make you feel all funny inside? Dungeon does its best to make all your dark fantasies come true. S&M stage shows, go-go dancers in leather gear, and a slave cage swinging from the ceiling are just the thing to start the week off right.

—JH

Klinik

The doctor will see you now.

Wednesdays (10 p.m.–2 a.m.) at The Pool (behind the Hollywood Athletic Club): 6525 Sunset Blvd. (just west of N. Cahuenga Blvd.), Hollywood; (323) 367-3822.

Wanna play doctor? This industrial/Goth/EBM club offers dancing, movies, and something called "dark-wave therapy" all in a "naughty nurse" atmosphere (medical uniforms will get you in free). If hospital gowns, bedpans, and those cool beds that crank up and down are the cure for what ails you, then Klinik will give you the treatment. Take two aspirin, a hot chick in a surgical mask, and call me in the late afternoon!

—JH

Perversion

Where to wear your prosthetic fangs on Thursday nights.

Thursdays (10 p.m.–3 a.m.) at The Ruby: 7070 Hollywood Blvd. (just west of N. La Brea Ave.), Hollywood; (323) 467-7070; www.perversionhollywood.com.

Put on the silver crucifix and your favorite velvet cape and head on down to Perversion for three rooms of stately Gothic decadence. Bump and grind among the other children of the night. Keep your eyes open, 'cause that gloomy gal or pallid, underweight fellow cowering in the corner might very well be your soul mate in eternal damnation!

—JH

Fetish | SMBD

Ouch, That Looks Painful!

The Lowdown on Erotic Piercing

While body modification dates back thousands of years, most contemporary popular piercings are less than 30 years old. And more than anyone, we have **Jim Ward** to thank for the fact that all of us can safely pierce our privates, including nipples and most genital piercings.

Ward began experimenting with various techniques and jewelry in the early '70s, piercing out of his small house in Los Angeles, and what had begun as a phenomenon in the gay leather scene expanded. In 1975 he opened the **Gauntlet** in West Hollywood. By the '80s, Ward was traveling around the country doing piercing clinics and giving the taboo art of piercing national exposure.

Since Ward moved his operation (and himself) to San Francisco, the Gauntlet in West Hollywood fell under bad management and closed. However, the popularity of body piercing was ignited, and now Los Angeles is home to many skilled body-modification artists who can pierce your privates with skill.

Remember, piercing is an unregulated institution, and you should think twice before placing any of your precious body parts in the hands of a stranger. Many places offer body piercing, but don't assume they execute it with the same hygiene or expertise. Our erotic-piercing glossary will fill you in on some of the options, followed by a recommended list of places that maintain their own high standards of sterilization and professionalism.

Along with the well-publicized **Prince Albert**, **guiche** (between the balls and asshole), and foreskin piercings come these lesser-known but just as enticing options for men:

With a barbell going straight through the head of the penis, **palang** or **ampallang** and **apadravya** are the riskiest but purportedly most rewarding of the male piercings. In the tribe where it originates, women refuse to have sex with a man who does not have this piercing because a plain pecker just doesn't feel as good.

Dydoe: Placed through the ridged edge of the head of the penis, it supposedly restores the sensation lost after the removal of the foreskin in circumcised men.

Frenum: Curved barbells or captive hoops are inserted into the shaft of the penis just below the surface. A series of these down the shaft are known as frenal ladders—ribbed for her pleasure!

Hafada: Captive hoops pierced on the upper sides of the scrotum, framing the penis—a purely decorative addition to any "package."

The best known piercings are the hood, labia, and clitoris, but there are these further options as well for women:

Christina: Barbell pierced vertically through the hood and out of the pubic mound—very new and purportedly dangerous. Ladies, beware.

Princess Albertina: Another recently developed, rare, and dangerous piercing. The jewelry goes through the urethra and exits at the top of the vagina.

Fourchette: Simply a rear labial piercing.

Triangle: Supposedly the most rewarding female piercing, a captive hoop is inserted under the clitoral shaft. —Alexandria Blythe

13 BC: 7661½ Melrose Ave. (east of Fairfax Ave.), Ste. 1, Melrose; (323) 782-9069.

Buzzbomb Tattoo and Body Piercing: 1301 Ocean Front Walk (at Westminister Ave.), Venice; (310) 581-0036.

Freakshow Tattoo and Body Piercing: 155 Highland Ave., San Bernardino; (909) 881-2887.

Incognito Tattoo and Body Piercing: 750 E. Colorado Blvd., Ste. 6, (west of Lake Ave.), Pasadena; (626) 584-9448.

Outer Limits Tattoo and Body Piercing: 3024 W. Ball Rd. (west of Beach Blvd.), Ste. 1, Anaheim; (714) 761-8288 or 125 N. Tustin Ave. (at Chapman Ave.), Ste. G, Orange; (714) 744-8288.

Outlaw Tattoo and Body Piercing: 472 W. Highland Ave., San Bernardino; (909) 882-7691.

Prix Body Piercing (in JJ Silver): 56 E. Colorado Blvd. (east of Fair Oaks Ave.), Pasadena; (626) 405-1492.

Puncture: 346 N. La Cienega Blvd. (north of Beverly Blvd.), West Hollywood; (310) 652-1588.

S & S Piercing: 909 Ocean Front Walk (at Brooks Ave.), Venice; (310) 396-0270.

Fetish | SMBD

The Crypt

Bring on the lube!

1712 E. Broadway (west of Cherry Ave.), Long Beach; (562) 983-6560. Open Sun/Mon & Wed/Thurs: 11 a.m.–10 p.m., Tues & Fri/Sat: 11 a.m.–midnight.

If you like fetish gear (can you say latex whips in rainbow colors?) and you love gay porn, check out The Crypt in Long Beach. Nestled between The Mineshaft (a cozy dive catering to the externally rough boys of the gay ghetto) and a coffeehouse, The Crypt offers plenty of leather and latex fetish wear, tons of novelties (like anal beads, dildos, even a glow-in-the-dark vagina or two), and plenty of gay porn, from magazines and cards to videos. I can honestly say this store has the best lube selection of any store—or even catalog—that I have ever seen in my life! There are usually plenty of locals sitting outside nursing coffees and floating interesting tidbits of conversation. If you come cruise the Heights, don't miss The Crypt.

—E. Holmes

"It's **so long** since I've had sex, I've forgotten who **ties up** whom."

— J O A N R I V E R S

Dream Dresser

The best windows in town.

8444 Santa Monica Blvd. (east of N. La Cienega Blvd.), West Hollywood; (323) 848-3480. Open Mon–Sat: 11 a.m.–8 p.m., closed Sun.

If you dream of latex jumpsuits and rubber miniskirts—or if Dream Dresser's window displays depicting scenes of naughty nurses and cruel doms simply cause you to pull over and park—this is the place for you. Dream Dresser is a clean, bright shop in which to indulge all your dark fantasies—at least as far as your wardrobe is concerned. Fetishists, weekend explorers, and those just looking to buy a few sex toys are all welcome. While the apparel is well-constructed and inventive, to say the least, this is no discount store. Of high quality and in an array of colors, shapes, and sizes, this latex will make a dent in your plastic.

—HC Brown

"Sex without **love** is an empty experience, but as empty experiences go, it's a **pretty good** one."

— W O O D Y A L L E N

Mr. S. Leather and Fetters

San Francisco leather comes to LA.

4232 Melrose Ave. (next to the Faultline bar), East Hollywood; (323) 663-7765. Open Wed/Thurs: 1 p.m.–9 p.m., Fri/Sat: noon–midnight, Sun: 2 p.m.–8 p.m., closed Mon/Tues.

Offering the same extensive collection of bondage gear as its San Francisco flagship store, Mr. S. Leather has everything you need for your own private (or public) rendezvous with pain. In addition to the usual cuffs, harnesses, whips, and lubes, you can also find specialty clothes (a full-body gimp suit, anyone?), nipple or scrotum weights, and devices such as the Deluxe Samurai Cock Cage and the Falcon Man Rammers toys, whose very names imply a certain kind of discomfort. Geared toward the hard-core gay leather crowd, Mr. S. is still a great place for heteros desiring punishment or folks just looking to outfit that new home dungeon in the rec room.

—JH

Make Out

Echo Park Lake Paddle Boats

Cheap, fun, and requiring an unexpected amount of strenuous exercise, the **Echo Park paddle boats** are the perfect spot for some covert touchy-feely. Ignore the candy wrappers, the beer cans, and that pesky bloated corpse in the water and simply enjoy your loved one's company as you paddle your way to make-out nirvana. —JH

751 Echo Park Ave. (bordered on other sides by Glendale Blvd., Bellevue St., and Park Ave.), Echo Park; (213) 847-8524.

Fetish | SMBD

Dr. Susan Block's Culture Mission
The Speakeasy Gallery

For some, sex is merely a pastime, a pleasant way to pass the hours, a cheerful diversion from the rigors of daily life. For others, it's a welcome necessity for a healthy and satisfying existence, and for a few, it's an overwhelming, all-consuming obsession.

For LA's Dr. Susan Block, radio and cable TV host (for HBO's *Radio Sex TV*), author of the best-selling *Ten Commandments of Pleasure*, preeminent sexologist, Yale-educated therapist, and all-around horny lady, sex is something she lives, eats, and breathes. Blonde, busty, and possessing a fondness for posing in photos clutching giant dildos and clad only in a revealing negligee, Block is doing her best to spread the gospel of healthy nymphomania the world over.

In addition to her highly successful show, Block also oversees a remarkably busy web site (www.drsusanblock.com), is a vocal proponent for the highly endangered bonobo monkey (whose pacifist, non-male-dominated, unusually randy lifestyle she uses as a framework for her own sexual philosophy), and runs downtown's **Speakeasy Gallery**.

Housed in a former speakeasy in one of the city's grand historic buildings, the gallery is part of the Dr. Susan Block Institute for Erotic Arts and Sciences, a center for "sex education and expression." The gallery's collection includes erotic painting, photographs, sculpture, and a variety of interactive art, including a quivering dildo chair and a giant black bondage cross.

This is the sort of stuff one rarely gets a gander at in more conservative museums, where the bare breasts are usually limited to the ancient Greek statuary. In addition to the titillating displays, the Institute also offers more daring fare, including live tapings of Block's Internet "shows" where various pleasant indiscretions apparently take place.

So if you're looking for sage advice concerning a sexual hang-up or if you just feel the itch to discuss monkeys and gaze at photos of hot bods in compromising positions, then take the road Downtown and pay the good doctor a visit. —Jessica Hundley & Kristine Ayson

Downtown Los Angeles; by appointment only. Call (213) 749-1330 for location and to schedule an appointment to view the collection.

Redemption

Clothes for evil girls and boys.

7280 Melrose Ave. (west of La Brea Ave.), Melrose; (323) 549-9128.
Open Sun–Thurs: noon–8 p.m., Fri/Sat: noon–9 p.m.

If you're looking to stuff Satan's stocking, Redemption would be the
place to start. German industrial music pounds as you browse the more
sinister side of modern attire. Pentagrams, upside-down crosses, and
wearable bat wings provide all the trappings for the uniforms of Hell's
varsity cheerleaders. If your kink rides somewhere between evil and cor-
ruption, then make a last stop at Redemption before your next trip to the
crossroads. Why not look fabulous while selling your soul?

—Aaron Reardon

"It's the **good girls** that keep the diaries;
the **bad girls** never have the time."
— TALLULAH BANKHEAD

Rough Trade

Sex, leather, and spurs.

3915 W. Sunset Blvd. (between Sanborn Ave. and Hyperion Ave.),
Silver Lake; (323) 660-7956. Open Daily: noon–9 p.m.

Looking to dish out some discipline? Rough Trade's the place to start.
Follow the red lights from Sunset Boulevard all the way up to a well-
stocked Leather Queen wonderland. A nice mix of ranchero and cowboy
wear takes the edge off, but it ain't called Rough Trade for nothin'. The
store has an extensive collection of chaps, paddles, masks, whips, ball
gags, dog collars, handcuffs, nasty-looking nipple clips, and a wide array
of cock rings. Rough Trade is definitely geared toward gays, but the staff
is friendly to all, and heteros can find some fun here as well. Check out
the great selection of cards featuring old pulp-novel covers with homo-
erotic titles like *Locker Room Lovers*, go rocker with some nicely priced
leather wrist bands (10 bucks!), or grab your sweetheart a cute little
S&M- attired teddy bear for a post-spanking snugglin'.

—JH

Fetish | SMBD

Road Trip!

Destination: San Francisco

Quick—grab a shuttle flight and take that $100 you would have wasted at a Sunset Strip club and really put it to use—in San Francisco. The city by the Bay virtually invented the modern strip club and pornography as we know it. Although LA has perfected and streamlined the sex industry, San Francisco gave it its gritty and spirited birth. San Francisco can proudly call itself America's most sexually progressive city as shame continues to give way to civic pride in the name of lust.

A great place to start any trip to San Francisco is the world-famous **Mitchell Brothers Theater**. The story of the two brothers who started the theater in the early 1970s was recently immortalized in *Rated X*, a movie starring Charlie Sheen and Emilio Estevez. Although the movie was abysmal, the club remains vital. Friendly girls, touching booths, a movie theater, and several stages make this the Disneyland of strip clubs. A permissive "anything goes" attitude still lives on at the Mitchell Brothers Theater. Also, check out the **Lusty Lady**, the best peepshow in all of California, where the girls sure are purty.

A more recent addition to the San Francisco sex scene is the flashy **Boys Toys** show club. In the heart of North Beach, this club caters to gluttons of all appetites. Not only can you get a mind-blowing lap dance from a redhead or a brunette—but you can also chow down on their "Vampy Veal Milanese" ($36) prepared by a chef from the four-star restaurant on site.

Also, S.F. has some real good make-out spots ranging from the city's giant phallus (**Coit Tower**) to the urban ruins of **Sutro Baths**. If doin' it outdoors in S.F. is your thing, bring a blanket. It gets cold as ice here in Baghdad by the Bay.

Finally, if strip clubs aren't your scene, make your way to the nation's premier underground party for swingers, the **Power Exchange**. In a nondescript warehouse in the Mission District, you can whip or get whipped in the dungeon, find an all-too-willing slave in "the forest," or just meet a nice guy or gal looking to enjoy some mutual masturbation in any one of the Power Exchange's play areas for public sex. Check out powerexchange.com for party listings (usually the last Friday and Saturday of the month). —Charlie Amter

See next page for the San Francisco digits.

Fetish | SMBD

The Digits for San Francisco

Boys Toys: *391 Montgomery St. (north of Pine St.), San Francisco; (415) 391-2800.*

Coit Tower: *1 Telegraph Hill Blvd. (south of Lombard St.), San Francisco.*

Lusty Lady Theatre: *1033 Kearny St. (east of Columbus Ave.), San Francisco; (415) 391-3126.*

Mitchell Brothers Theatre: *895 O'Farrell St. (east of Gough St.), San Francisco; (415) 776-6686.*

Power Exchange: *74 Otis St. (west of Van Ness Ave.), San Francisco; (415) 487-9944; www.powerexchange.com.*

Sutro Baths: *Located at the end of Geary Blvd. at Great Highway (in Sutro Heights Park, near The Cliff House), San Francisco.*

665 Leather

Everything from enema kits to leg cuffs!

8722 Santa Monica Blvd. (between La Cienega Blvd. and N. San Vicente Blvd.), West Hollywood; (310) 854-7276; www.665leather.com. Open Sun–Thurs: noon–10 p.m., Fri/Sat: noon–midnight.

If you like to beat or be beaten, spank or be spanked, whip or be whipped, then strap on your gas mask and your jackboots and head on down to 665. This West Hollywood stalwart hosts a huge selection of bondage and fetish supplies, like the always practical full-face neoprene mask. Friendly sales staff will point the way to the leather chaps or the latex gloves or, if you're the shy type, you can order anything from their extensive collection online.

—JH

"Love is not the **dying moan**
of a distant violin—it's the triumphant
twang of a bedspring."
— S.J. PERELMAN

Fetish | SMBD

Skinn

For the rock star in you!

6406 Hollywood Blvd. (at N. Cahuenga Blvd.), Hollywood;
(323) 464-5150. By appointment only.

When it comes to sexy-ass Gothic rock-and-roll hand-tooled leather, suede, and silver goods, Hollywood Boulevard's Skinn is most definitely the place. With prices ranging from *oh my* all the way up to *wow!*, they are not cheap, but you get handmade goods and odd pelts such as stingray and shark—and don't forget, these are the same clothes worn by such disparate folks as Rob Zombie, *NSYNC, and Jon Bon Jovi. Skinn also sells really cool accessories like wallets, watchbands, and a great line of heavy silver jewelry. Beware: All of Skinn's clothing is custom-made, so call before you decide to drop by, and when you do go to the store, check out the Station of the Cross wall divider. God help us all.

—JAG

> "If it wasn't for pick pockets and frisking at airports I'd have no sex life at all."
> — R O D N E Y D A N G E R F I E L D

Sledge

Leather for every part of the body.

7326 Melrose Ave. (at N. Poinsettia Pl.), Melrose; (323) 933-2726;
www.sledgeusa.com. Open Mon–Sat: 11:30 a.m.–7:30 p.m.,
Sun: noon–7:30 p.m.

Sexy, sleek, and simple, with an assortment of well-made chain and spiked jewelry, Sledge leads the pack in street wear, jewelry, and leather goods. Somewhere between fetish and fashion, between biker and bad boy, Sledge has shoved its heavy spiked heel on Melrose Avenue and set up shop. With custom tailoring and a knowledgeable sales staff (don't mention you wear vinyl!), Sledge is set to dominate.

—Aaron Reardon

Fetish | SMBD

Syren

With these threads you'll be luring poor sailors to the rocks.

7225 Beverly Blvd. (between N. Poinsettia Pl. and S. Gardner St.),
Fairfax District; (323) 936-6693; www.syren.com. Open Tues–
Sat: 11 a.m.–6 p.m.

Specializing in men's and women's rubber wear (everything comes in
both rubber and leather), Syren is the place to live out all of your purr-
fect Catwoman fantasies (they made Michelle Pfeiffer's *Batman* cos-
tume). Featuring a wide variety of women's clothing such as dresses,
gowns, skirts, and tops, as well as menswear including full suits (make
sure to check out the rubber briefs and shorts), Syren could be the one-
stop shop for all the fetish needs of you and your beau.

—JAG

"Sex is part of **nature**,
 and I go **along** with nature."
— M A R I L Y N M O N R O E

Through Your Skin

Body piercing, right there on Melrose.

7372 Melrose Ave., (two blocks east of Gardner St.), Melrose;
(323) 655-7107. Open Mon–Thurs: 1 p.m.–8 p.m., Fri–Sun: noon–8 p.m.

Getting a post through your tongue can be fashionable, but the underly-
ing functionality of such a device always raises an eyebrow. The endless
evolution of piercing has led from those that are simply attractive to
those that increase sensation and can even make it easier to find certain
parts of the body. Specializing in the myriad piercings for your privates
(some you didn't even know there was a name for), Through Your Skin's
friendly staff will help you select the right kind of jewelry and guide you
through their safe and clean practices. Of course, the more squeamish
can always browse through the shelves of erotic books and novelties in
the lobby while their friends are adding more minerals to their diets.

—Aaron Reardon

Dominatrix Lady Elizabeth Tells It Like It Is

Owner of **Lady Elizabeth's Dungeon** (see p. 176) and lifestyle dominatrix, Lady E. shares her wisdom with the SMBD curious.

Q: What is some advice for people wanting to become involved in this lifestyle?

A: Education is the most important advice I can give anyone who is interested in this scene. There are a lot of great books out there that people can read to let them know what this scene is all about. A couple of suggestions are *Screw the Roses Just Send Me the Thorns* and *The Story of O*.

Q: What are some tips you'd give first-time dungeon-goers?

A: If you decide you want this experience in your life, the next step is to find the right facility. Call potential establishments and ask if they give tours, which most do. Go in and take that tour armed with a list of questions that are important to you. Don't be afraid to ask. I always encourage newcomers to do this. It tells them what they need to know and puts their minds at ease. It also tells them whether this is something they want to incorporate into their lives. Having a fantasy is one thing, facing the reality is the final test.

Q: What can a first-timer expect?

A: A first-timer will come in and, after a tour, may decide this is something he or she really wants to experience, pick one of my ladies, and interview her. In this interview the guidelines of the session are discussed, as well as the house rules, and finally, what the individual wants to experience. If they are both in agreement, then they do a session.

Q: What are some rules for dungeon behavior?

A: In a legal house the rules are simple. No sex, no penetration, and no exchange of bodily fluids.

Q: What are your most requested services?

A: Spanking, bondage, tickling, foot worship, and roleplaying, to name a few. —JH

The Chateau

Beating you with a paddle since 1976.

7403 Fulton Ave. (south of Raymer St.), North Hollywood;
(818) 503-3003 or (800) 696-4414; www.thechateau.com.
Call for schedule.

One of the oldest dungeons in the city, The Chateau is also the only one legally licensed for full nudity and other assorted nastiness. Overseen, with patriarchal perversion, by the sprightly 76-year-old Sir James (ask him about his erotic art collection and the time he rode with Betty Page through Central Park in a carriage pulled by six naked ladies!), this dungeon has none of the theme-room fussiness nor any of the theatrical touches of other LA establishments. Punishment is doled out without frills in an atmosphere not unlike your high school weight room. The result is a no-nonsense "spank and go" feel, which may put off some curious ladies but certainly keeps businessmen looking for someone else to be in charge for a change comin' back for more.

—JH

Eros Station

If she's not in your face, you're in the wrong place.

15164 Oxnard St. (a half-block east of Sepulveda Blvd.), Van Nuys;
(818) 994-6100; www.erosstation.com. Open Mon–Thurs: 10 a.m.–
1 a.m., Fri/Sat: 10 a.m.–2 a.m., Sun: 10 a.m.–midnight.

With more than 20 ladies, ranging from very pretty to pretty hot, and myriad of distinctive rooms, Eros Station has all the different strokes for all the different folks: Get all dolled up like the bitch you are in The Cross-dressing Room; pretend you are a captain of industry in The Executive Suite; visit The Doctor's Office where a sexy nurse will take your temperature; get humiliated into good behavior in The Jail Room; get flogged, chained, and wax-dipped to your heart's content in The Firehouse Dungeon, and these are only a few of the many enticing options. The Station also has a full service adult store in the front, so if role playing ain't your thing, maybe *Tampa Tushies 3* is. Caveat emperor.

—JAG

Fetish | SMBD

Lady Elizabeth's

Blood, sweat, and fear.

10914 La Cienega Blvd. (between Lennox Blvd. and W. Imperial Hwy.), Inglewood; (310) 410-1144 or (877) LUV-BSDM; www.passivearts.com. Open Mon–Sat: noon–midnight, Sun: noon–8 p.m.

This is the place to go when you've been a very, very naughty boy or girl. Conveniently located near the airport, this full-service dungeon is a labyrinth of theme rooms, jail cells, and medieval torture chambers. Run with an iron fist (or a velvet glove, depending on your whims) by Lady Elizabeth herself, this is not a dungeon for the faint of heart. The Mae West Room provides privacy (and lipstick) for cross-dressers, the Windsor Room provides all you need for your strict English headmistress fantasies, and the Marquis De Sade Room features various menacing devices and a giant iron birdcage for those desiring some real abject humiliation. Specializing in marathon sessions (customers can be locked up for hours at a time), Lady E's is also the only dungeon to offer pony training—those with an equine fetish can strap themselves to a carriage and take a few turns around the track or grab a bit and bridle and learn to prance like a blue-ribbon show pony. Yee-haw!

—JH

Lady Laura's Dominion

Sugar and spice and everything (not) nice.

8875 Venice Blvd. (just west of La Cienega Blvd.), Culver City; (310) 204-6777 or (310) 559-7111; www.ladylauras.com. Open Mon–Thurs: 11 a.m.–midnight, Fri/Sat: 11 a.m.–1 a.m., Sun: 11 a.m.–7 p.m. Schedule is subject to change without notice, slave.

The most female-friendly and low-key of LA's dungeons, Lady Laura's is situated in a sweet little storybook bungalow on centrally located Venice Boulevard. The vibe here is laid-back, with lots of cute Goth chicks who like to boss boys around and cheerleader types playing at "naughty schoolgirl." With more than 30 employees (all shapes, colors, and sizes), Laura's is prepared for any demand and features the usual equipment— racks, whips, cuffs, plus a Rock Room which could have been lifted straight from Frankenstein's castle. Lady Laura's Room is outfitted in high-kitsch leopard print, and the cross-dressing area is done up all frilly

and pink. In addition to the tickling and spanking, the dungeon also offers more risqué services, such as ball-and-cock torture and mummification. When you're finished with your punishment, you can relax in the Dean Martin Room or share a cigarette or two with the gals on the back patio.

—JH

The Tyranny of Bad Porn Aesthetics

I'll admit it: I don't much enjoy going to strip clubs or porn shops, even though I'm a fun-lovin' gal and enjoy the seductive smiles and shakin' booty of a pretty lady as much as the next guy. Even though I'm basically straight like so many others, I'm a product of a dominant culture that fetishizes the female body. Due to early formative sexual experiences reading *Penthouse* and *Playboy*, my fantasies often place me in such scenarios as I'm the middle-aged truck-driver man who seduces the teenage hitchhiker girl. Yup, the male gaze is so pervasive in the media and elsewhere that it has managed to commandeer something as primal as sexual instinct. I desire women as a man might. But assuming the role of the dominating cock is actually quite liberating when the alternative is identification with the woman. Sitting at the club, it's far more fun to imagine screwing the girl than to be the girl and have to concern myself unduly with matters of shaving, breast size, thong underwear, and practicing the splits for the pole-dance finale. So I'm not complaining, I'll be the cock. It's just that when I go out and spend all that money on tips and overpriced drinks, I want better style. I'm craving lightly seared ahi tuna on a bed of spinach risotto but all I can find is a Big Mac. Why is the sex world tyrannized by such a lame, normative aesthetic?!

How about some '30s pre-Code glamour, hottie Alpine girls in dirndls, orgeishas disrobing from beautiful vintage kimonos? And can't we have a little more coquettishness, some burlesque sparkles, and shimmy-shammy? Sheesh, porn these days is so literal you feel like you're watching the baboon cage at the zoo. So, first step, better style for the ladies, next step, mix it up even more, and let some androgynous mod boy dancing to Radiohead try to do the splits. —Nancy Pearce

Still Horny?

If It Itches, Go See a Doctor!
Free Clinics

First things first. It is a good and natural thing for people to have sex. Lots of sex. Morning, noon, and night, damnit. But, please, for god's sake, use a condom . . . every time. Please, please, please. Some people are jerks and don't tell you when they've got something, some folks don't know. Like the old adage goes, better safe than sorry. But if you do need some medical help, or just want a few free condoms or the pill, here are a few clinics that can help you out.

Free Health Plan: 2209 S. Main St. (between E. Anahurst Pl. and W. Warner Ave.), Santa Ana; (714) 668-1750.

Harbor Free Clinic: 599 W. Ninth St. (at S. Grand Ave.), San Pedro; (310) 547-0202; www.harborfreeclinic.com.

Hollywood Sunset Free Clinic: 3324 W. Sunset Blvd. (south of Micheltorena St.), Hollywood; (323) 660-2400; www.hollywoodsunsetfreeclinic.org.

Knights Of Malta Free Clinic: 2222 Ocean View Ave., # 112 (between S. Coronado St. and S. Lake St.), Westlake/MacArthur Park; (213) 384-4323.

Los Angeles Free Clinic: 6043 Hollywood Blvd. (between N. Gower St. and N. Bronson Ave.), Hollywood; (323) 462-4158; www.lafreeclinic.org.

Also at 8405 Beverly Blvd. (east of N. La Cienega Blvd.), by the Beverly Center; (323) 653-1990.

Planned Parenthood: 1014 1/2 N. Vermont Ave. (at Santa Monica Blvd.); East Hollywood; (323) 226-0800; plannedparenthood-la.org.

Also at 1316 Third St. Promenade, (between Arizona Ave. and Santa Monica Blvd.), Santa Monica; (310) 787-2666.

Also at 1045 N. Lake Ave. (between E. Claremont St. and E. Mountain St.), Pasadena; (626) 798-0706.

Simi Valley Free Clinic: 2060 Tapo St. (at Valley Fair St.), Simi Valley; (805) 522-3733; www.freeclinicsv.homestead.com.

SOS Free Medical Clinic: 1550 Superior Ave. (between 16th St. and 17th St.), Costa Mesa; (949) 650-0640; www.shareourselves.org.

South Bay Free Clinic: 742 W. Gardena Blvd. (at S. Orchard Ave.), Gardena; (310) 327-2535; www.commpages.com/SBFC/.

Also at 1807 Manhattan Beach Blvd. (west of Aviation Blvd.), Manhattan Beach; (310) 318-2521.

UMMA Free Clinic: 711 W. Florence Ave. (between S. Hoover St. and Figueroa St.), Inglewood; (323) 789-5610; www.ummaclinic.org.

Wilmington Community Free Clinic: 1009 N. Avalon Blvd. (at W. Opp St.), Wilmington; (310) 549-1551.For more clinics, visit www.harp.org/clinics.htm.

Free AIDS tests are given at Out of the Closet thrift stores around Los Angeles, visit www.aidshealth.org/TreatLife/testing.htm for locations.

Alphabetical Index

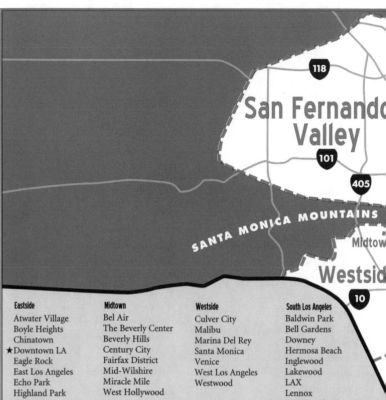

Eastside
Atwater Village
Boyle Heights
Chinatown
★Downtown LA
Eagle Rock
East Los Angeles
Echo Park
Highland Park
Koreatown
Larchmont Village
Los Feliz
MacArthur Park
Pico-Union
Silver Lake

Hollywood
Beachwood Canyon
East Hollywood
Hollywood
Melrose
Sunset Strip

Midtown
Bel Air
The Beverly Center
Beverly Hills
Century City
Fairfax District
Mid-Wilshire
Miracle Mile
West Hollywood

San Fernando Valley
Burbank
Calabasas
Canoga Park
Chatsworth
Encino
North Hills
North Hollywood
Sherman Oaks
Studio City
Van Nuys
Woodland Hills

Westside
Culver City
Malibu
Marina Del Rey
Santa Monica
Venice
West Los Angeles
Westwood

San Gabriel Valley
Altadena
Azusa
City of Industry
Covina
Duarte
Glendale
Hacienda Heights
La Puente
Montebello
Monterey Park
Pasadena
Rosemead
Upland
Whittier

South Los Angeles
Baldwin Park
Bell Gardens
Downey
Hermosa Beach
Inglewood
Lakewood
LAX
Lennox
Long Beach
Manhattan Beach
Mid-City
Palos Verdes
Redondo Beach
South Central LA
Torrance

Orange County
Anaheim
Costa Mesa
Garden Grove
Lake Forest
Orange
San Clemente
Santa Ana
Westminister

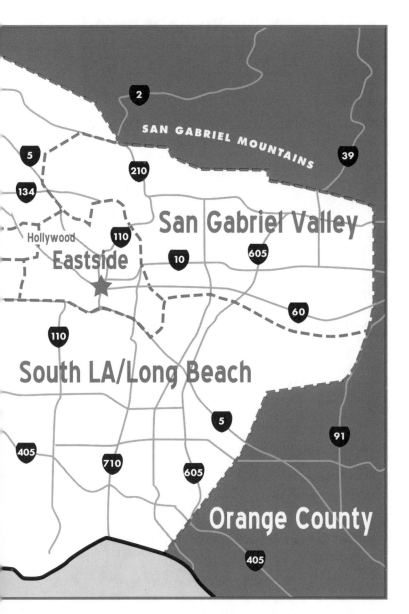

Index by Neighborhood

Eastside

Hollywood

Beachwood Canyon Melrose
East Hollywood Sunset Strip
Hollywood

Midtown

Bel Air	Fairfax District
The Beverly Center	Mid-Wilshire
Beverly Hills	Miracle Mile
Century City	West Hollywood

Westside

San Fernando Valley

Burbank
Calabasas
Canoga Park
Chatsworth
Encino
North Hills

North Hollywood
Sherman Oaks
Studio City
Van Nuys
Woodland Hills

Cyberspace

Index to Sidebars

About the Contributors

Steve "Bun" Allison, born and raised in New Zealand, is a businessman working in downtown Los Angeles. In his spare time he runs an incubator that develops ideas aimed at improving the lives of everyday people.

Charlie Amter lives in San Francisco and has written for *The San Francisco Examiner*, *Maxim*, *Nerve*, and the *SF Weekly*. He spends his spare time learning Destiny's Child songs on his Casio.

John Baldrica, an overworked creative type, is less likely these days to get to first base than to fall asleep in the dugout.

Melissa Bellovin, though happily "married," is still looking for the perfect dance partner: the strong and silent man on the lam who can make her feel like Ninon Sevilla.

Alexandria Blythe once had many piercings. Most have been removed. If she's horny, it's probably not for you.

Chuck Bronco is a two-time AVN award-winning pornographer. He has learned how to use a Macintosh.

Coner Brook is a hopeful romantic searching for his one true love. All interested candidates should enjoy hikes to the top and views from the balcony. Call (323) 664-4645.

"Velvet ropes are apparently quite functional," says **Chad Brown**, a self-styled Renaissance man, a sinner who can order a dinner. "One minute they're herding the masses on the sidewalk and the next they're hoisting you ten feet above the ground in a man-sized birdcage."

H.C. Brown is an aspiring writer who has lived in LA long enough to know about stuff horny people might want to know about.

Tim Catz, ex-con, seeks companion. Good looks, chops, and pro attitude a must. Likes bowling, blue snow cones, and long walks on the beach. New book *Hangover Palaces* available at GatoLocoBooks.com

Barb Choit is a Canadian refugee, currently making both enemies and exes here in LA. Her current projects are American Citzenship and finding a reliable dealer.

Justin Clark (1977–) is a fiction writer and freelance journalist who lives in Chinatown. He enjoys hitchhiking and television.

Cris Contreras hails from De Longpre. Cris writes when he has the time, and has the time when he makes his own dinner.

Bruce Craven wrote the novel *Fast Sofa* (William-Morrow, 1993) and co-wrote the screenplay for the feature film of the same name.

Paul Cullum is a writer and man about town. His work can be seen in *L.A. Weekly*, *Mean*, and other fine publications 'round the world.

Dancer X has decided to remain anonymous because her contributions are the truth, and she has discovered the truth angers people. She has a Master's degree in writing and usually enjoys stripping immensely.

Evangeline Heath is a daringly shy, charismatically anonymous writer who composes taglines for movie posters. Her favorite line, "Columbine is so last year" never made it to print. Until now.

Erin Holmes is a writer and editor with two cats, two hamsters, and a strange sense of humor. She enjoys writing, surfing, group therapy, and doing things that will embarrass her mother, like putting her real name in this book!

Marty "Gemini" Jimenez is a herpetological expert living in Los Angeles. An expert in the hoovery of miniature ponies, he is at work on a book about marsupial lactation.

Steve Kandell is an editor at *FringeGolf* magazine in San Francisco, where he lives, writes, and has sex.

The perennially horny **Sally Kleinbart** is a writer, lover, musician, and loves all things sensorial. Sally has lived in Los Angeles most of her life, having left for a couple years to study journalism and philosophy at California State University, Chico.

Josh Levitan is often horny. He once went to a live sex show in Thailand with his whole family. He does not recommend this.

Jen Liu is an artist/writer living in LA. She is known for being a good listener, and she was raised to be a nice girl. It worked; she's pretty nice.

Rebecca Lorimer is newly 21-years-old, but still a pick up scene expert.

Matt Maranian is the author of the do-it-yourself home style book *PAD: The Guide to Ultra Living* (Chronicle Books), and coauthor of *L.A. Bizarro! An Insider's Guide to the Obscure the Absurd and the Perverse in Los Angeles* (St. Martin's Press).

Jonathan Miertschin was trying to get his FBI card in LA until his girlfriend told him that Female Body Inspector was not a real job.

Molly Mormon is recovering from her cultish upbringing by immersing herself in LA's sexual subculture.

Writer **Phuong-Cac Nguyen** likes sex and food, oftentimes substituting one for the other. She's never felt healthier.

Joey Nicchitta is identifiable by his statuesque presence, Old World charm, refined taste for rich foods and delicate wines, and needle-sharp instincts, all tempered by years of intensive Liberal Arts training.

Noel has stupid amounts of sobriety.

Nancy Pearce is a refugee from Utah seeking political asylum in Los Angeles. She is a founding member of the FUTUREflapper, SnuggleWarrior, and Post-Millennial Slut (PMS) Associations.

Robert D. Petersen is a Los Angeles historian and musician who grew up in Pasadena and currently resides in Angeleno Heights.

Todd Philips is a writer and musician who transplanted himself from Boston to LA in 1998. He has been a member of several bands including Bullet LaVolta and The Juliana Hatfield 3, and has written for various entertainment publications. He enjoys sex.

Gary Phillips has written in several mediums in various states of undress, duress, and sobriety. Check out his web site at: www.gdphillips.com for more goodies.

Aaron Reardon shot himself out of a giant circus cannon, flying across the desert in his search for the perfect martini . . . My god did he find it . . .

Andrea Richards is a writer and editor living in Los Angeles.

Jonathan Sanford lives in Venice, CA with his wife. He works as a cameraman for film and TV. Like everyone, he's trying to get financing for his hot script, which he plans to direct.

Aurisha Smolarski is a multi talented musician who co-fronts the band Vanity Press, writing, singing, and playing guitar and violin. She has been teaching and recording for years; there's something about a beer, a tear and a sweet violin.

Travis T. Stevens thinks he knows everything. He lives in Los Angeles and is one of the founders of Pink Bubble Bath: The Sexy Film Festival. He also imagines himself to be a DJ and a Musician—but most people don't agree.

Z Bone is an average horny guy with too much time on his hands. His wealth of strip club knowledge can be accessed at www.zbone.com.

About the Editors

Jessica Hundley began her writing career as a late '80s zinester, founding and editing the mag *Mommy And I are One* for 8 years until she just couldn't stand it any longer. Currently, Hundley writes for *Dazed and Confused, Flaunt, Maxim, New York Press, Paper, Salon.com, Hustler, Playboy,* N*erve.com, Soma,* and others. She is also attempting to complete the eternal process of editing her first feature film while simultaneous working on several shorts and screenplays. She likes having sex a whole lot more than writing about it.

Jon Alain Guzik is a writer living in Los Angeles. He has an MFA from CalArts in Critical Studies. For the New Millennium, Mr. Guzik has decided to keep clear of all the peccadilloes that have plagued him in the past and focus on a life of moneyed Bohemia and *Les morale de la guerre contre laideur.* If you wish to join him in the good fight, please send an inquiry to the publisher. *Viva La Resistance!*